JERRY GARCIA

The Collected Artwork

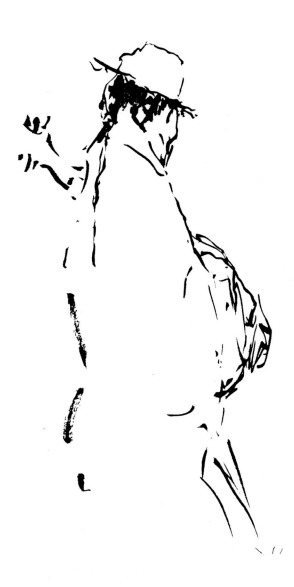

Preface by BOB DYLAN *Foreword by* MICKEY HART *Edited by* APRIL HIGASHI

THUNDER'S
MOUTH
PRESS

Jerry Garcia
The Collected Artwork
© 2005 Jerry Garcia Estate LLC

Published by

THUNDER'S
MOUTH
PRESS

An Imprint of Avalon Publishing Group
245 West 17th St, 11th floor
New York, NY 10011-5300
Distributed by Publishers Group West

Produced by
Insight Editions in association with the Jerry Garcia Estate LLC

INSIGHT EDITIONS

www.insighteditions.com

www.jerrygarcia.com

PREFACE: p. ix, © 1995, 2005 Bob Dylan. FOREWORD: p. x, © 2005 Mickey Hart. PROLOGUE: p. xiii, © 2005 Deborah Koons Garcia. Brother Jerry, p. xix; © 2005 Tiff Garcia; The Drawing, p. xix; © 2005 Annabelle Garcia-McLean; Navigator, p. xxi, © 2005 Carlos Santana; Doodling on the Baby, p. xxii, © 2005 Donna Jean Godchaux-MacKay; Saving the Wetlands, p. xxii, © 2005 Tom Turner; Connecting, p. xxvi, © 2005 Grace Slick; Tip of the Iceberg, p. xxvi, © 2005 Victor Moscoso; Anchorman, p. xxvii, © 2005 Jim Donaldson; Cover Story, p. xxviii, © 2005 Andy Leonard; A Helping Hand, p. xxix, © 2005 Paul Pena; Art and Soul, p. xxx, © 2005 Baron Wolman. CHAPTERS ONE – FOUR: The Other Side of Jerry Garcia, p. 2, © 2005 Jon Carroll; Imaginative Drawings for an Imaginary Film, p. 4, © 2005 Len Dell'Amico; Shamanic Vibrations, p. 138, © 2005 F. Lanier Graham; The Mark of a Man, p. 148, © 2005 Patti Smith. AFTERWORD: Dispatch from the Land of Night, p. 173, © 2005 Herbert Gold.

COVER & P. v: © 2005 William Coupon/www.williamcoupon.com.

JACKET FLAP: © 2005 Angelina DeAntonis/www.ocelotclothing.com.

PHOTOGRAPHS OF JERRY GARCIA: p. xvi & p. xxxi, © 2005 Baron Wolman/www.fotobaron.com; p. xxiii, © 2005 Michael Dobo/www.dobophoto.com; p. viii & p. xxxii, © 2005 Herb Greene/www.herbgreenefoto.com; p. 74, © 2005 Henry Diltz/www.morrisonhotel.us; p. 76 & p. 176, © 2005 Jay Blakesberg/www.blakesberg.com; p. 136, © 2005 Jon Sievert/www.humblepress.com; p. 146, © 2005 Anne Fishbein/www.annefishbein.com; p. 172, © 2005 Richard E. Aaron/Star File/www.starfileonline.com; p. 170 & p. 178 © 2005 Susana Millman/www.mamarazi.com; p. 180, © 2005 Robert Altman/www.altmanphoto.com; p. 177 © 2005 Roberta Weir/www.robertaweir.com. CONTRIBUTOR PHOTOGRAPHS: p. ix & p. 181, © 2005 David Gahr; p. x, © 2005 John Werner; p. xxvii & p. 181, © 2005 Robert Minkin/www.minkindesign.com; p. xiii & p. 181, © 2005 Lori Hope/www.lorihope.com; p. 2 & p. 183, © 2005 Tracy Johnstone; p. 4 & p. 183, © 2005 Mick Stern; p. xix & p. 181, © 2005 Mark Burstein; p. xix & p. 181, © 2005 Scott McLean; p. xxii & p. 182, © 2005 David MacKay; p. xxii, Keith and Donna Album, courtesy of Round Records, © 1975 Round Records, All Rights Reserved; p. 138 & p. 183, © 2005 Howard Gerstein; p. xxix & p. 182, © 2005 Baron Wolman; p. xxii & p. 182, © 2005 Mary Jorgensen; p. xxvi & p. 182, © 2005 Joel Lipton; p. 148 & p. 183, © 2005 Frank Stefanko; p. xxvi & p. 182, © 2005 Dennis Wheary; p. xxviii & p. 182, © 2005 Dr. Edward Carden; p. 173 & p. 183, © 2005 Ella Gold Wade; p. xxvii & p. 182, © 2005 Zoe Donaldson; p. xxi & p. 181, © 2005 Jay Blakesberg; p. xxx & p. 183, © 2005 Dianne Duenzl; p. xvii, © 2005 Angelina DeAntonis; p. 183, © 2005 Celeste Tang.

Compilation, text, images, and contents © 2005 Jerry Garcia Estate LLC unless otherwise noted.

ISBN: 1-56025-755-5 (PBK)
ISBN: 1-56025-791-1 (HC)
ISBN: 1-56025-792-X (LTD ED)

9 8 7 6 5 4 3 2 1

Printed on acid-free, partially recycled paper. Insight Editions, in association with Earth Aware (www.earthaware.org) and the World Wildlife Fund (www.worldwildlife.org), non-profit organizations whose missions include reforestation, will plant two trees for each tree used in the manufacturing of this book.

Printed in China through Palace Press International www.palacepress.com

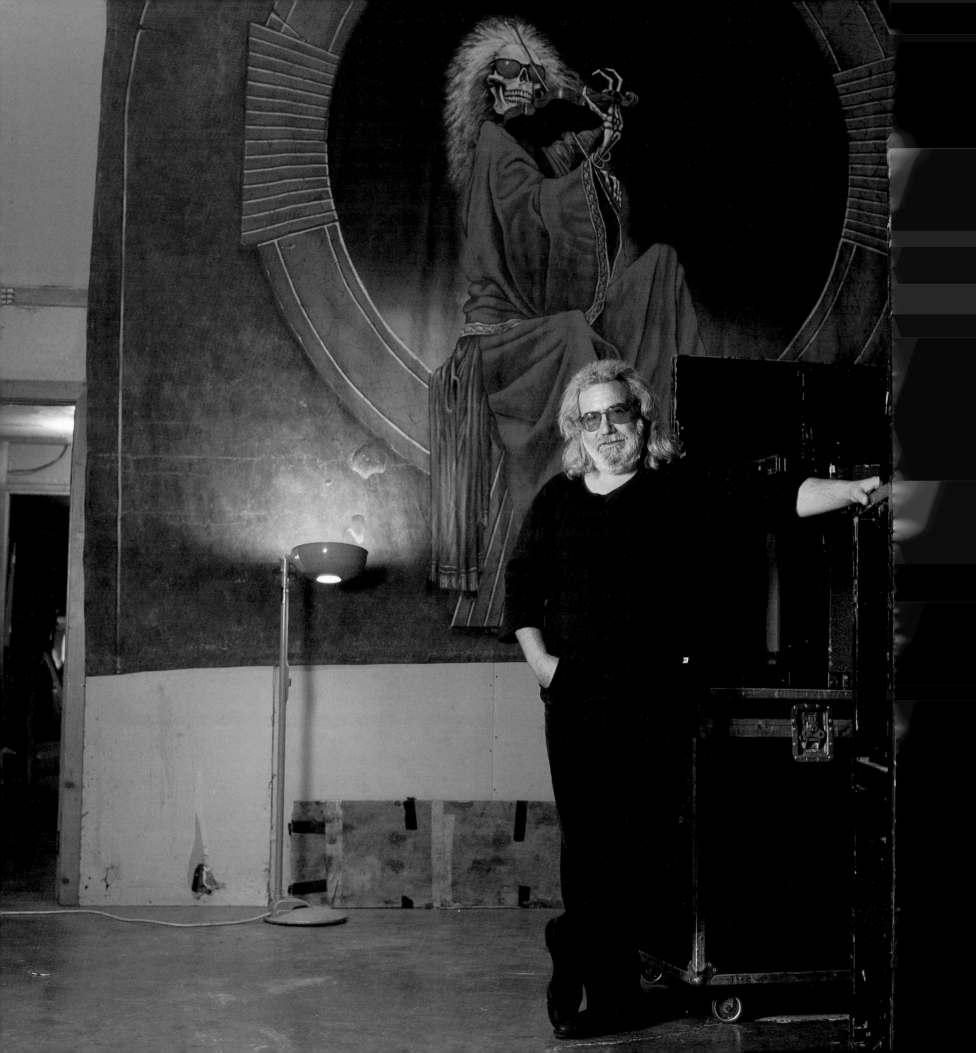

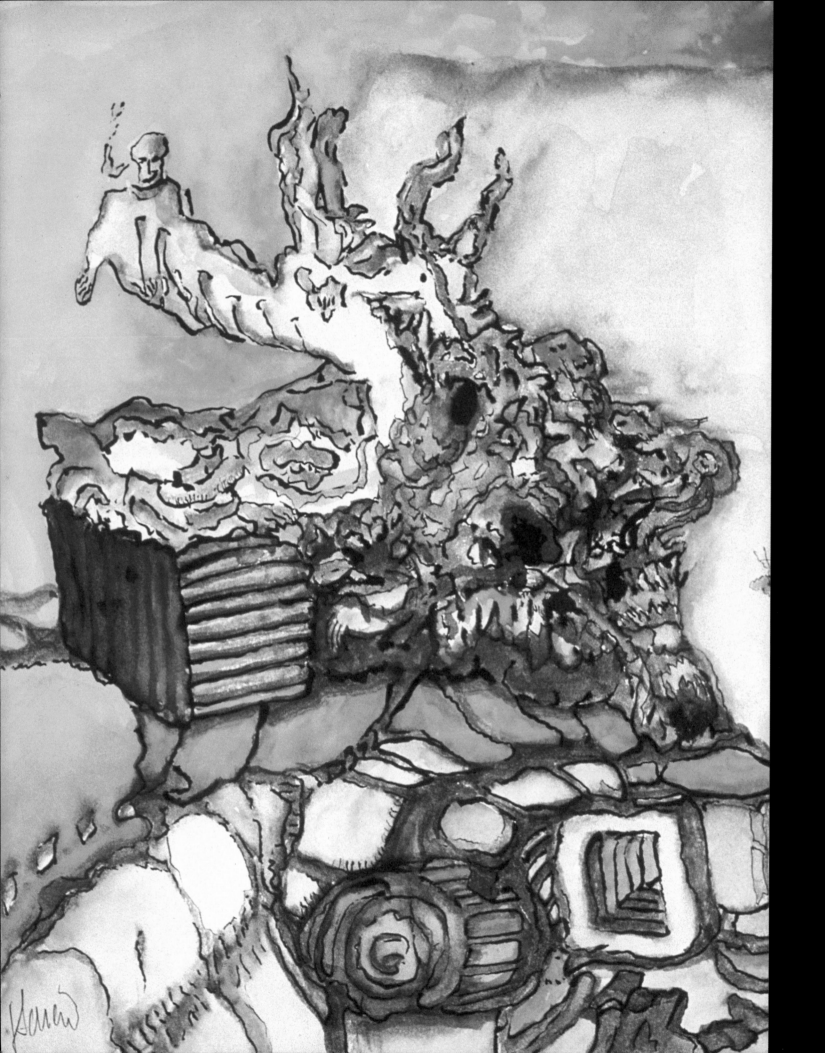

BUTTERFLY TRAP
Watercolor & ink on paper, 9⅝″ x 8″, 1993

Contents

Preface Bob Dylan ix

Foreword Mickey Hart x

Prologue Deborah Koons Garcia xiii

Introduction April Higashi xvii

Brother Jerry *Tiff Garcia* xix
The Drawing *Annabelle Garcia-McLean* xix
Navigator *Carlos Santana* xxi
Doodling on the Baby *Donna Jean Godchaux-MacKay* xxii
Saving the Wetlands *Tom Turner* xxii
Early Works xxiv
Connecting *Grace Slick* xxvi
Tip of the Iceberg *Victor Moscoso* xxvi
Anchorman *James R. Donaldson* xxvii
Cover Story *Andy Leonard* xxviii
A Helping Hand *Paul Pena* xxix
Art and Soul *Baron Wolman* xxx

Drawings 1
The Other Side of Jerry Garcia *Jon Carroll* 2
Imaginative Drawings for an Imaginary Film *Len Dell'Amico* 4
Etchings 65

Watercolors & Gouache 75
Processes and Influences 76

Acrylics 137
Shamanic Vibrations *F. Lanier Graham* 138

Digital 147
The Mark of a Man *Patti Smith* 148
Art and Commerce *Peter McQuaid* 174
Dispatch from the Land of Night *Herbert Gold* 177

Selected Exhibitions 180

Chops and Provenance 182

Contributors 185

A Last Word April Higashi 190

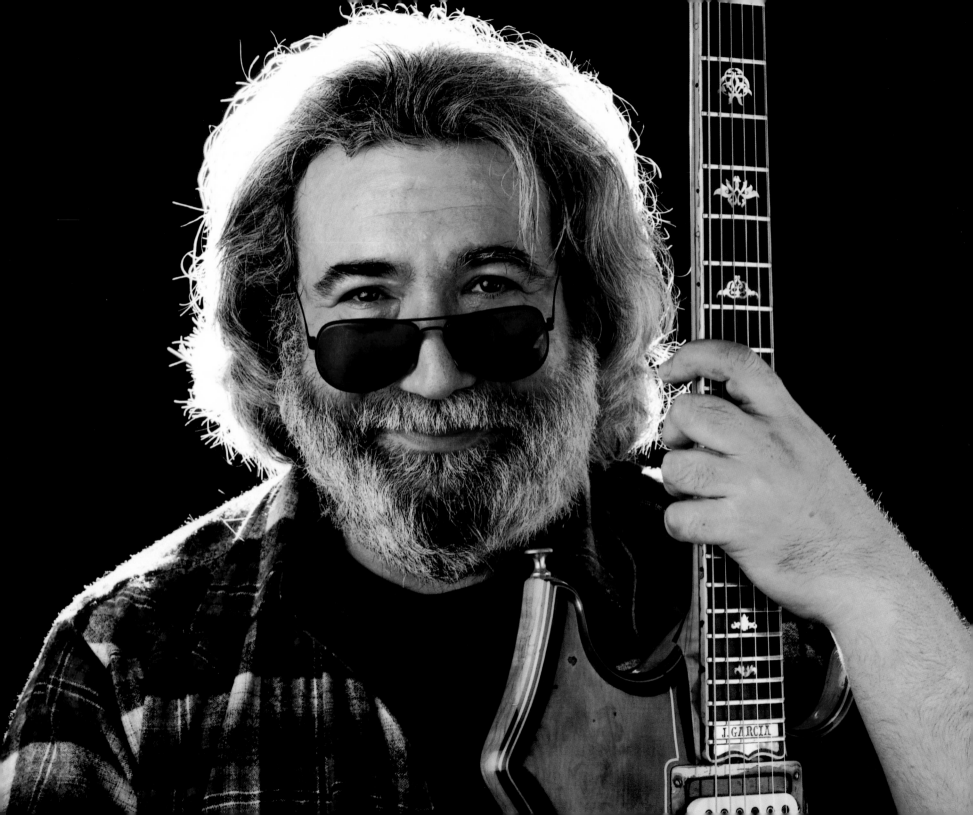

and articles, it has rarely been recognized that it was this downtime that gave Jerry an opportunity to refocus on his visual art.

When the band returned to touring, Jerry continued with his renewed love. The road in rock'n'roll is often a lonely one, and can be incredibly tedious when you're not playing. Jerry would airbrush and draw constantly in his room at night and visit museums in the daytime. Painting, drawing and sketching kept him busy. He couldn't rehearse all the time. His art was another form of creativity, and was something that was easy and portable. He could take it with him, put it in his pocket and work on it whenever or wherever the muse visited.

Drawing was something that inspired Jerry. At first, he had bamboo-tipped pens that were fun to draw with, but he soon upgraded to Rapidographs. He then began to work in black ink with drafting pens. One line would play off the other, spiraling, cascading into streams of consciousness with no beginnings, no endings, just flow. These little squiggles slowly morphed into forms, limitless fluid designs, not related

STILL LIFE
Oil on board, 25 ½" x 17 ½", circa 1958

through their specific imagery, but all connected somehow. A man with an umbrella suddenly emerges from a little building and then turns into an elephant, then back into the man with an umbrella. The work always grew organically and was never forced. His hand had a poetic flow to it… relaxed and steady. He was a man of chaos, the most wonderful kind of raw, unfettered weirdness. A stretch of consciousness here, the identifiable image there, allowing the mystery to unfold like a maze. Many of these images had no literal meaning but were serpentine in nature, and very dense.

He moved from medium to medium. By the late 1980s airbrushing became his passion…then computer art in the 1990s. He penned original art, scanned it into the computer and then enhanced it with colors. It was a unique approach

DANSE
Ink on paper, 6" x 4", 1992

and a challenge to get the color right on the computer and then translated to the printed page. At the time, this was a technological feat. But always there were the notebooks and the sketches.

For many years, his guitars were pure red or black. Shades in between were a challenge for him as he drifted deeper and deeper into the mysterious world of synesthesia, where sound evoked colors and colors translated themselves to sound. It was a kind of silent game he played in his mind. On occasion, Jerry would ask me if I saw images while playing.

He delighted in musical colors and often changed the tone of his guitar. He was painting, exploring between the cracks, in shades of colors and sounds, mutating slowly from one to the other. Spending his waking and dreaming hours in this zone was a powerful influence on both his music and his art. It was like colored hearing, a form of sensory fusion and a union of the senses.

In 1978, while the band was in Egypt, Jerry and I went to the *Son et Lumière* (Sound and Light) show that told the story of ancient Egypt. It was held out of doors beside the great pyramids in Cairo. After the show he noted that the color of the music that accompanied the visuals were wrong—"wrong key, wrong colors." To him, all this was very real and not imagined.

When in New York City, we often went in search of jack-hammers and buildings being demolished. There was something ecstatic about that sound of explosion as the wrecking ball smashed into the walls. We'd grab a hot dog and just sit there taking it all in. He loved noise. The cities were full of noises and sounds were everywhere. Music to him was flowing water, rumblings, the sound of snapping flags, sliding doors, crowds and the roar. He stayed up many nights waiting to see the sunrise as it came up over Central Park. He was inspired by the road, and would take in the sights of different cities, like the arch in St. Louis, Central Park in New York, and Red Rocks Canyon in Colorado. He loved to draw his surroundings. Painting was his entertainment, passion, and relaxation.

When he returned to art in the 80s, he couldn't believe that people loved his work. Typically humble, he never took his artwork seriously in any sort of a commercial sense, and was always self-effacing almost to the point of apology when discussing it with others. Jerry was shocked when his art was turned into ties and was truly overwhelmed by the popular response, as he himself would never wear a tie. It was a big chuckle for him in that way. His art poured into his music and the music inspired his art; true synesthesia.

As a person, Jerry was so big-hearted that if someone approached him and wanted the drawing he was working on, he would just give it away. He was almost allergic to keeping stuff; it made him uncomfortable. No doubt there are hundreds of his small sketches and drawings out there

somewhere. He loved to teach kids how to sketch and would always take the time to show them little drawing tricks.

He most often came to the work with an open slate, a sense of humor and a sense of the weird. A seat-of-the-pants musician, an in-the-moment player, he was a fluid improvisationalist and amazingly prolific, both in his visual art and music. Jerry believed that music and art were bits of your subconscious rising to the surface and turning into a form that could be shared. This is the role of any artist. The thought itself is invisible. Feelings move the soul and make the hand create the visible. A focus of the imagination, the creative mind...spirit into sound, or the soul translated into images on paper.

The creation of art is about self-expression. At the core are feelings, emotions and passion. Jerry had the ability to transform his feelings onto paper in a way that had meaning for those who saw it. It is no wonder that many of his drawings capture our spirit. He was an artist in his music and his visuals, probing beneath the obvious, the mundane, into the deeper realms. The appeal of great art is never purely visual, but contains magical and mythical themes coupled with illusion and the appearance of visual truth. He was a gifted maverick who approached his art with a kind of haphazard spontaneity.

Jerry could say things with pen and ink that couldn't be said any other way. He spoke in watercolors and oils, giving shape and meaning to the things he saw, but always with a bit of anarchy thrown in. He said he felt quiet inside when he drew, suspended in time, hanging somewhere between heaven and hell.

Many of Jerry's sketches and paintings have been lost to the ages, tossed off to be enjoyed by those lucky enough to have encountered him in the midst of an artistic burst. In this compilation, though, we have those that were preserved by his closest friends and family. It is a magnificent collection that is brilliant testimony to his unique artistic vision. I hope you see these images as a reflection of his soul in the same way you understand and feel his music.

Prologue

Deborah Koons Garcia

Jerry Garcia was an artist: it was his nature, his work, and his avocation. Like many people of our generation, Jerry was obsessed with transformation. His path involved focusing hand and eye, mind, body, and spirit to create, to express himself.

For Jerry this meant using his hands: real work, actually making some thing. He was industrious by nature and curious, even as a child. He spent the downtime caused by his childhood asthma attacks creating, filling long hours with drawing and daydreams. The outside world was closed off to him, so he created an inner world, materialized it with his hand, cared for it. As Jerry grew up he continued to draw for pleasure. He wandered the streets of his native San Francisco, sketched lonely people in cafes, even went to art school as a teenager. As music claimed more and more of his time, his playing in bands became a job, then a career, then a lifestyle, and there was no time for exploring visual art, only doodling. There was no room for the purely personal endeavor. In keeping with the era and subculture he found himself in, all creative effort was owned by the group. The more successful he became, the less he owned his own life.

During those years, even as that life turned against him, Jerry learned to relate to an audience, to express himself in a way that commanded the attention of thousands, tens of thousands, hundreds of thousands of people. He trans-

formed himself into a truly amazing performance artist. He was more than just a guitar player, or a musician, or a rock star—he was all those things, but he also transcended them. I think this was Jerry's highest art, his greatest gift: to provide people with an experience they treasured. They loved him. It wasn't just the music, or the environment, the expectation, the familiarity, the marketing: it was Jerry himself and the kind of magnetic quality he had that drew people in. It was at once intimate and vast, familiar yet new, individual yet with companions—thousands of them. The participant, the dancer, was transformed by the experience. You took nothing away but a transformed self. You can't really describe it or capture it. It's like the difference between eating a peach and looking at a picture of one. You just had to be there.

As I stood near my husband and observed him playing hundreds of concerts, there was a lot of opportunity for wondering why I found him so fascinating, what was so unusual about him. For one thing, he was the most graceful, most coordinated man I have ever seen. He moved beautifully. He

ments actually made him develop his natural intelligence, which was in itself considerable. I liked that idea. Of course, Jerry did a fair amount of things that weren't intelligent at all, but making music usually wasn't one of them.

Then in the late 1980s, in spite of the claustrophobic nature of his existence, Jerry started to draw again and to paint. It was to him a lifeline. If he could prove he owned his own body by destroying it, he could prove he owned his own creative nature by putting pen to paper and drawing out what was on his mind: no one could interfere or "cop" it. It was an affirmation of his ability to create, by himself for himself. He used his hands, again in skillful deliberate movements. What came out first were nightmares, adolescent art school grotesques, a reflection of his state of being. Gradually, more beauty, more craft and imagination came into play. By the last few year of his life, Jerry was happily drawing and painting all the time. He relished creating *Harrington Street*, the visual autobiography of his youth. He wanted to own his own life again. The art he created was an antidote to his non-life, the structure built up around him that had inhibited his individual artistic nature. As he had done when he was a child when he felt shut out of the real world, he put pen to paper and created another world, his own. This activity gave him pleasure, and soon he felt comfortable enough to sell his work, have art shows, and try to make a living with his art. Art was his way out.

After his death, one of my concerns was the "J. Garcia" tie line, ties with patterns made directly from Jerry's art. We had often sat together when he was alive, going through the ties, approving some, rejecting others. I was resolute with the manufacturers, that they always show Jerry's exact line, that patterns come directly from the art, that you could see Jerry's creative touch, his hand, in every tie. I approved each design as Jerry and I once had, a happy mix of art and commerce.

A few years ago, I went to a wedding and, as everyone was standing around outdoors in a beautiful California vineyard garden, a stiff breeze came up and all the men's ties started flapping in the wind, dozens of them. I realized that almost all of them were "J. Garcia" ties, all colors, all waving: Jerry's hand, waving at me. I felt both joy and sorrow. I felt he should have been there. And that in some sense, he was.

had the exactness of gesture from his Spanish heritage, and the freedom of the native Californian. For another thing, his head was really substantial, even without his Leo mane. I suppose he could have had more brain mass than most people. And then there was what he did with his brain, which was to use it to move his hands, his fingers, in exquisitely refined movements which turned into music that moved thousands of people. His hands were a kind of fulcrum. I knew that a huge part of the human brain is given over to hand and finger movement—that's one of the things that makes us human—and that the more we use our brains the more they develop, so I figured Jerry's music-making move-

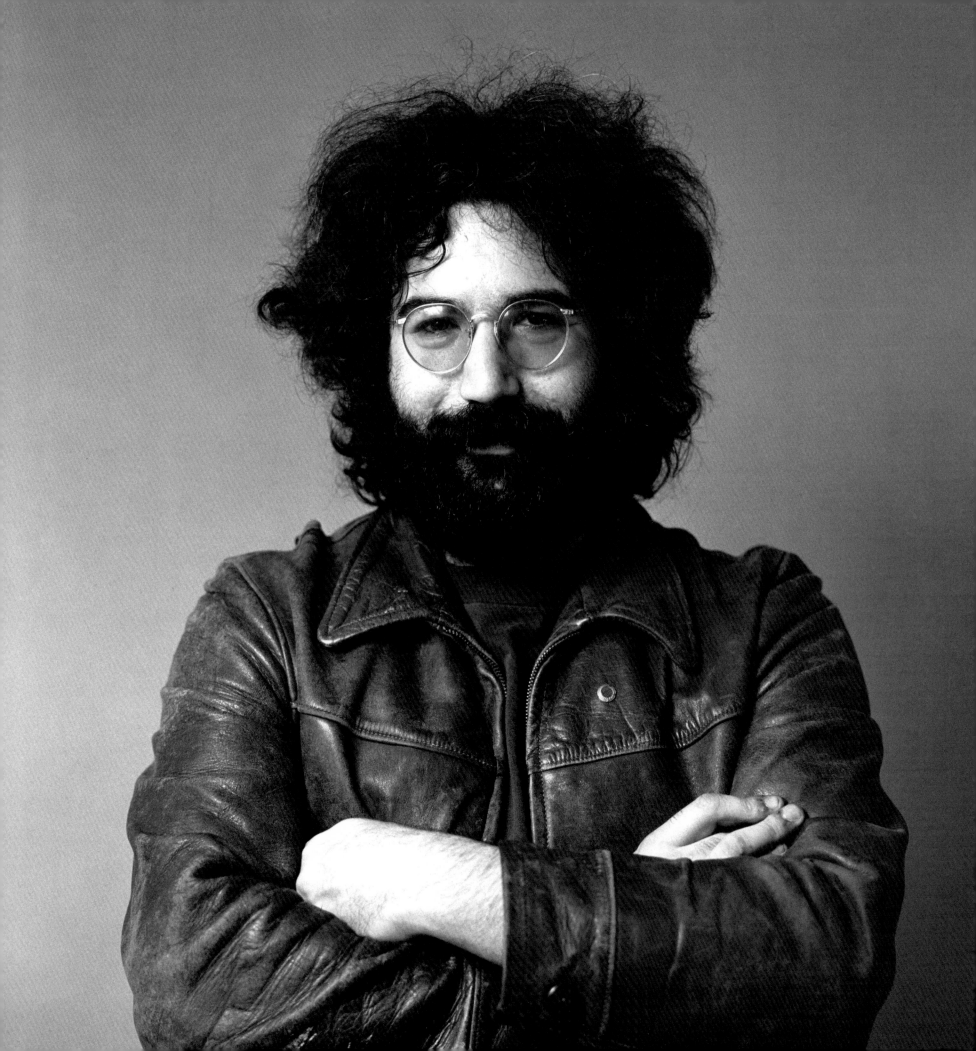

Introduction

April Higashi

Jerome John Garcia was born August 1, 1942 to Jose and Ruth Garcia, and was named after the composer Jerome Kern. His father was a Spanish-born "ballroom jazz" musician, and his mother a nurse—a family often described as hard-working.

At the tender age of five, Jerry saw his adored father drown in a river. "We were on vacation," he told *Rolling Stone*, "and I was there on shore. I actually watched him go under. It was horrible. I was just a little kid, and I didn't really understand what was going on, but then, of course, my life changed." Jerry and his brother were sent to be raised by his grandparents on Harrington Street, in San Francisco, a story told in the eponymous illustrated book.

He soon developed asthma and spent much of his time drawing in bed. Despite his childhood traumas, which also include the absence of his mother and a horrific accident at age four when his older brother, Clifford ("Tiff"), chopped off Jerry's middle finger, he was said to be a happy, industrious child. He had a smile on his face and was always singing and drawing.

Growing up in San Francisco's Excelsior district, at around the age of eight Jerry became seriously interested in art. He enjoyed cartooning and sketching, often borrowing comics from Tiff. Jerry loved *MAD* and the EC gothic horror line, the more grotesque the better. His juvenilia reflects this sanguinary side; he loved horror comics, novels, and films

till the day he died and was a big fan of Stephen King, Boris Karloff, and Clive Barker. Even the name and iconography of the Grateful Dead reflect his obsession with the necromantic.

The first film that made a big impression on him was Universal's quirky *Abbott and Costello Meet Frankenstein*. If Jerry were to have fully developed yet a third talent, it would probably have been filmmaking, which he dabbled in and studied. He spent time in his young adulthood as an unofficial auditor of the Stanford University Film School, where his musical talents led him to compose the scores to any number of student films. This love of his never left him. He worked as editorial director for both *The Grateful Dead Movie* (1974) and *Grateful Dead: So Far* (1987), a blend of in-studio performances and computerized graphics.

From any early age Jerry and his brother, Tiff made up their

own words, creating an evolving language. Words like "smoketites goffitus," "heap-swiper," and "televeiwus visionatusion" were in their shared childhood vocabulary; in *Harrington Street*, we encounter "anecdoubts," and "autoapocrypha." The adult Jerry was always described by those who knew him as extraordinarily intelligent and articulate.

As a young boy, he found his interest split between visual and musical expression; his first passion was art. "I was serious about being an artist. I was thinking of myself as an artist. And then, of course, I got my first guitar, and the rest, as they say, is history." He was fifteen. Jerry was too proud to take lessons and taught himself, spending up to ten hours a day practicing.

> *"Somewhere before that, when I was in the third grade in San Francisco, I had a lady teacher who was a bohemian, you know, she was colorful and pretty and energetic and vivacious and she wasn't like one of those dust-covered crones that characterize oldtime public school people; she was really lively. She had everybody in the class, all the kids in this sort of homogeneous school, making things out of ceramics and papier-mâché. It was an art thing and that was more or less my guiding interest from that time on. I was going to be a painter and I really was taken with it. I got into art history and all of it. It was finally something for me to do."* –Jerry Garcia

His only formal art training came a few years later, when he studied at the California School of Fine Arts, now known as the San Francisco Art Institute. At sixteen and seventeen, he attended "Pre-College Art," a class on Saturdays. Jerry studied with Wally Hedrick and Elmer Bischoff, both of whom were important and influential artists at the mid-century, and had prominent and distinguished careers. Jerry later said it was the only school he was proud to have attended. Wally Hedrick was a genuine beatnik; even keeping a "job" ironically posing as a bohemian sitting at the bar at Vesuvios, a famous hangout in San Francisco's North Beach, and it was he who turned the young Jerry on to Kerouac's *On the Road* and all its attendant attitudes. "Wally taught me that art is not only something you do, but something you are." Hedrick later described Garcia's artwork as "figurative,

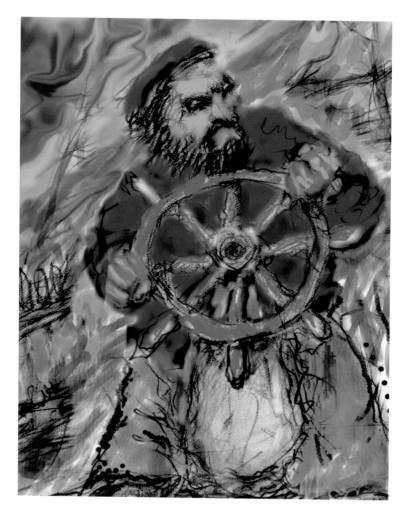

CAPTAIN OLSEN
Digital media, 1995

but with freewheeling brushwork…strongly painted, heavily textured."

> *"I owe a lot of who I am and what I've been and what I've done to the beatniks from the Fifties and to the poetry and art and music I've come in contact with. I feel like I'm part of a continuous line in American culture, of a root."* –Jerry Garcia

In 1961, at age nineteen, Jerry turned his attention fully to music. The Sixties came blasting in, in all their technicolor glory, and the story of his becoming the somewhat unwilling leader of the near mythical rock band the Grateful Dead and all its attendant phenomena needs no explication here, save

perhaps to say that despite the rigors and pitfalls of life on the road, in the center of the storm, he always found time to draw or paint and that, more than anything, helped him to transcend the madness of that existence.

"It's like when you're drivin' down a road past an orchard, and you look out and at first all you can see is just another woods, a bunch of trees all jumbled up together, like there's no form to it, it's chaos. But then you come up to a certain point and suddenly—zing! zing! zing!—there it is, the order, the trees all lined up perfectly no matter which way you look, so you can see the real shape of the orchard! I mean you know what I mean? And as you move along, it gets away from you, it turns back into chaos again, but now it doesn't matter, because now you understand, I mean now you know the secret." –Jerry Garcia

In the course of writing this book, we found numerous friends, acquaintances, colleagues, admirers, and family members who wished to contribute reminiscences, observations, or thoughts on the art and spirit of this remarkably creative soul. What follows is a mosaic of their stories.

Brother Jerry
Tiff Garcia

When he was about five, Jerry started drawing on the back of laundry lists—our grandpa was in the laundry delivery business. Back then there wasn't a lot of media to relate to: radio shows were limited, and we didn't have a record player, so we'd look at comic books, and he would draw. He was influenced by MAD magazine and was really into monsters, too—like Frankenstein—images that were lively in his mind. He spe-

cialized in making things as grotesque as possible.

From when Jerry was around ten to about fifteen we were pretty close. I was four years older. I let him help me work on my first car, but he was kind of a klutz. He didn't get into it much—he'd rather draw, or listen to records, or read comic books. When he drew, Jerry seemed to get into more detail on the little drawings than the big ones.

We also had a band saw—Jerry would draw characters on a piece of wood, and I was supposed to cut them out for him. I don't remember doing too many of them.

He never considered himself an Artist; he'd just been drawing for so long. After a while, you get good at it whether you want to or not.

The Drawing
Annabelle Garcia-McLean

It was late, it was damp and it was the end of a long and frustrating night for my dad.

The show was not a good one. His spirits were down and he was mumbling curses all the way to the hotel. Fingers still twitching from the impulses of the show tapped out random rhythms. The perennial white towel hung over his sweat-soaked black tee-shirt, adding to his defeated, hangdog air. The car pulled in and we slumped out of it; immediately, a lone fan waving his little autograph book set upon us. My dad tried to make the door but it was too far. Resigned to the encounter, he took the proffered book in one hand and started writing his name with the attached pen. The fan stopped him and asked him to draw a little picture along with the signature, as that was what he collected.

My dad stopped and took a moment to look through the little book; it was jammed with all kinds of odd doodles, faces and a couple of "I can't draw" pages. My dad started smiling and shaking his head, then he turned to the blank page, stared at it a second, then with trembling, exhausted fingers

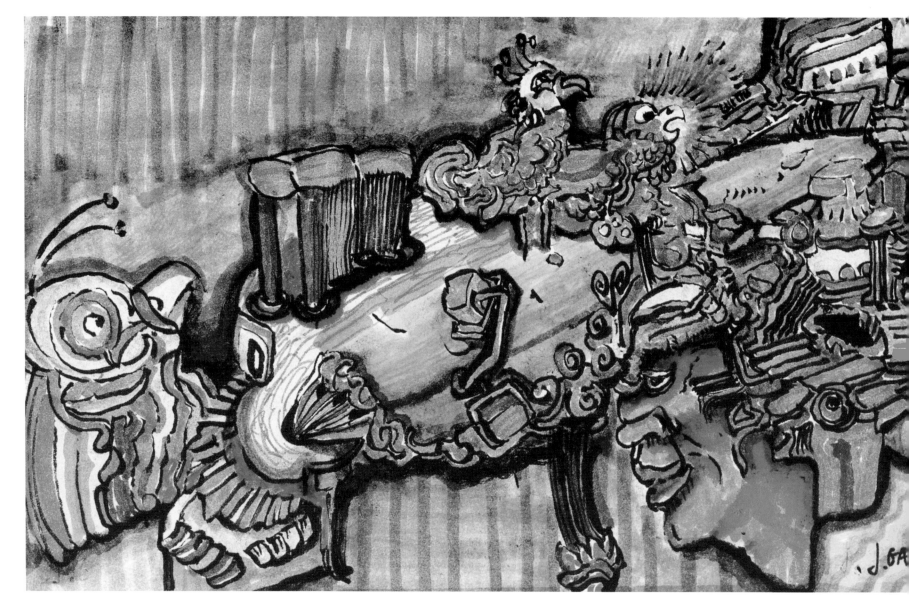

BIRDLAND
Marker on paper, 5″ x 7″, 1985

he drew an elephant and signed the rest of his name. The fan thanked him and took off into the wee hours of the morning. I looked at my dad and it was like looking at a dawn: his disappointment and exhaustion melting away; that old sparkle that says "Life is truly hilarious" was awakened again in his eyes. He gave me a grin and said, "Let's see if room service is up and I'll show you how to make an old-fashioned milk-shake."

Just that moment in time changed the rest of the night for both of us. The contents of that book were so delightful to my dad it altered his reality. He was still exhausted, but his spirit had returned, and it returned a great deal lighter.

And in this moment, in this collection of moments, I would ask that you allow him the chance to return the favor.

Navigator

Carlos Santana

Jerry Garcia wasn't a little fish in a little fishbowl: he was the captain of multidimensional navigating. Opening this book, people will have an opportunity to see his multifaceted creativity, how he utilized his energy in many beautiful ways, not just pickin' the guitar.

He was a great teacher, too. The things he showed me on the guitar were like little keys that opened big doors. I feel really honored that he took the time to share his music with me, and information, and now, his colors. It is refreshing to see his hands manifest colors rather than notes; it's just an extension. There's still a child in all of us, and his colors are very childlike.

I also used to doodle a lot. These works bring back memories of watching your hand create these things. I'm just glad that his art is now available for people to appreciate.

In "Race Record Dream," he really captured something. This art is so raw; these people are very true to life. It's right down to the bone. You hear the music and you smell the cookin'.

"California Mission" is precious. It could be any day around Napa with those beautiful churches and the wineries. It's definitely California—it's not Spain or New Jersey or Connecticut. "Orange Horizon" is very golden, very Japanese. "Who Goes There?" reminds me a lot of the work of Lee Conklin, another great artist from the Bay Area.

Everything is said in "Inferno." Sometimes when you take an LSD trip, you see the glorious sun and at the same time some people are not so nice and have mean intentions they can't hide. It's definitely an acid trip, with Mr. Jones in the middle there, asking "What's going on?"

Another really outstanding piece is "Demon." The colors are magnificent. And I know that devil guy, too. I used to be afraid of him, but not any more. It's great to see that Jerry was communing with that energy. It's just like cooking: you need garlic and you need onions to make a delicious meal. You can't have just some bland, nice food. You need pepper, you need spices to mix it up. That's what evil is to me—just something to spice it up. It's beautiful the way Jerry captured it.

It's nice to validate people, to be appreciative, to look at the beauty in someone—it means they're seeing the beauty in themselves. Your outlook is your intake. The goal for all of us musicians is the same: to give people something where they can relax and feel their own light. The music is almost incidental to the vibe.

Jerry Garcia, Bill Graham, Miles Davis: one thing they had in common is that they were all rascals (and another is that I miss them immensely). Rascals have a certain look, a certain smile like they knew that you knew. If you're too serious with life, then you're not a rascal.

In any case I have no doubt that whoever sees this book is going to get a lot of joy. Not only Deadheads, but people who never even saw him play live. Especially the youngsters; maybe they haven't even seen Phish live. Fifteen years from now, they'll say "Hey, you know, and the guy could paint, too, man. He really could paint."

I congratulate you on this book, and for being devoted to this mission, to this vision of Jerry. I'm sure he'd be really happy with the outcome. It has great consciousness. We don't need to know all the other stuff—that's for biographers and critics to zero in on. I only know the beauty, the grace, and the elegance.

Doodling on the Baby
Donna Jean Godchaux-MacKay

Around September of 1974, we were living at our house at Stinson Beach and had just completed the Keith and Donna album. Having played on many of the tracks, Jerry (who lived nearby) was quite familiar with the titles and, more importantly, the heart of the songs. We had had trouble deciding on the cover design, finally settling on a full-on picture of our nine-month-old son, Zion who, like Keith, had a huge forehead. Jerry saw a copy of the picture on our kitchen table and spontaneously suggested drawing Zion's "thoughts" onto his forehead. (After all, the music had all been recorded at the house, and Zion had been exposed to it all.) I was not aware at that time of what a brilliant artist Jerry was. He just sat down and started drawing his feelings about some of the songs. For instance, the little tree with the hearts on it comes from "My Love for You." He took different aspects of the songs and translated them onto Zion's little head. It was really cool—it came out of him in just a few minutes. In

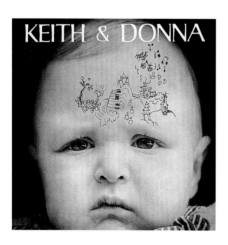

his life and his music and his speech, Jerry was very articulate and very sensitive, and that came out as I watched him doodling on my son's forehead. I was blown away.

Saving the Wetlands
Tom Turner

In 1988, Dexter Lehtinen, a U.S. attorney in South Florida, filed a federal lawsuit against the South Florida Water Management District and the state of Florida. The district's alleged crime was discharging fertilizer-laden runoff from sugar cane fields directly into the Everglades. The state's crime was not doing anything about it. The wetlands were withering and dying in the face of relentless chemical assault.

Soon a phalanx of conservation groups, represented by the Sierra Club Legal Defense Fund (now Earthjustice), joined the suit. In short order, Lehtinen left his job to become a counsellor for the Miccosukee Seminole Indians, the people most directly affected by the damage, and his colleague, David Guest, took over.

Jerry Garcia must have been touched by the story. We never knew what prompted the call, but some time in 1993, an agent of Jerry's telephoned Earthjustice headquarters in San Francisco. Garcia's representative said that Jerry wanted to help, and he suggested that the proceeds from sales of a necktie, based on a lithograph known as Wetlands I, be donated to the legal battle for the Everglades.

We were as thrilled at the association with Jerry as we were with the wonderfully generous gesture. We sold the ties to our supporters through the mail, earning a substantial sum.

Our then-president, Vic Sher, kept a few in his office in case he had to spruce up for an unexpected interview or meeting. Meanwhile, David Guest provided ties to all his witnesses to wear on the stand, which added a touch of class and good karma to the Florida courtroom.

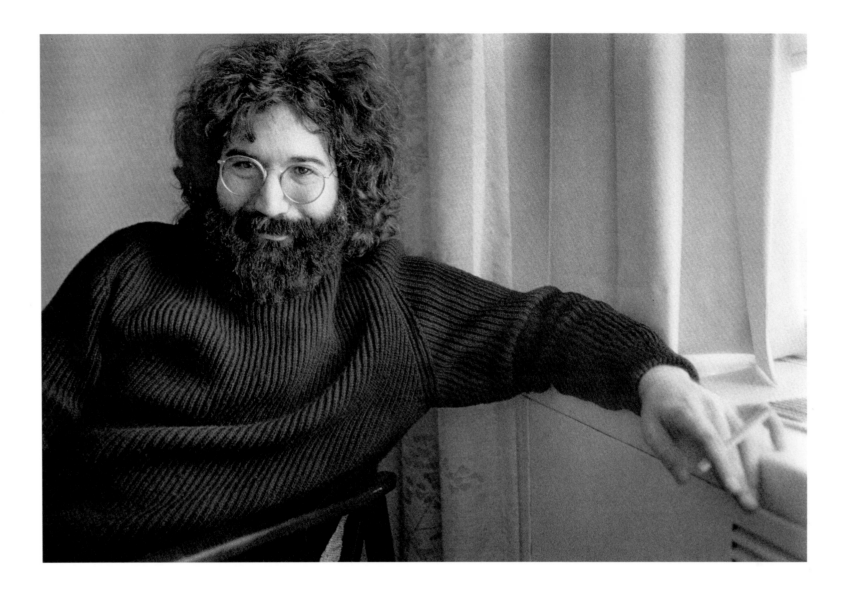

The suit was attempting to force the sugar barons to pony up the money to build some kind of system to remove the fertilizers from the water before it reached the Everglades. By the late '90s, the industry and the state had agreed to build a sprawling artificial wetland encompassing 42,000 acres to filter water before it reached the 'glades. With the advent of Bush II, however, the Feds lost their zeal for restoration, and the case kept humming along in the courts. The defense of the Everglades has largely been left to the tribe and its conservationist allies. Today, the lawsuit is still going strong and new evidence of sugar industry chicanery has surfaced.

The neckties are now collectors' items, but they provided a needed boost to what continues to be quite a marathon. Jerry's kindness and support in time of need continues to inspire us to carry on.

Early Works

Jerry began drawing and cartooning at an early age. Two excerpts from small booklets he made at the age of eleven are published here for the first time: opposite, a few pages from "WHAT HAPPENS When you Smoke," and "What Happens If you watch to [sic] much Television," both portraying the evils of bad habits.

A few selected oil paintings from his weekend stints at the California School of Fine Arts are seen below. Although they were done at the age of sixteen and seventeen, they display his burgeoning talent, as well as his fondness for landscapes, particularly those involving trees or oceans, which he painted and drew throughout his life. The portrait of a man reading, perhaps in a church, is reminiscent of the style of one of his teachers, Elmer Bischoff. Bischoff was associated with the school of Bay Area "realist" or figurative expressionists (along with his colleagues Richard Diebenkorn and David Park). The rich, painterly quality and moodiness of his works clearly influenced his young student.

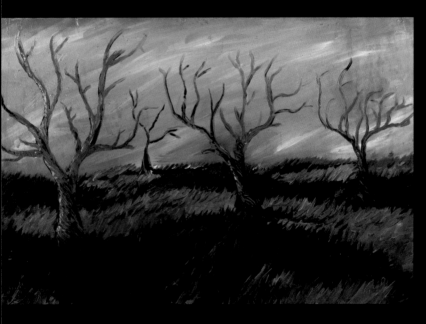

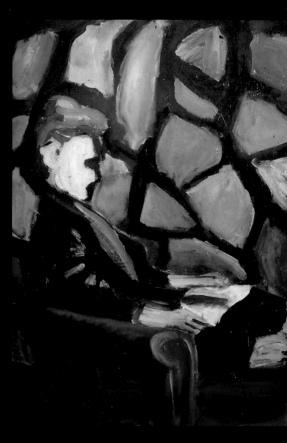

Above: FOUR TREES
Oil on board, 20½" x 30", circa 1958

Center: OCEAN
Oil on canvas, 42" x 30⅛", circa 1958

Right: MAN SEATED
Oil on board, 4¼" x 29¾", circa 1958

The booklets, clearly influenced by *MAD* and other EC comics and horror films, are amusing in their own right, but have become poignant knowing what we do about Garcia's adult lifestyle when it came to television viewing and cigarettes. These cartoons are from the collection of his brother, Tiff.

WHAT HAPPENS WHEN YOU SMOKE (detail from eleven-image series)
Pencil on paper, 8½″ x 6″ each, 1952

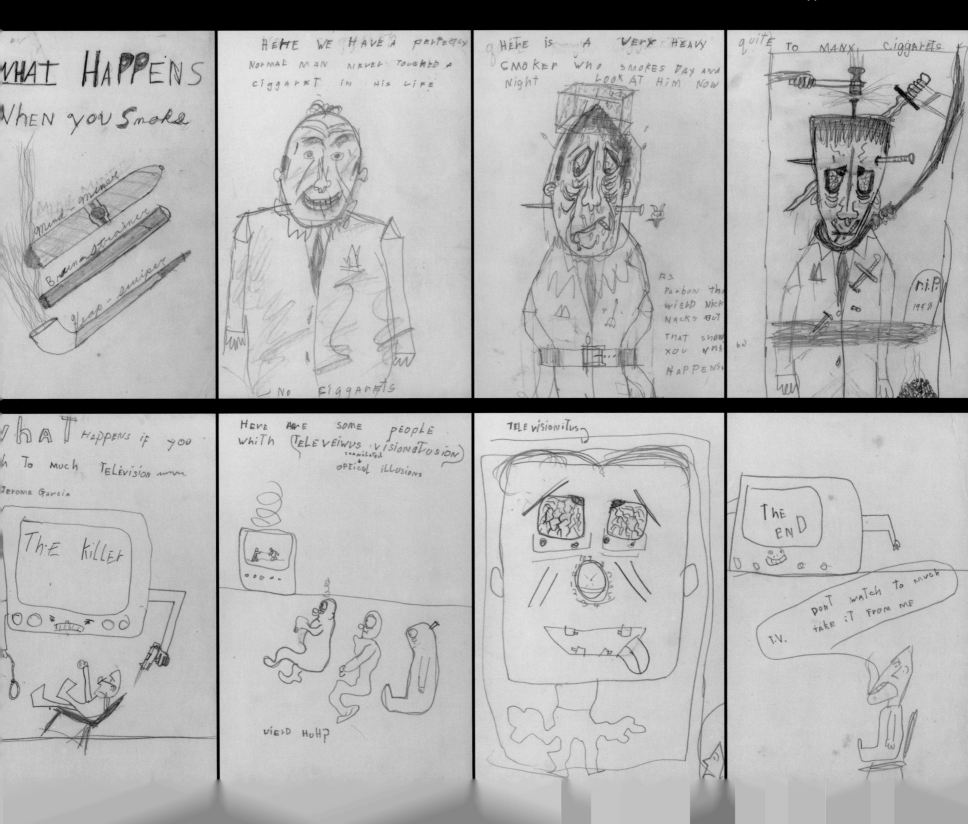

Connecting
Grace Slick

Tip of the Iceberg
Victor Moscoso

The word Art just makes me cringe. It's so effete. Jerry had the same thing going on. Things I've seen of his are very immediate, even those that are impressionistic. He would do landscapes that were almost abstract, but they are right here, they're immediate and there's no question about understanding something in them.

He even drew the side of a building, but I loved the way it looked. Just the side of a building, lots of windows in it. It reminded me of New York, it reminded me of a certain time of year, a cross between autumn and winter, and it reminded me of when I had been in that area, and it was a thing where I went "Yeah, I know that, I've been there," although I don't know whether I had. Maybe it was the Plaza, maybe it wasn't, but it put me there, so it was a good connection, a good communication.

[The music business] is this huge amount of people and engineers and producers and audiences, but painting is right here. I think that's probably why Jerry liked it too. As much control as you can have, you've got, completely different from what's going on around you. There's nothing going on or there's everything going on, yet the focus and appreciation is the same. Jerry to me seems as good either way.

Music, art, I don't know that he wrote a lot, but I'm sure he'd be good at that too. I can write or sing music or write a book or sculpt or sew: I like creating stuff. The process is just amazing, as it was for Jerry. You could see it, you could feel it in him.

(in conversation with Deborah Koons Garcia)

I met Jerry in San Francisco's North Beach, in post-Beatnik coffee houses, when we were both playing guitar and singing folk music. As time went by, I watched as Jerry and the Dead became the most successful garage band in music history.

Years later, while at an art dealer's house, I took a long look at a painting on her wall that had caught my eye. I asked, "Whose work is that?" "That's Jerry's art," she answered. I was surprised; I did not realize that Jerry was that good. The piece was "The Blue Iceberg", and for someone who did art solely for his own pleasure, it displayed excellent command of craft.

What if Jerry had decided to devote the energy that he put into his music into his art instead? Considering the time and place, he just might have become one of the "Big Six" poster artists of the psychedelic era.

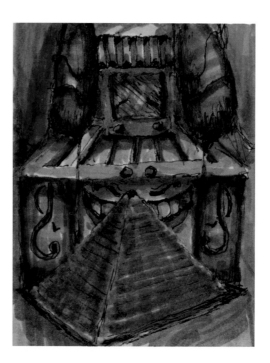

JUKEBOX
Ink & marker on paper, 4 ½" x 3 ½", 1985

Anchorman

James R. Donaldson

In 1982, a request was fostered by HRH Prince Philip and the World Wildlife Fund to document on film, for the first time, Sperm and Blue whales in their underwater habitat in the Indian Ocean. The film, Whales Weep Not, was lacking a score and I happened to meet Mickey Hart, who ended up contributing a remarkable musical soundtrack and, over the years, becoming a close friend. Mickey also composed the score for a feature documentary I produced and directed in Australia (America's Cup 1987) which featured my very good friend Walter Cronkite as on-camera narrator and presenter.

Mickey and I thought it would be quite entertaining to bring Walter and his wife Betsy to a Grateful Dead show. That summer (1987), Mickey arranged to have Walter driven to Madison Square Garden. Sitting in the back seat of the limo happened to be Jean Erdman, Joseph Campbell's widow. Walter had an absolute ball at the show and thoroughly enjoyed his initiation. They were seated on a riser near the soundboard. At the beginning of the break, Cameron (Sears) brought Walter and Betsy to Mickey's dressing room. So there we were, sipping on drinks, when all of a sudden there's a knock on the door and in walk Ram Rod, Dennis McNally, and Jerry and Deborah, holding hands.

All of a sudden, I am sitting at the feet of two enormously wonderful iconic figures, unexpectedly juxtaposed, and it's rapidly becoming the Walter and Jerry show. They just hit it off instantaneously, bantering during the entire intermission, covering those political and ecological issues for which Jerry tentatively sought answers, and the reporter in Walter asking Jerry questions about his life and his music. Imagine: the journalist who described the Vietnam conflict as a war we could not win, the man who reported the death of President Kennedy —and Jerry Garcia, who had given so generously of this life of music and art.

Jerry spoke: "If there's ever a time you'd like to play with the band you'd be more than welcome." Walter chuckled. "The extent of my musical talent is standing off to the side of the Vienna Boys' Choir and hosting their show." "No problem," said Jerry, "we can polish up a triangle and you can just sit there and beat out a tune." I often picture to myself the stunned looks on the audience's faces had this come to pass.

Jerry got the sense that Cronkite, having spent time as a young journalist in Texas, had a penchant for good ol' country music and bluegrass, so for the entire second half that evening, he chose songs that were traditional, had that country flavor, as a secret tribute to Walter. It was a night I'd never forget.

A few years later I got a call from Jerry, who had been diagnosed with diabetes and had remembered that I was a juvenile diabetic. "What do I do?" he asked. "You start taking care of yourself," I replied, "You stay in the transportation business. You do what you do—better than anyone—but take care of yourself."

In London a few years later, they happened to run

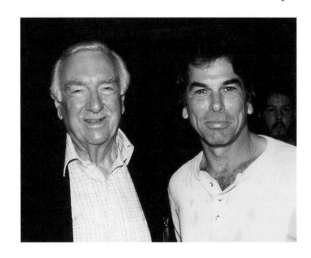

WALTER CRONKITE & MICKEY HART, NEW YORK CITY, 1989

into each other in a hotel lobby. Cronkite had just come from a black tie event, and heard a loud, warm "Walter!" and turned around to see Jerry, Mickey, the Dead and their entourage. There was much embracing. Walter went to the Meadowlands one more time to see the Dead, standing onstage directly behind "The Beast" and "The Beam," Mickey's drum sets. He's a bit hard of hearing, but I'm sure this was one concert he heard.

Cover Story

Andy Leonard

Although all the members of the band had input to a greater or lesser degree, Jerry was the de facto art director for most of their album covers I was involved with. He seemed to have far and away the deepest concern, the best eye, and the graphic vocabulary to back it up. I remember these two in particular.

In 1972, Jerry hired some of his graphic buddies—Rick Griffin, Victor Moscoso, Kelly-Mouse Studios (Alton Kelly and Stanley Mouse), and Robert Williams—to each do a work of original art, and implied to each of them that theirs would possibly be the cover to the upcoming album, eventually called Wake of the Flood. (Additionally, I had to explain to these artistes that the name of the record really did need to go on the front of the album.) This was followed by a lot of argument about who owned the original art, whether it was a commission by GDR (Grateful Dead Records) and therefore owned by them, or done on spec and owned by the artist. In the end, we chose Griffin's cover for Wake of the Flood, but Jerry particularly coveted Robert Williams' piece which, if memory serves, was called New Eyes, a very cool painting of a blind Little Bo Peep, wearing shades and selling pencils from a cup, being offered new eyes by an extra-sleazy, mustachioed Big Bad Wolf. Jerry wanted it so badly that he sent me back down to L.A. on an airplane with a 9 mm German Luger pistol in my handbag (one could do that in those days), not to rob Williams but to trade the gun for the painting. It worked: Williams collected that sort of stuff.

When the next record was being recorded, we were again under pressure to come up with a name and a cover. Having recently driven by the Mars Hotel in San Francisco on the way to the studio and being caught by its name, Jerry told me to go photograph the place. We decided on dawn, when it was somewhat honey colored; so I did. Later, we took hours to lay out the front of the album, based on my photos. When we were done and I was happy with the result, he dropped the bomb: "Now go give it to Kelly and Mouse." Somehow the notion had come up that it was to be set on Mars. I dutifully delivered the big photo montage to them—with instructions to "put it on Mars"—so the pair of them started airbrushing on the paste-up. This led to Jerry wanting a picture of the band sitting in the lobby of "The Mars Hotel" for the back cover. Herding the Grateful Dead out of a studio session and into a nearby flea-bag residential hotel (while herding the residents out and moving all the furniture around the lobby) became my personal science project, as you can imagine. After it was done, of course Kelly and Mouse had to put fins, helmets, and fur coats on everyone and paint them in DayGlo colors.

As the unofficial art director, Jerry was a sort of éminence grise, yet his senses of color, proportion, aesthetics (and humor) produced some of the most memorable and wildly inventive album covers in the history of the medium.

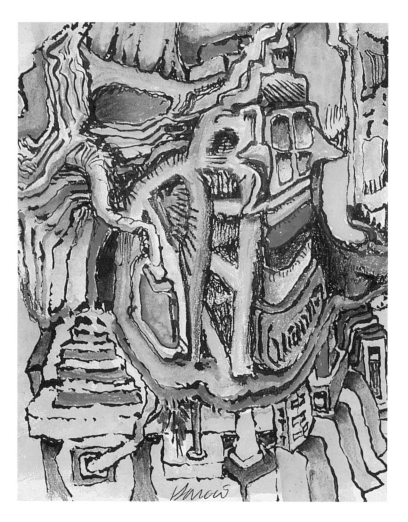

EMERALD CITY
WATERCOLOR & INK, 9¾" X 6½", 1992

A Helping Hand
Paul Pena

Jerry was one of the lowest profile people I ever knew, as I learned from different situations we shared, like being backstage. I don't mean to say he didn't talk: he talked a blue streak. But it was all very relaxed and extremely interesting because Jerry was a very smart guy. He knew a lot about a lot of different things. I only relatively recently found out that he was into painting, for example.

When you walked into a room where Jerry was, you weren't forced to be riveted, to concentrate solely on him. He was just talking to somebody, and he'd go on talking to somebody until you came up and introduced yourself. And, if you did, he was very courteous. In my case, he was, without question, one of the reasons that I have any career or notoriety at all.

When I got out to San Francisco, I thought, how am I going to make a living? What am I going to do about getting work? Nobody knows me out here except some of the Grateful Dead people. So, cussed fool that I was, I called the Grateful Dead office. I remember to this day that the person I talked to was Annette Flowers, bless her heart. I told her my story and she said: 'Well, look, if there's anything I can do for you, I'll give you a call...'

I really didn't expect anything to happen from that, to be perfectly honest. I'm not so naïve as to think that a phone call from somebody that you haven't seen in two years and probably don't remember at all is going to make miracles happen. Try to imagine how surprised I was when, fifteen minutes later, the phone rings and the person on the other end says, "Is this Paul Pena? This is Annette Flowers, I was just talking to you and Jerry says he remembers your band, and I told him that you were doing a solo act now and he said he'd be willing to give you a paid audition, next Tuesday." That was how I wound up opening for Jerry when he played with Merl Saunders in Bay Area clubs when he wasn't touring with the Dead.

You could get up on stage with Jerry and it really wasn't too hard to feel how to fit in with him musically. The other thing was that he gave you some room in the sense that he expected you to make a few errors while you were finding your way. He wasn't the kind of guy who would read you the riot act if you made a few errors on a page. That can be a big deal, especially for a newbie. He was very unpretentious and easy to relate to.

I went to work one night, doing a gig with Jerry and Merl [Saunders], and I had a recording session the next morning. It was my first big record, later released as New Train on the Hybrid label. I wanted Merl and I really wanted Jerry to be on my record. I wasn't worried about Merl because he and I had gotten to know each other a little better, but Jerry, Jerry was a pipe dream. And if I had any sense in the world, if I had any manners, I wouldn't have even asked him. But, like the fool that my mother's first son is, I walked up to him and said: "Jerry, could you do me a favor, man? I'm embarrassed to ask, but the fact is that I got this record I'm working on and I'd sure love to have you on it. And it just happens that we're doing a session at Wally Heider's tomorrow." He said just two words, "What time?" What else can I say?

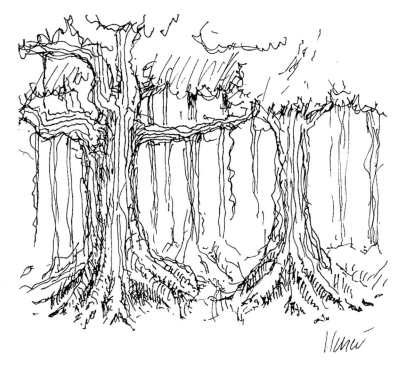

BANYAN TREES
Ink on paper, 5″ x 6″, 1991

Art and Soul
Baron Wolman

First there was Jerry Garcia, the man—the man with the hair, with the 9½ fingers, with the ever twinkling eyes. No argument about that—it's there for all to see in my photo portraits of him. Then there was Jerry the artist—ever creative, ever creating. More of us knew the art better than we knew the man. We danced and tripped to his music, smiled as we wrapped our necks with his colorful ties, brought his illustrations into the intimacy of our own rooms. Now Jerry the man is gone and only his art remains. And yet, in the end, aren't they one in the same, the artist and his art? And yet, in and through his art, isn't he, too, still with us?

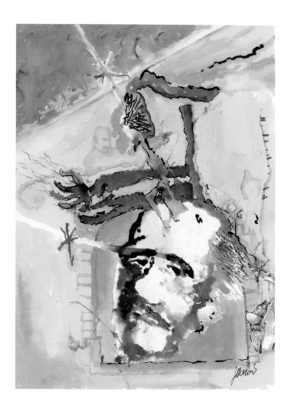

POET ABSORBS THE WAR
Ink on Paper, 12″ x 9″, 1990

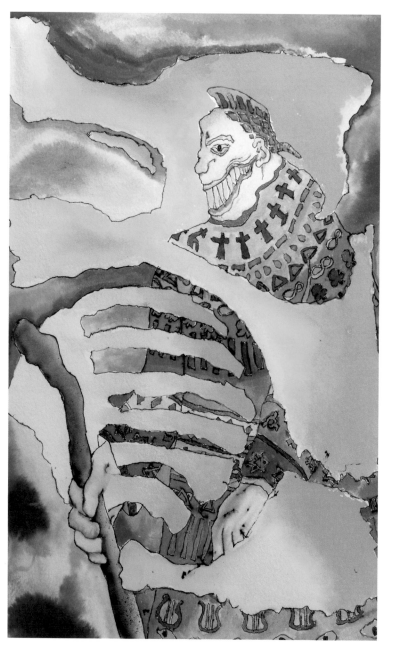

THE KABBALIST
Watercolor on paper, 13″ x 9″, circa 1992–3

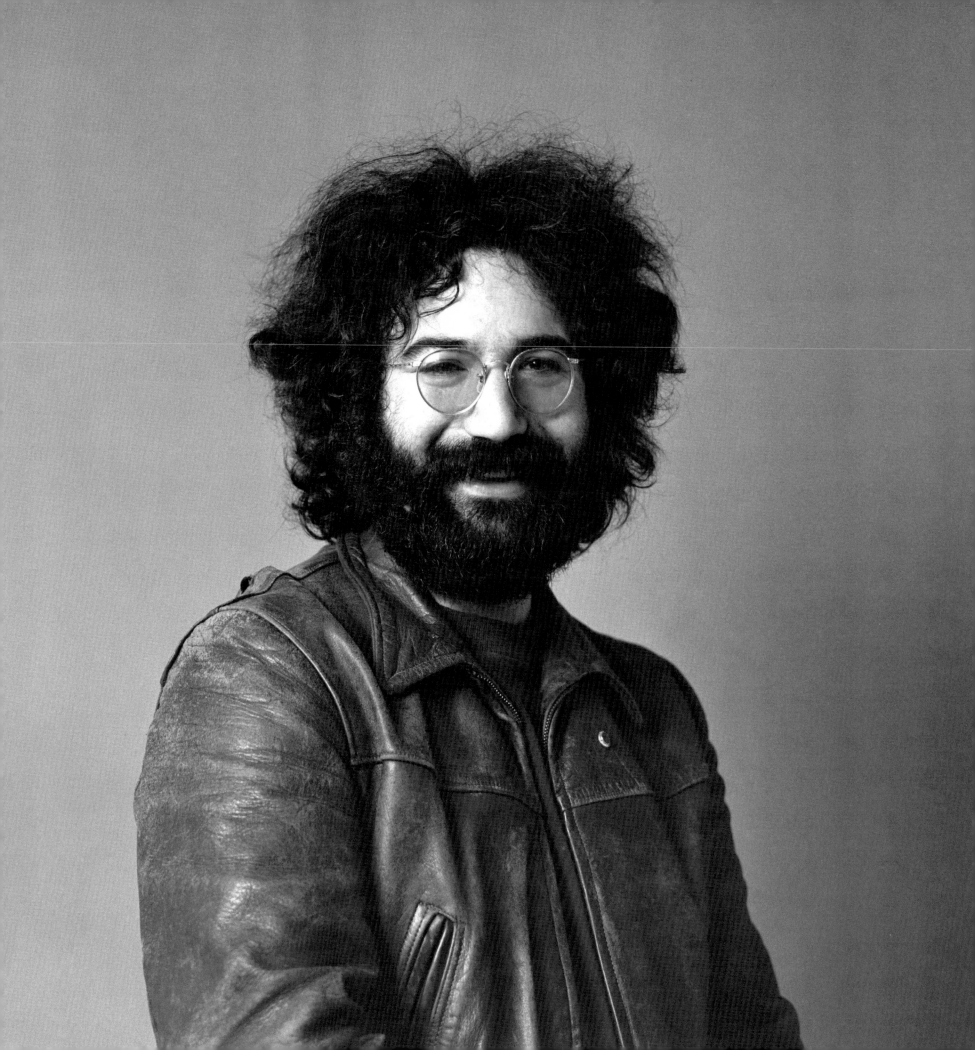

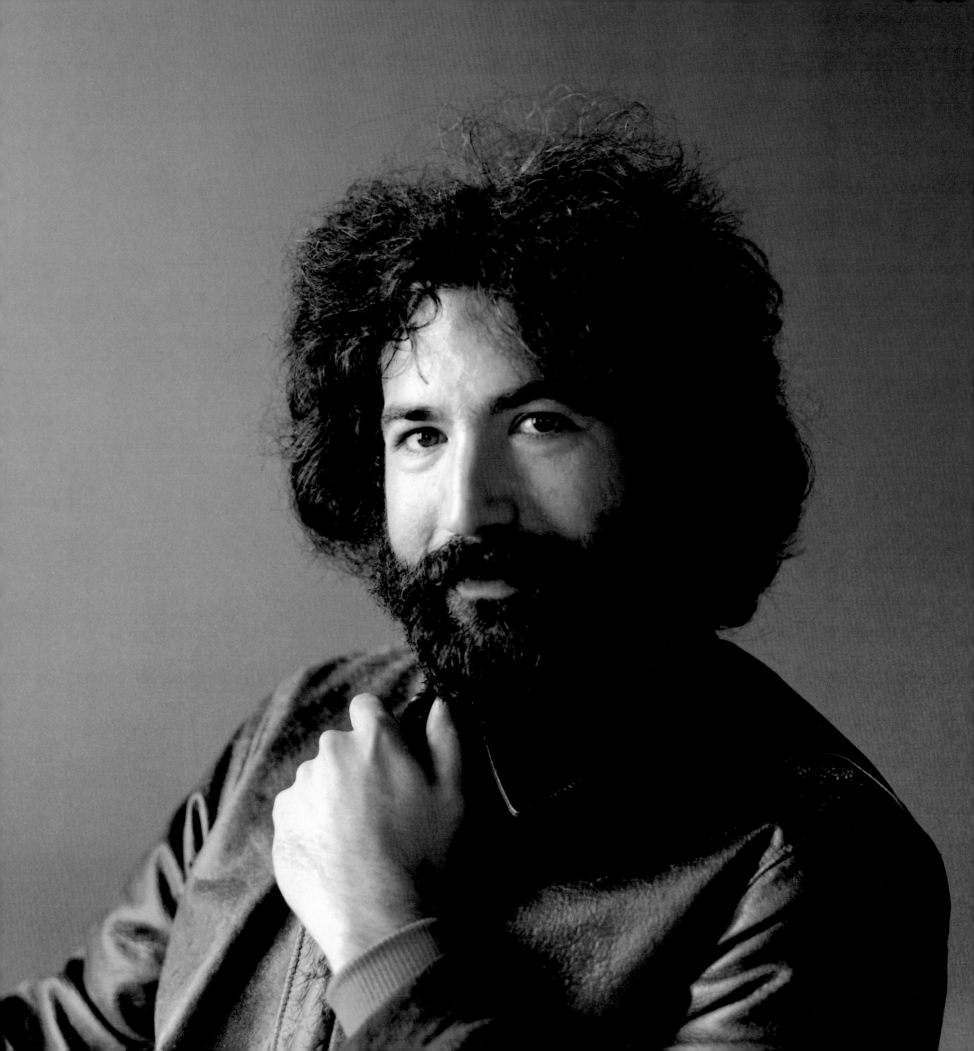

DRAWINGS
chapter one

The Other Side of Jerry Garcia

Jon Carroll

In the end, Jerry Garcia did not want to be Jerry Garcia. He certainly wanted to make a living playing music, and he certainly enjoyed all the hedonistic perks that a rock-and-roll lifestyle brings, but Jerry Garcia got a lot more, more than any sane person would want or could be expected to handle.

He got overwhelming fame; adulation by a loose-knit group of people who, if they were not exactly a cult, were not exactly not a cult either; de facto paterfamilias status for a large and changing cast of characters, some of them duplicitous or whacked out or both. They gave him love, protection and musical companionship. They also gave him flattery, substances, and bad advice.

The poet John Berryman, writing about the novelist Stephen Crane, said this: "Fame opens up, first, every irony back onto one's past; one is abruptly *valued* by one's *friends*. Then actual envy and malice are hard to ignore. It is difficult just to be watched. There is injury to one's sense of rebellion."

Modern fame is our cultural disease. It is an engine that eats souls for the amusement of the masses. Every report from inside the fame bubble is the same: "I know it seems cool to be in here, but trust me, it's not fun at all." People who are famous are required to stay famous; anything else is failure. People who are famous get all of the things we think we want, but they rarely get the things we actually want—privacy, a stable family, an examined life.

I do not doubt that Jerry Garcia wanted those things. In most ways, he disdained the rock-star lifestyle. He was not Mick Jagger, nor did he want to be. He did not take vanity roles in movies. He did not build a mansion in Malibu. He lived in Marin County, which is a haven for people who happen to be rich rather than a haven for rich people. Some parts of the image of the Grateful Dead have to do with danger, but Jerry Garcia was never a danger, except to himself.

There was always a disconnect between the iconography of the Grateful Dead and the music. The name was horror-movie scary, like some kind of sequel to *Night of Living Dead.* There were lots of glyphs that looked like Hells Angels' logos. There were skulls, and lettering that only snapped into readability when you were stoned. This was an outlaw band on a mission across America; these were the people who had come to steal our women.

But listen to the music without the iconography. Pretend you don't know. "Ran into the devil, babe, he loaned me twenty bills / I spent a night in Utah in a cave up in the hills"—that fits. But the tune is so happy, so bouncy; so much

of their music sweet or happy or both, mellow in a way that the devil's minions rarely are. That was the sort jug-band, roots-music, musician-friendly milieu that Jerry Garcia came from; there is ample evidence from his non-Dead recordings that he didn't see himself as emerging from the gates of Hell, ready to challenge the demons of conformity and oppression.

To me, he always sounds happiest on his non-Dead albums, particularly the collaborations with David Grisman, another musician who sometimes felt (to use one of the many names they traveled under) Old and In The Way. With Grisman, he got to act his age; on stage as The Leader of the Band, he didn't.

This is the problem with being the leader of a popular rock and roll band: You have to live with the decisions you made when you were 22. You've got that touch of gray now, and you will believe you will survive, and yet there's still a skull T-shirt with your name on it. You live inside your own contradictions, and everyone can see inside.

"It is difficult just to be watched"

For Jerry Garcia, the dilemma was even more intense. The place he felt safest was inside his music, playing with the band, improvising and laughing and soaring. He was very good at it, and he made the people he played with better, which was part of his great charm. But he was being watched. Keeping up with your own legend is hard. In the universe of the Grateful Dead—and that was a very big universe—escape was impossible. Which brings us to his other art, his private art: paintings, drawings, prints, computer art, lithographs, all presented in this volume.

I am not qualified to discuss the artistic merits of the works; I like the autumnal colors and the soft focus. They seem to be divided between landscapes of various degrees of surrealism and loving portraits of musicians, some recognizable, some not. It is interesting but not surprising that he portrayed musicians the way he did—unornamented, mostly not even on stage, not surrounding by trappings of any sort. He saw them the way he saw himself, a guy with a guitar, a man and his music.

The landscapes are something else. As an obvious example, look at "Who Goes There?", a saturated green forest peopled by creatures of uncertain and perhaps malign intent. The naked women are posed in unnatural positions, and they are not smiling. The faces are menacing. The les-

son seems to be pretty clear: These woods may look pretty, but there are dangers lurking everywhere. Pretty women are sometimes not what they seem, and the people you encounter along the way may wish you harm. For me—and I understand this is a stretch, but I'll make it anyway—it's like a message from the Great Riverside in the Sky, from the man who left the Brokedown Palace too soon.

Welcome to the other side of Jerry Garcia. Stay as long as you like.

DR. CARSTAIRS
Ink on paper, 10½″ x 8¼″, 1992

Imaginative Drawings for an Imaginary Film

Len Dell'Amico

T**he year was 1985. Garcia and I were tossing around ideas for a film project to commemorate the twentieth anniversary of the Grateful Dead. Somewhere early on, we conceived of what I now refer to as our Imaginary Film.**

Roughly speaking, six "energy-beings" (voiced by the six band members) from a distant galaxy are joyriding around in their enormous spaceship, looking for a good time, when they monitor an electromagnetic wavefront originating from a place called Earth. The wavefront, as transformed by their gigantic computers (equipped, of course, with an awesome sound system), reveals the history of modern times, including the career of the Dead, to which they excitedly "tune in." This segues to the actual content of the film—intercutting historical live performances (1965 to 1985) with animated segments about the space aliens for a little comic relief.

The spaceship Garcia imagined was a bizarre patchwork. Steam-powered radar dishes, medieval towers, Middle-Eastern turrets, '50s Detroit chrome fenders, a huge duck-face viewing port on the exterior; inside, tap-dancing robots inhabited a jungle of organic-looking corridors, ducts, and pipelines, and control panels/computer stations doubled as videogames and slot machines.

The pictures you see here are the early storyboards for the film project. Some relate to the concept in a very direct and obvious way, such as the duck-spaceship, the tap-dancing robots and the spaceship interiors. Others are a little farther afield, such as the giant faces looking down on a body of water, where the tiny boat might actually be the same duck-spaceship, now floating on some strange planet's lakes.

We would meet at his house in San Rafael—Jerry on his Barcalounger. Based on what came out, I'd go away and write more of the script; he'd make pictures or storyboards. In addition to illustrating the film project, he also made a number of drawings that were purely imaginative, which had nothing to do with much of anything as far as I could tell. The script grew to forty pages, and we did some test animations and special effects.

Jerry attached no importance to the drawings themselves (nor to "things" in general), and I must admit that neither did I at the time. I kept them in a file folder, along the screenplay, and when we moved on to another concept for the twentieth-anniversary video, I asked him what to do with them, and he just chuckled and said, "You can have 'em."

I vividly remember what an enormous pleasure it was to collaborate with Jerry. He was an absolute joy to work with, always considerate of your ideas, willing to adapt his own work to your input, always seeking to find the best in himself and in everyone else. His work ethic seemed to be "first order of business, have fun." What strikes me looking back twenty years later at these drawings is his sense of humor, his imagination, and their extraordinary playfulness.

M–I
Ink on paper, 8″ x 6″, 1985

ROBOTS II
Ink on paper, 8½″ x 5½″, 1985

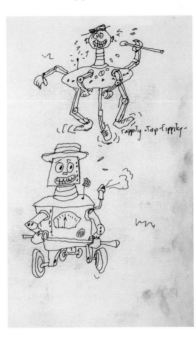

SPACESHIP
Ink and marker on paper, 8½″ x 5½″, 1985

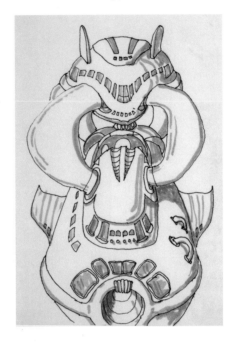

SPACE TIME
Ink and marker on paper, 8½″ x 5½″, 1985

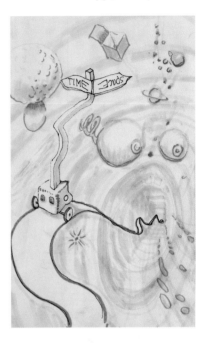

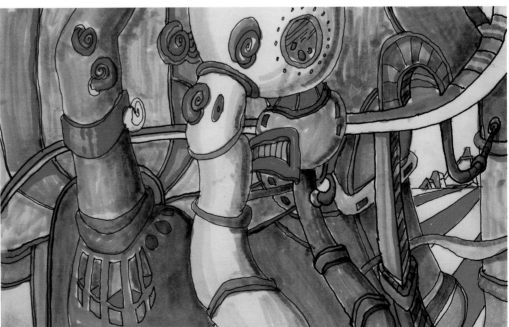

FACES
Ink and marker on paper, 6″ x 8″, 1985

PYRAMIDS
Ink and marker on paper, 8½″ x 5″, 1985

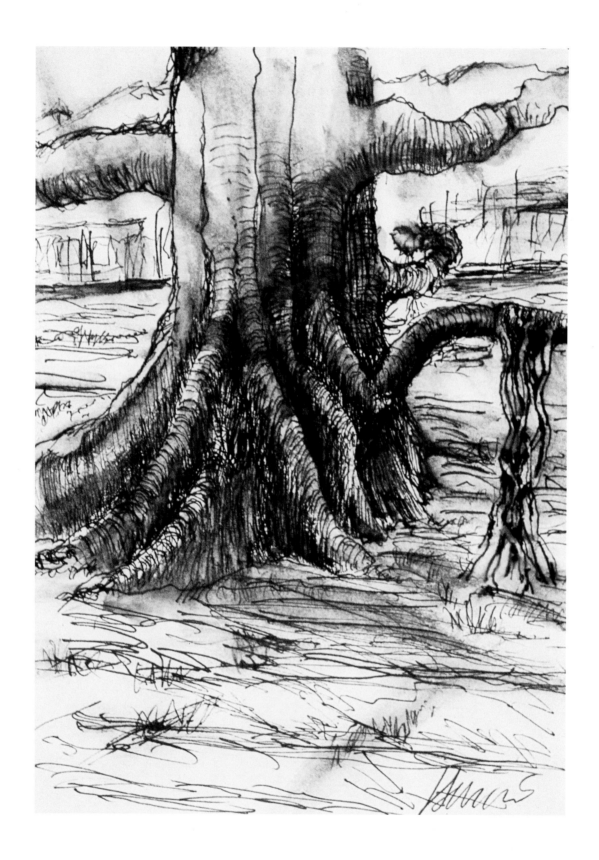

BANYAN TREE
Ink & watercolor on paper, 7 ½″ x 6″, 1993

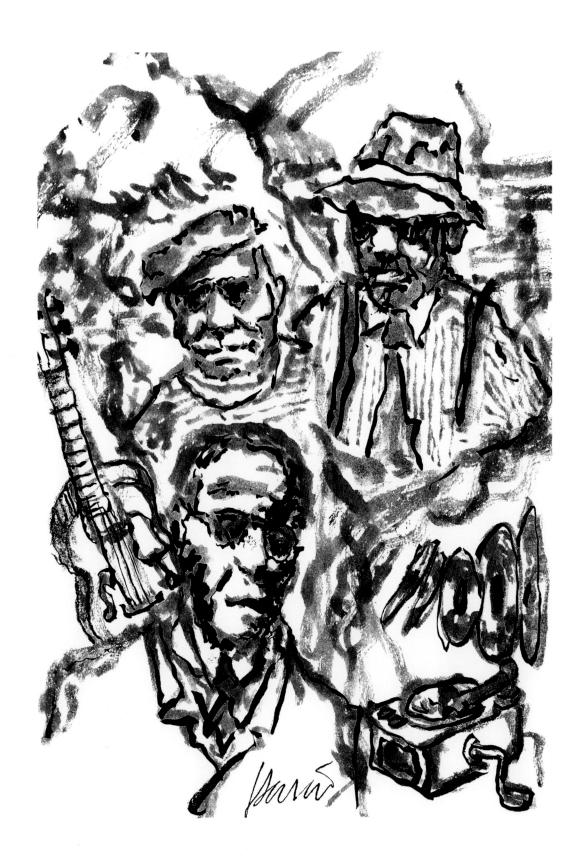

RACE RECORD DREAM
Ink & marker on paper, 5 ¾″ x 4″, 1993

JOHN WAYNE
Ink on paper, 8″ x 5″, 1992

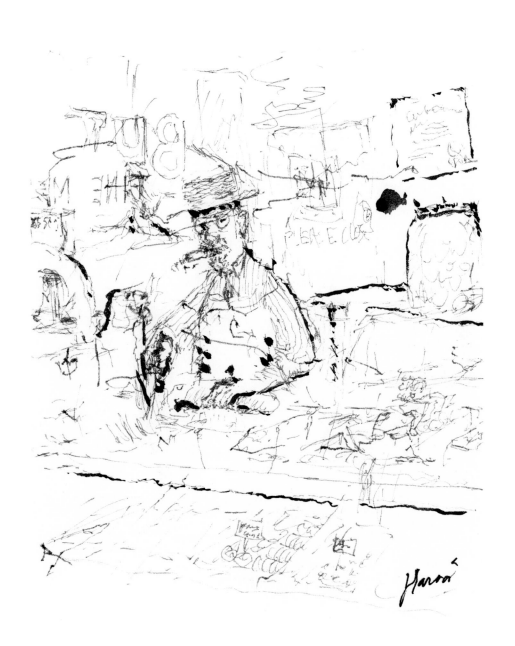

AL'S MEATS
Ink on paper, 5 ½″ x 4 ½″, 1992

AMERICAN ABROAD
Ink on paper, 20″ x 15″, circa 1985–1986

TRUMPET PLAYER
Ink on paper, 15 ½″ x 12 ⅞″, circa 1985–1986

UNCORRECTED MANUSCRIPT
Ink on paper, 6″ x 4″, 1989

DAVID (a.k.a. MANDOLIN PLAYER)
Ink on paper, 5″ x 3″, 1990

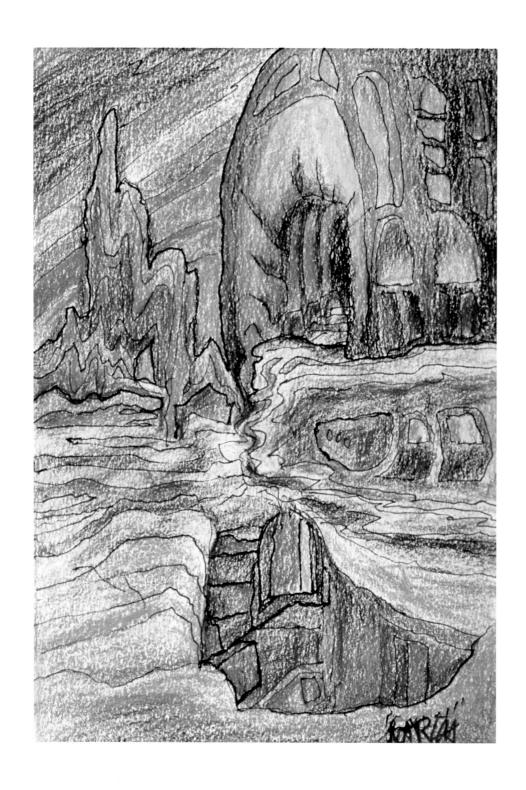

NORTHERN LIGHTS
Ink & oil pastel on paper, 6″ x 4″, 1990

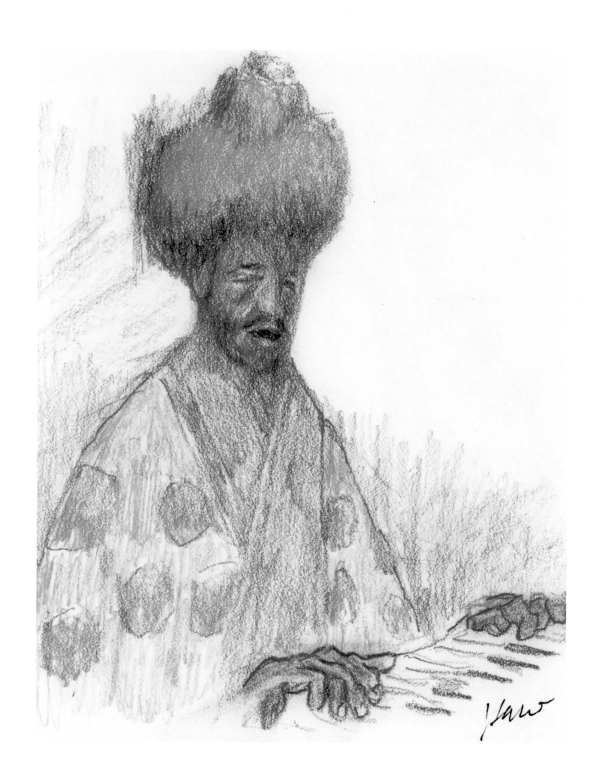

PIANO PLAYER
Pencil & colored pencil on paper, 8″ x 6″, 1992

TREE
Ink on paper, 12″ x 9″, 1992

FLAMENCO DANCER
Ink & watercolor on paper, 11¼″ x 8¼″, 1993

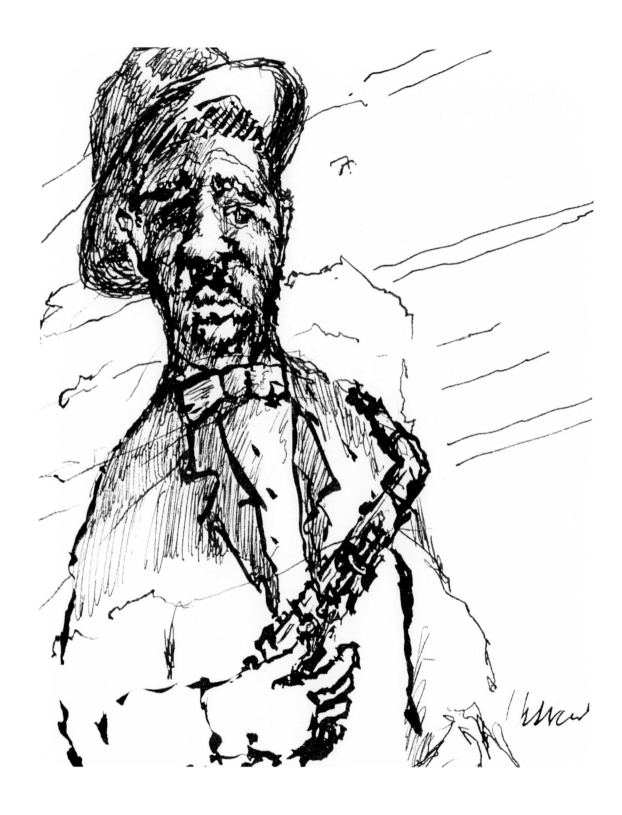

ZOOT (a.k.a. SAX PLAYER)
Ink on paper, 6″ x 4″, 1991

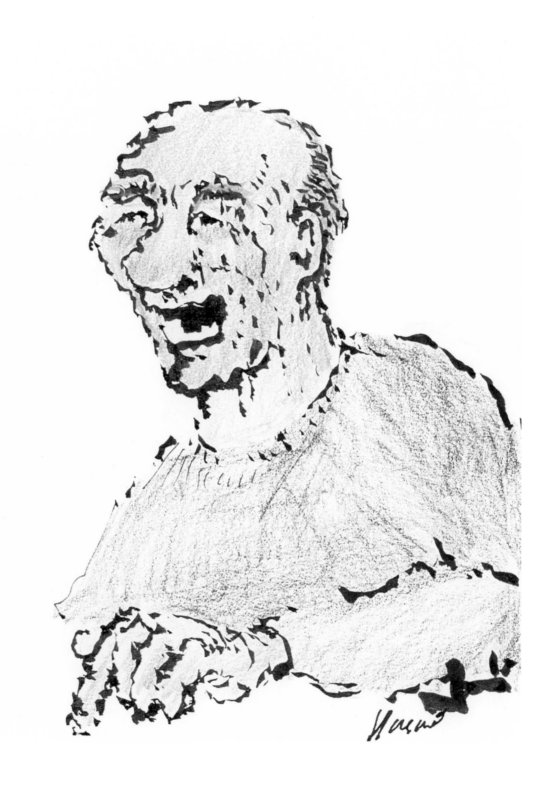

BUKOWSKI
Ink & colored pencil on paper, 6″ x 4″, 1991

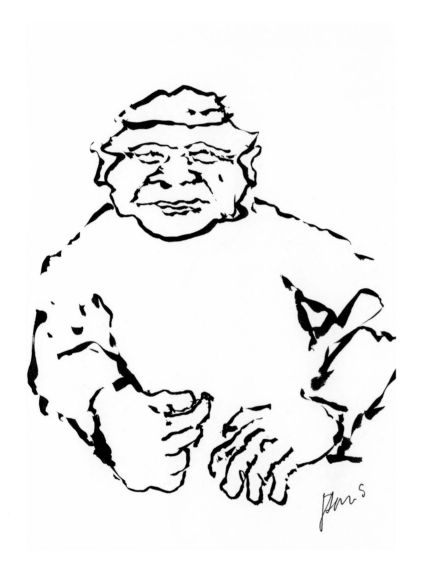

ORIENTAL GENTLEMAN
Ink on paper, 7 ½˝ x 5 ½˝, 1992

MAKE BELIEVE JAPANESE
Ink on paper, 7 ¾˝ x 5˝, 1992

ERUDITE GENTLEMAN
Ink on paper, 8″ x 4″, 1990

SADAAM
Ink on paper, 8″ x 5½″, 1992

LENIN
Ink on paper, 5″ x 3 ½″, 1992

UNTITLED
Ink & oil pastel on paper, 7½″ x 4¾″, 1992

NEW TEETH
Ink & oil pastel on paper, 5″ x 7 ½″, 1992

GARCIA / GRISMAN
Ink & watercolor on paper, 6″ x 7½″, 1993

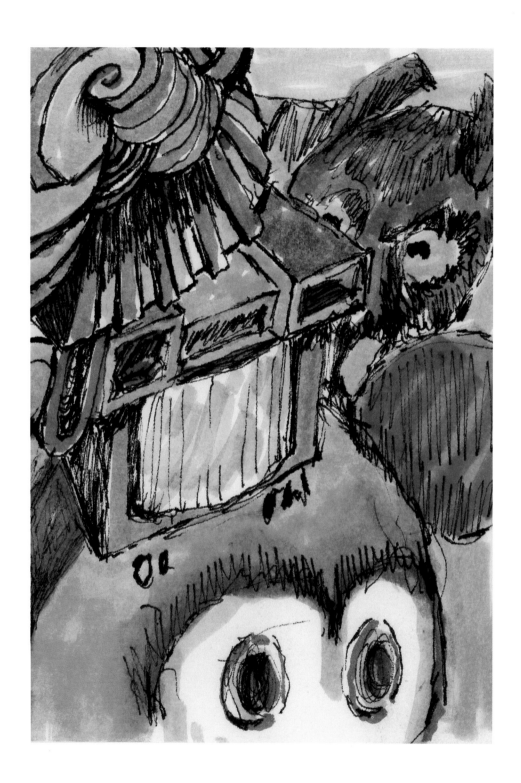

MICKEY
Ink & marker on paper, 4 ½″ x 3 ½″, 1985

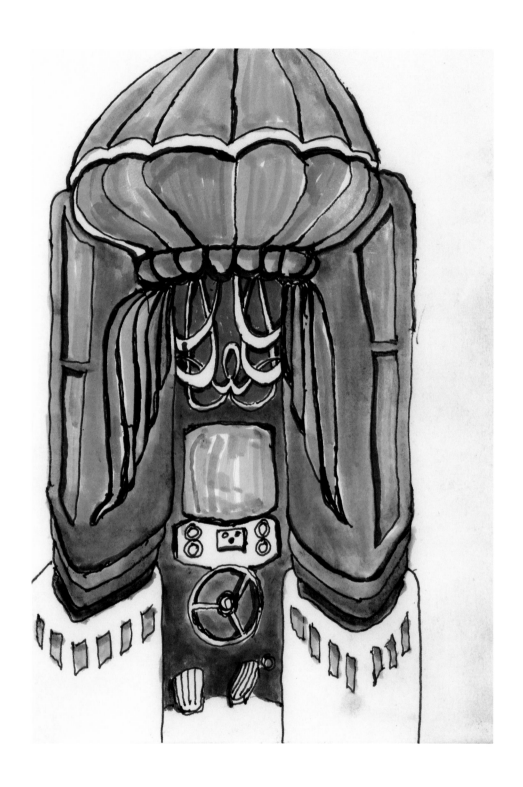

VID–GAME
Ink & marker on paper, 4 ½″ x 3 ½″, 1985

FRANKENSTEIN
Ink & pencil on paper, 5″ x 3″, circa 1991–1993

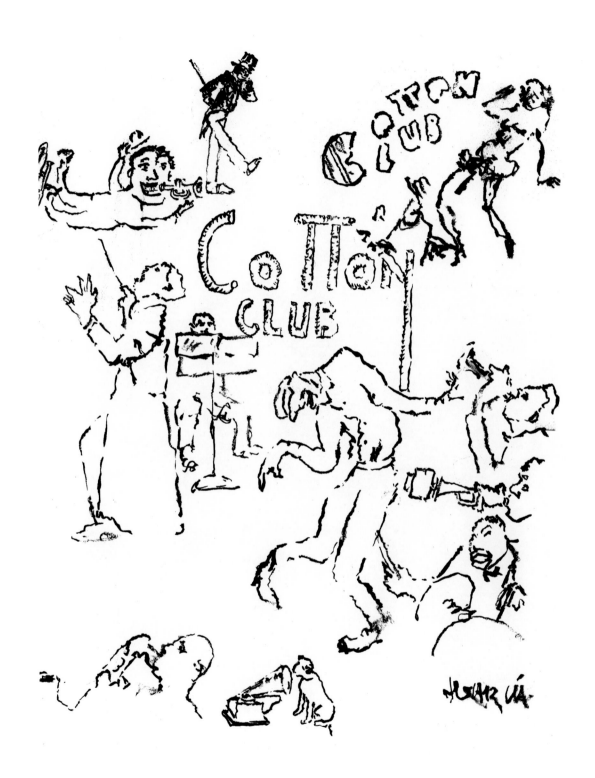

COTTON CLUB
Ink on paper, 18″ x 15″, circa 1985–1986

FOX TROT TH–4 ROMBO CRY BABY CIRCUS
Colored pencil & ink on paper, 7¾" x 5¾", 1992

RELUCTANT DRAGON
Oil pastel & ink on paper, 8″ x 5″, 1991

BLUEGRASS MUSICIAN
Ink on paper, 9″ x 6″, 1992

TRIGGER FINGER
Ink on paper, 5″ x 3″, circa 1991–1993

IN THE BACK
Ink on paper, 6½″ x 5″, 1992

SOUTH OF THE BORDER
Ink on paper, 6″ x 5″, 1991

YO! (a.k.a. PUNK DUDE)
Ink on paper, 6″ x 4″, 1990

THUG
Ink on paper, 7″ x 5″, circa 1992–1993

ERIC THE PHANTOM
Ink & watercolor on paper, 6˝ x 5˝, 1990

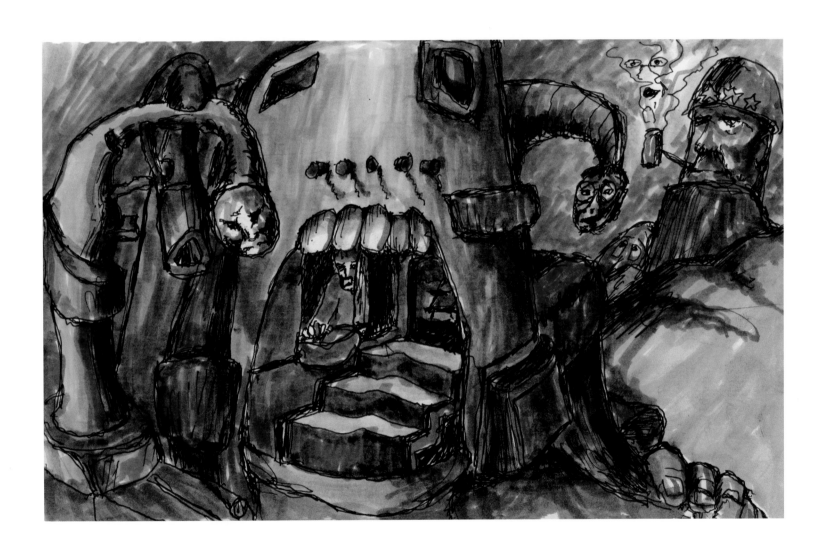

WAR MACHINE
Marker & ink on paper, 5″ x 8½″, 1985

PINE & ROCK
Ink on paper, 6″ x 4″, 1991

MAYAN TEMPLES
Ink on paper, 5 ¼″ x 6 ¼″, 1992

AFTER MONET
Ink & charcoal on paper, 6″ x 4″, 1990

PARIS IN THE RAIN
Ink & watercolor on paper, 4″ x 6″, 1991

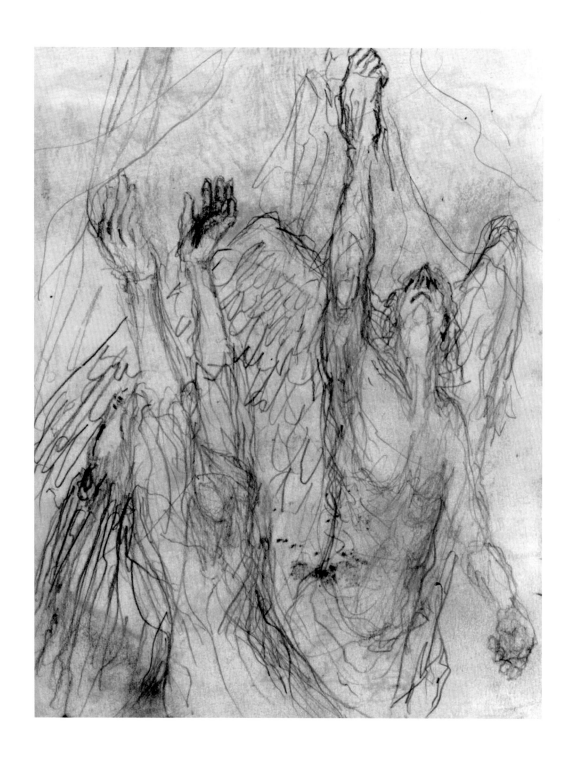

ANGELS
Pencil on paper, 10¼" x 8", 1994

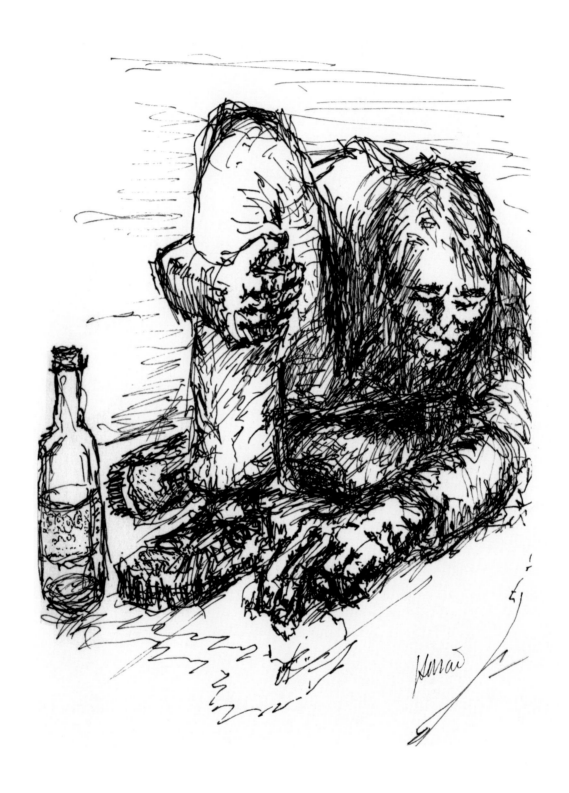

AUGUST WEST
Ink on paper, 9 ½″ x 5 ¾″, 1992

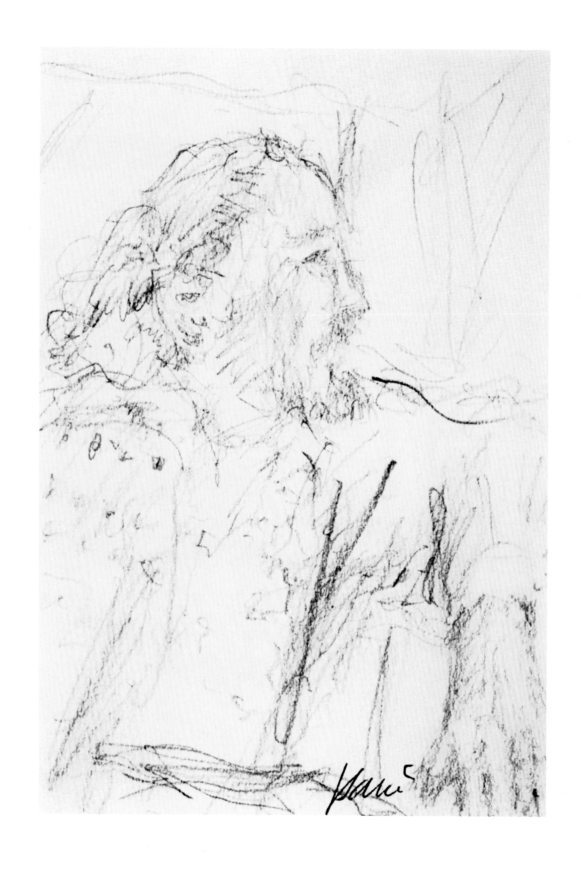

VINCE
Pencil on paper, 6″ x 4″, 1993

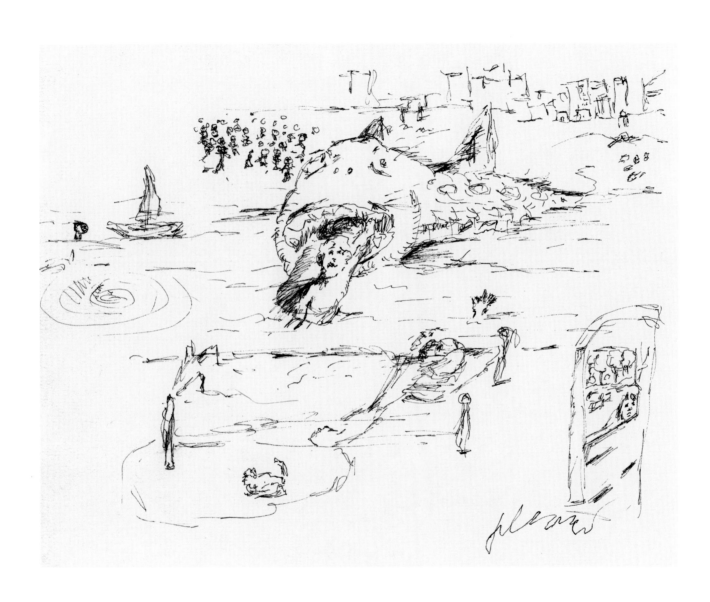

DREAMING WITH FISHES
Ink on paper, 10 ¾" x 20 ¼", circa 1985–86

BACKGROUND NOISE
Ink on paper, 10″ x 12″, circa 1985–1986

LOVERS' LANE
Ink on paper, 5″ x 8″, circa 1985–1986

MICE
Ink on paper, 6 ⅝″ x 4 ½″, 1992

STUDIES
Ink on paper, 6 ½″ x 4″, 1992

I just about came unglued when I saw what that Alien creep
and his Eskimo pal had done to my cherry '57 nash Metropolitan!

CHERRY '57 NASH
Ink and watercolor on paper, 4 ½″ x 4 ½″, circa 1990

BIRD GUY
Ink on paper, 6″ x 4″, 1993

IBID
Ink & oil pastel on paper, 6″ x 4″, circa 1992

MIXMASTER
Ink & gouache on paper, 5 ¾″ x 3 ⅝″, 1992

BLUES BROTHERS
Ink on paper, 4″ x 4″, circa 1991–1993

LITTLE FISH
Ink on paper, 3″ x 3″, 1991

FLAUTIST
Ink on paper, 6″ x 4″, 1986

LOOKING
Ink on paper, 7 ½″ x 6″, 1992

THE COOK
Ink on paper, 7 ½″ x 4 ¾″, 1992

PROFILE
Ink on paper, 4½″ x 4¼″, circa 1992

SUMO BABY
Ink on paper, 7¾″ x 5″, circa 1993

FISH
Etching, 4″ x 6″, 1991

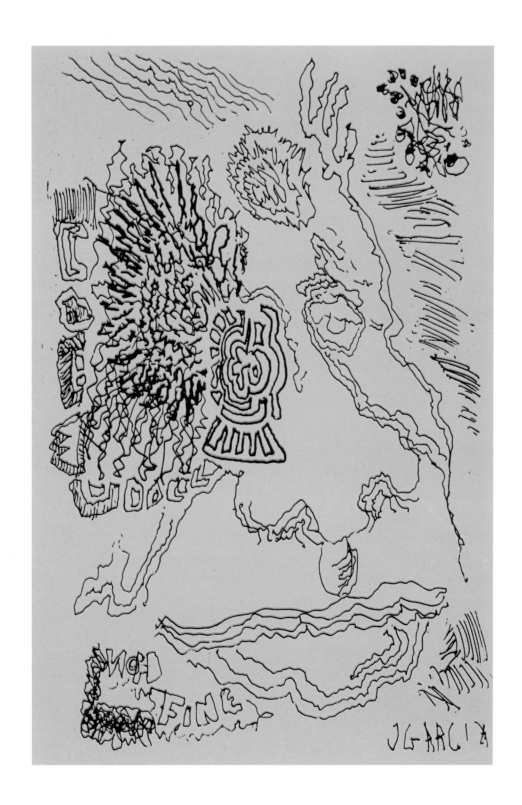

HOW FINE
Etching, 6″ x 4″, 1991

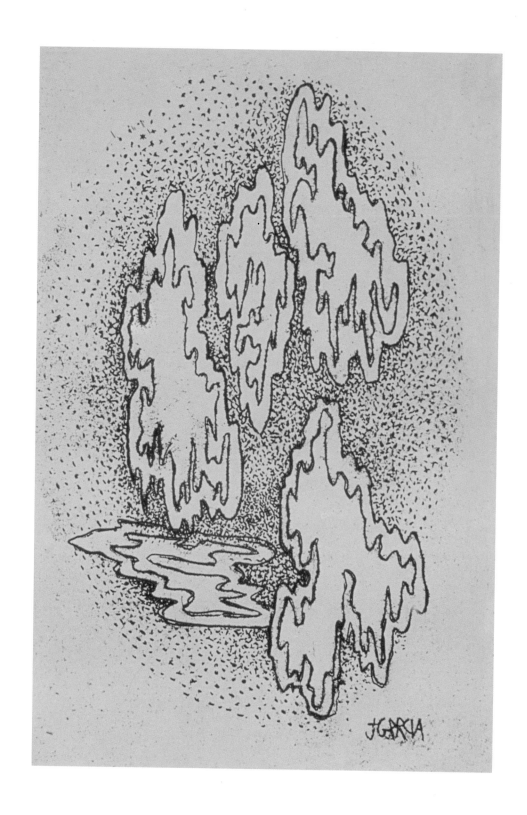

QUASAR
Etching, 6″ x 4″, 1991

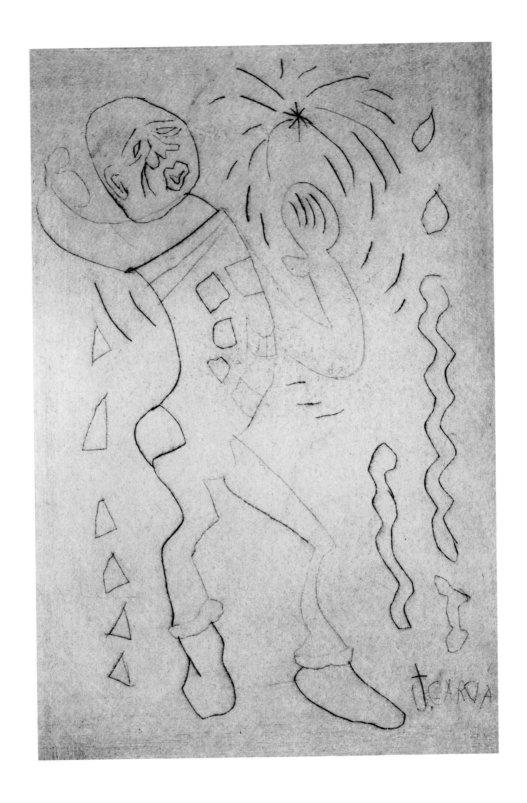

DANCE
Etching, 6″ x 4″, 1991

Etchings

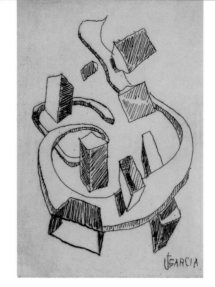

E*tchings were yet another experiment for Jerry. They were a chance to work in a new medium, which he explored primarily between 1990 and 1991.*

In etching, an artist works directly on a metal plate, from which original prints are then hand-pulled. The drawing is done with a pointed needle on a polished zinc or copper plate that has been covered with an acid-resistant layer (wax, mastic, or asphalt), and blackened with a fumigating candle in order to render the design (a mirror image of the final print) more visible. The plate is then immersed in acid (etched)—often several times—to achieve varying tones; cleaned, reground, and reworked. When the plate is finally ready to be printed, the edges are beveled and burnished and the plate inked and carefully wiped clean—all by hand—leaving ink only in the etched lines. Various colored inks may also be added at this point. Softened paper is then forced into the inked lines as it passes through the steel rollers of the press.

Each etching is considered an original fine art print, and no two prints are ever exactly alike. The edition is limited as well by the simple fact that the metal plate wears down as it is being printed.

Gallery owner Roberta Weir, a fine artist herself, instructed Jerry on how to do etchings. Roberta said Jerry was charming to work with, but he could be a tad lazy and wanted her to prep and finish the prints. He only liked to do the fun part, drawing. She writes:

"I thought that Jerry would enjoy a very traditional and authentic type of printmaking. I am also an etcher. Jerry had seen some of my own handmade prints, etchings and stone lithographs, and he was open to learning from me.

"He was delighted to try the medium and often said he would come to the studio to process the plates himself, but he was not always free to do as he wished with his time. So I prepared the plates for drawing, made a brief written instruction sheet, and sent them out for Jerry to pick up. We talked on the phone about technical details. I sent him my gravers to use, and a little bottle of stopping-out varnish for corrections. Jerry wasn't given to making corrections and never used the varnish. When he made an error, as he sometimes did when he forgot that the result would be a mirror image with the picture and letters backward, he would just scribble over it or leave it. He was not one to rework things. That is something I learned from Jerry: whatever you do, just go with it, don't look back.

"He and [bass player] John Kahn spent many hours together working on their plates. Both of them found great pleasure creating imagery in a "serious" artists' medium. Etching has an aura of scholarship and connoisseurship that appealed to both of them.

"Among this series of six etchings were *Fish*, which is the most well known, *Bees* and *First Try*, which were all made into editions of two hundred copies; for *Dance*, *Quasar*, and *How Fine*, only experimental artist proofs were pulled."

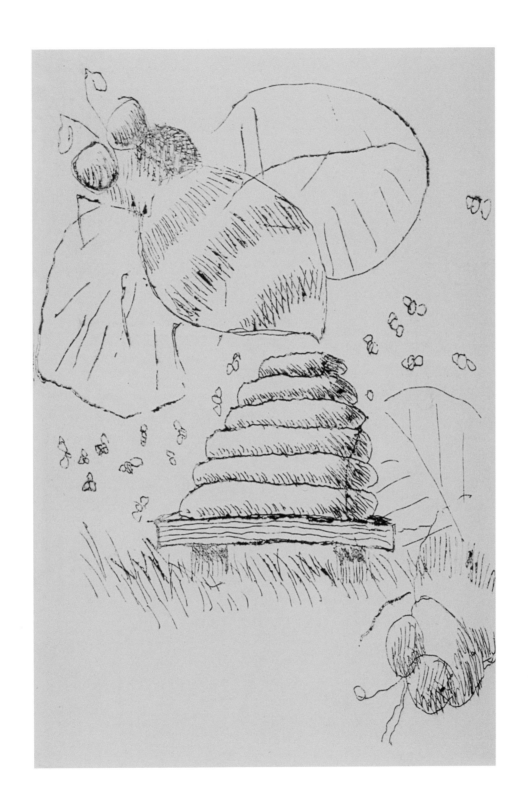

BEES
Etching, 6″ x 3¾″, 1991

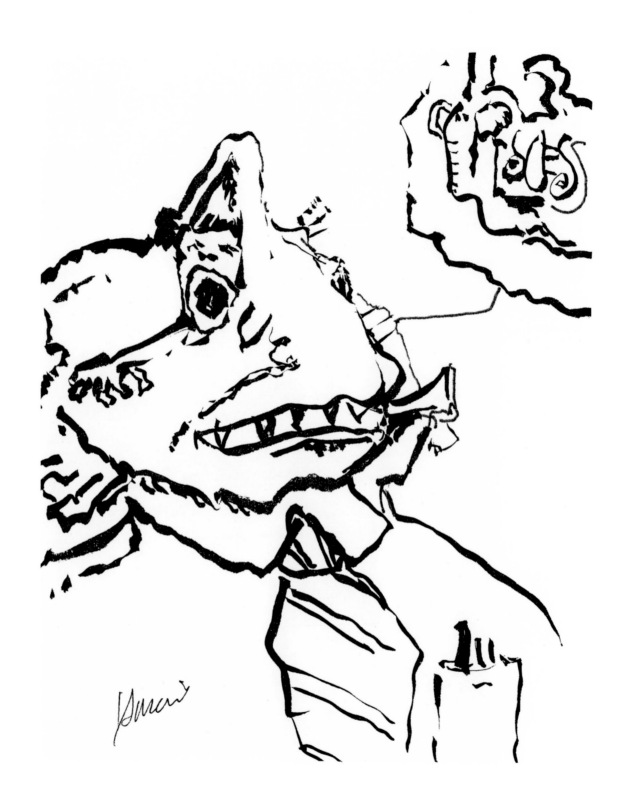

FROG BOY
Ink on paper, 5¾″ x 4¾″, 1992

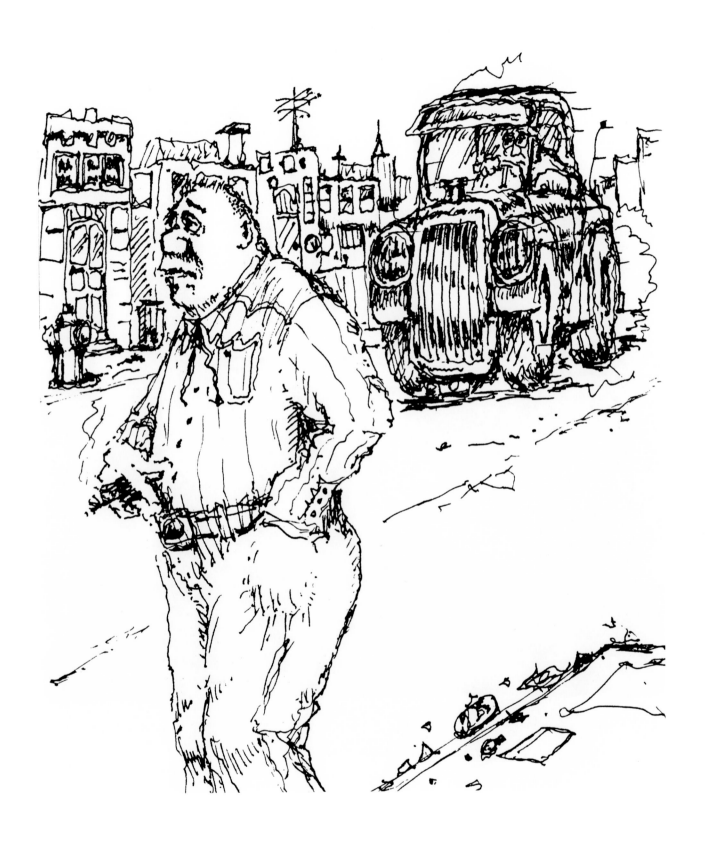

ATTITUDE ADJUSTMENT
Ink on paper, 7 ⅜″ x 6 ¼″, 1992

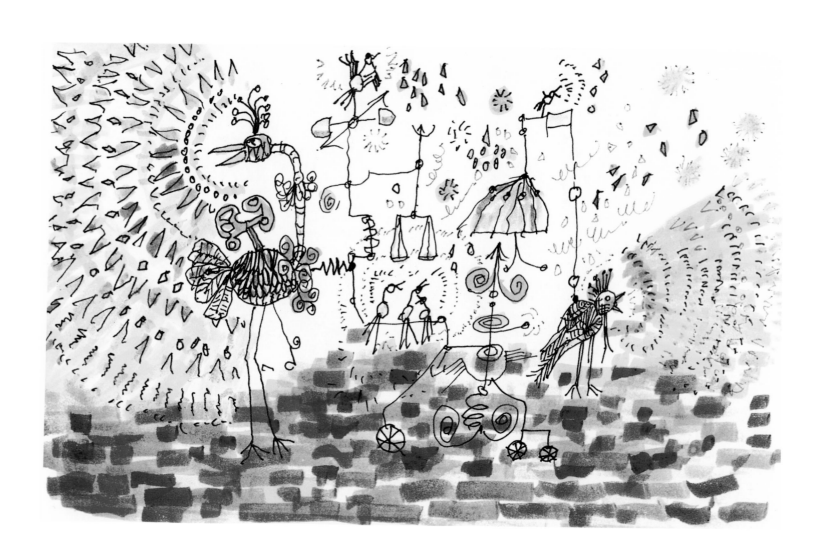

LIKE THE TWITTERING MACHINE (FOR PAUL KLEE)
Ink & watercolor on paper, 5″ x 7″, 1985

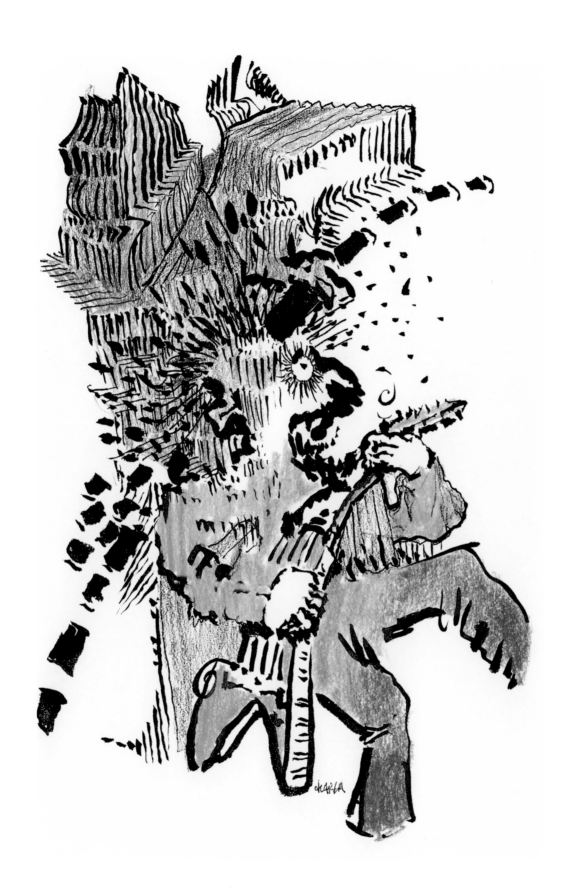

THE ROCKER
Ink & oil pastel on paper, 8″ x 5″, 1990

WATERCOLORS & GOUACHE

chapter two

Processes and Influences

The creative fire that was Jerry Garcia was as all-embracing as his beatific smile. He belongs to that select cadre of contemporary performers who are talented both as musicians and visual artists, and the bountiful light of inspiration shone on whatever he turned his hand to, from filmmaking to songwriting.

Yet, like many people who are dedicated to imaginative expression, he was continually dealing with the challenges of how to balance his artistic life with his practical life. Success does not take these obstacles away; it may even exacerbate them. Success for Jerry continued to mean being deeply connected to his creativity.

> *"Jerry's work is full of surprises, personal notations of an inquisitive eye and unselfconscious hand that provide a intriguing glimpse into the mental play of this multitalented artist."* –Roberta Weir

For Jerry, the "good part" was the act itself; once a piece was finished, its subsequent fate was of little interest to him. "That was that" was the core of Jerry's process and being. He was a generous soul and even through his fame he continued to uphold his utopian vision, wherein things were communal and anachronistic. As long as his needs were met he was not possessive of his artwork or his music. Art was not a business to Jerry; he engaged in it because he had been compelled to.

> *"Art doesn't live past the moment for me… It has no value except for the execution… I have never had a graphic idea in my mind visually before the doing. My pen starts going; after a while I recognize it and finish it."* –Jerry Garcia

He never corrected his mistakes and often would turn his artwork around or upside down to work on it. In some of the pieces, certain figures become more obvious when viewed from another perspective. His methods express his freewheeling subconscious and the serendipity of discovery, exploration, and experimentation, much like his music. Yet, unlike his music, which was for the most part about collaboration, his artwork was highly personal and done for his own enjoyment. He was very humble about his gift, and never took himself too seriously in this realm.

> *"I don't feel like I'm inventing it, I feel like I am discovering it. For me the process is best when it is surprising and fun. The important thing to me is to stay interested by things."* –Jerry Garcia

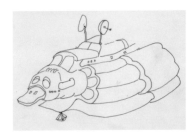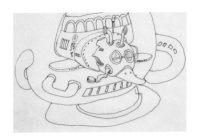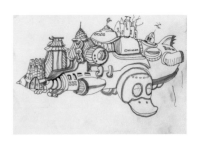

PROCESS DRAWINGS OF DUCK SPACESHIP
Ink on paper, 5″ x 8 ½″ each, 1985

Jerry's cited artistic influences range from the Expressionists to George Herriman, creator of "Krazy Kat." Picasso, Klee, Max Ernst, Van Gogh, De Chirico, and Ralph Fasanella, who colorfully depicted the joys and trials of the lives of working people, were all artists he had studied and admired.

His color palette runs distinctively bright, with many primary colors and jewel tones, with shades of black, and ink linework. In the literal subject matter, Jerry draws what he observes—a banyan tree on one of his diving trips to Hawaii, the cityscape from his hotel window while on tour—or visualizes the landscapes of his imagination.

Portraits and caricatures of people are done with lyrical contour and whimsical brushstrokes. Many of his personal demons from childhood and beyond also make appearances in his work, as does the influence of his beloved horror films. Jerry also painted political issues that concerned him, in such pieces as "Desert Storm," "Sadaam," "Lenin," and "Ted (Koppel)."

His work is always full of surprises and refreshingly unselfconscious. Garcia's drawing and painting techniques, while not at the apex of artistic achievement, are still quite adept, and he draws with a wonderful sense of rhythm and line, which could only have been developed through many hours of practice, and an evanescent joy that shines through the work.

Louis Pasteur's aphorism "Chance favors the prepared mind" is particularly apt. Jerry Garcia often seemed to be a conduit, simply stepping back and letting the creative force flow through him, whether improvising a guitar solo or doodling in his sketchbook. Of course, this belies the thousands of hours of practice and study that is the backdrop of his apparent nonchalance.

He rarely traveled without his "recreation" bag, a suitcase crammed with discs, paints, sketchbooks and Japanese calligraphy brushes. Working mostly at a small scale in spiral-bound notebooks, Jerry created drawings and paintings that were quirky and amusing, sometimes simultaneously expressing his dark side.

Although Jerry had drawn and sketched throughout his life, his most productive period was the decade preceding his death, from 1986 to 1995, when he created myriad drawings and paintings. His Estate has archived over 500 pieces from this period, but much of his artwork was never documented, sold during his lifetime with laissez-faire accountings and records. Taking into account the various doodles that Jerry did at Grateful Dead meetings—and for Significant Others, friends, and fans—tucked away in private collections, the actual number of works created during his lifetime is estimated to be at least twice that.

"It can take Garcia all day to get out of his apartment. Always the last to bed, he is slow to get going in the morning and can spend hours puttering. He may decide to fiddle with his Macintosh and generate some computer art, or open a sketch pad and begin to draw. It's surprising what a good draftsman Garcia is. The best of his drawings are witty, spare, and whimsical". –Bill Barich in *The New Yorker*, October 11, 1993.

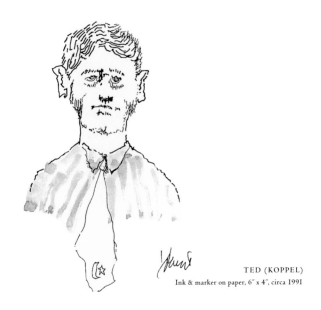

TED (KOPPEL)
Ink & marker on paper, 6″ x 4″, circa 1991

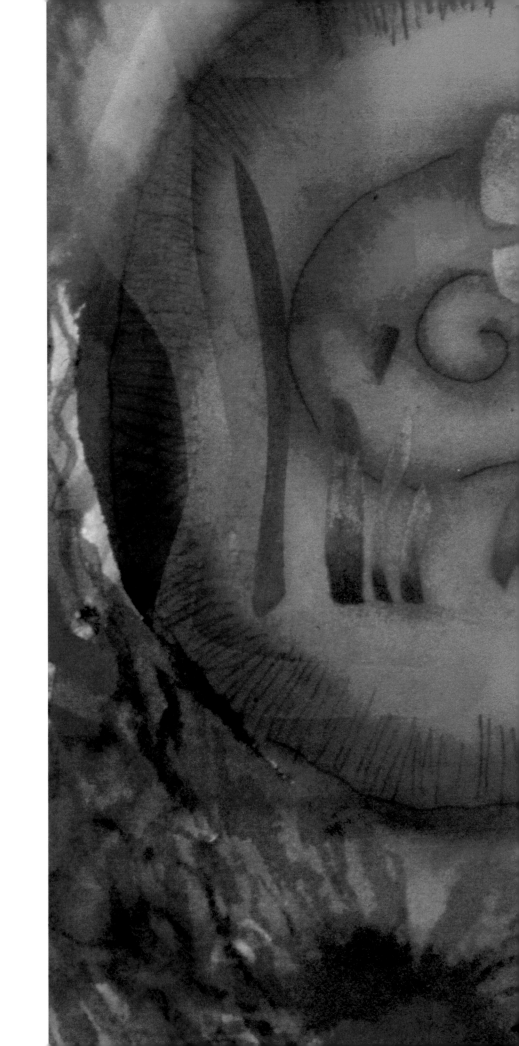

SNAIL GARDEN
Watercolor & ink on paper, 7″ x 10¼″, 1993

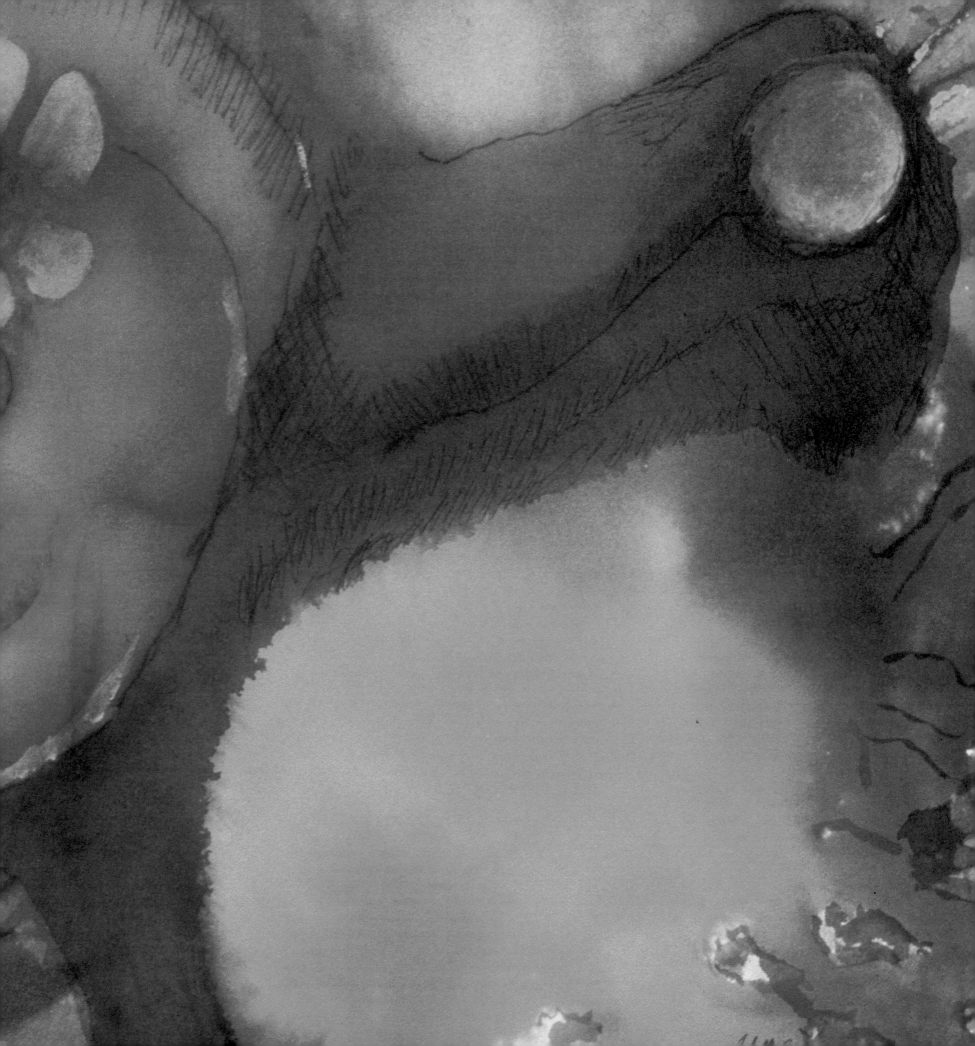

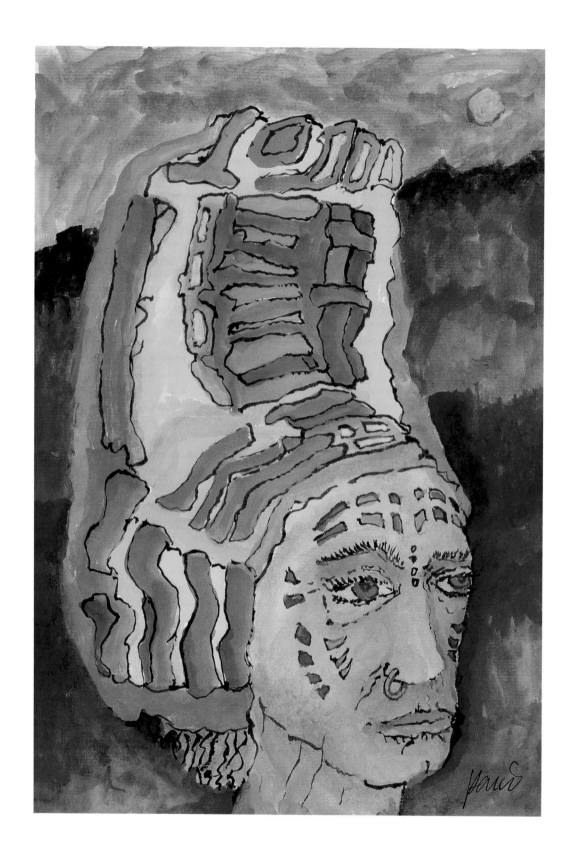

RITUAL MOON
Watercolor & ink on paper, 12″ x 8¼″, 1993

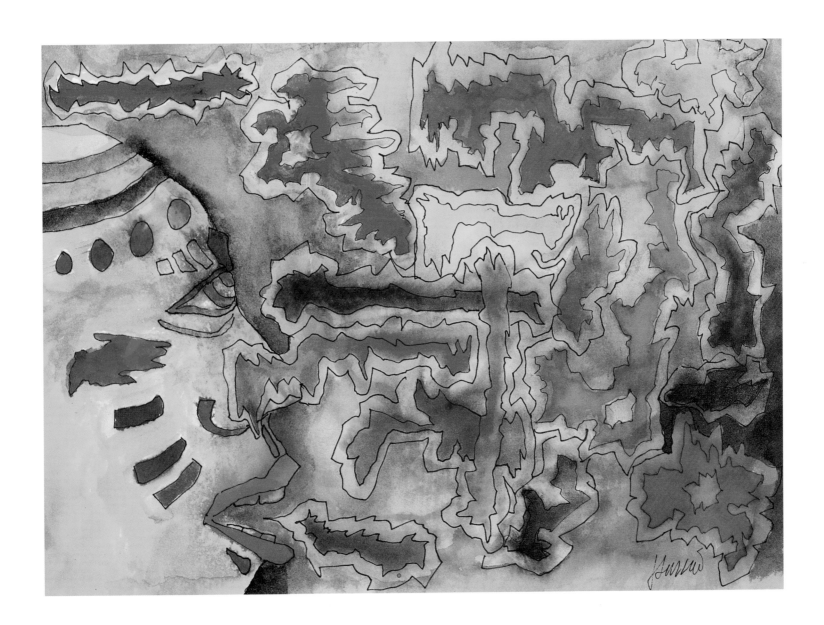

SHAMAN
Watercolor & ink on paper, 9″ x 12″, 1990

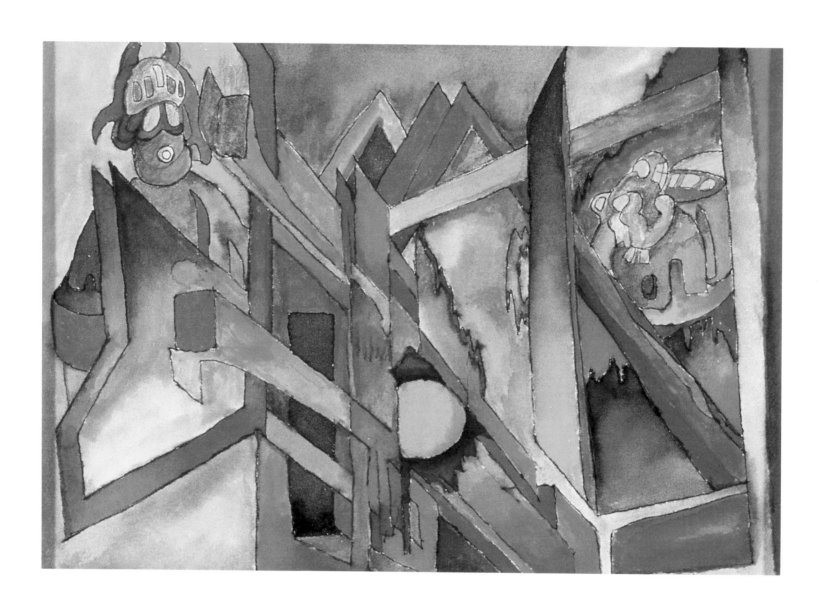

SPACE CONTAINERS (a.k.a. ABSTRACT ANGLES)
Watercolor & ink on paper, 9″ x 12″, 1991

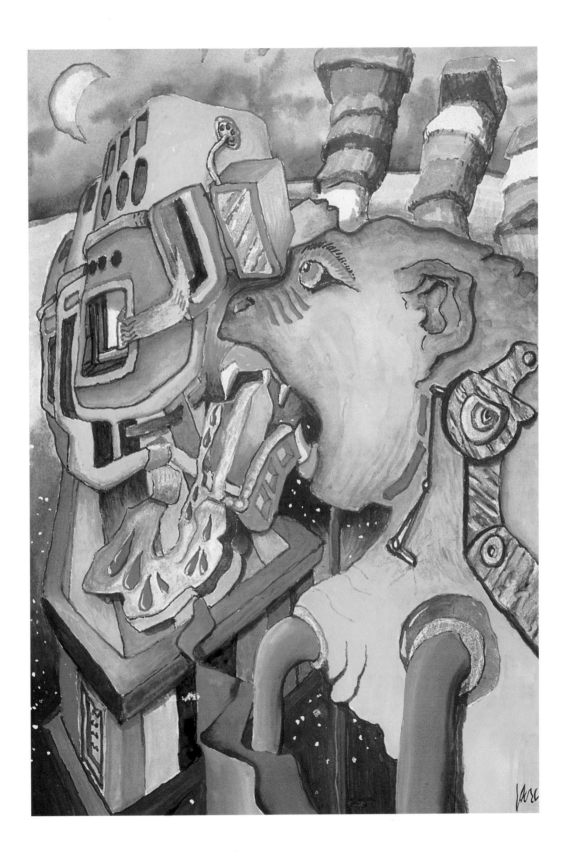

VIRTUAL REALITY APE
Gouache on paper, 13″ x 9 ½″, 1993

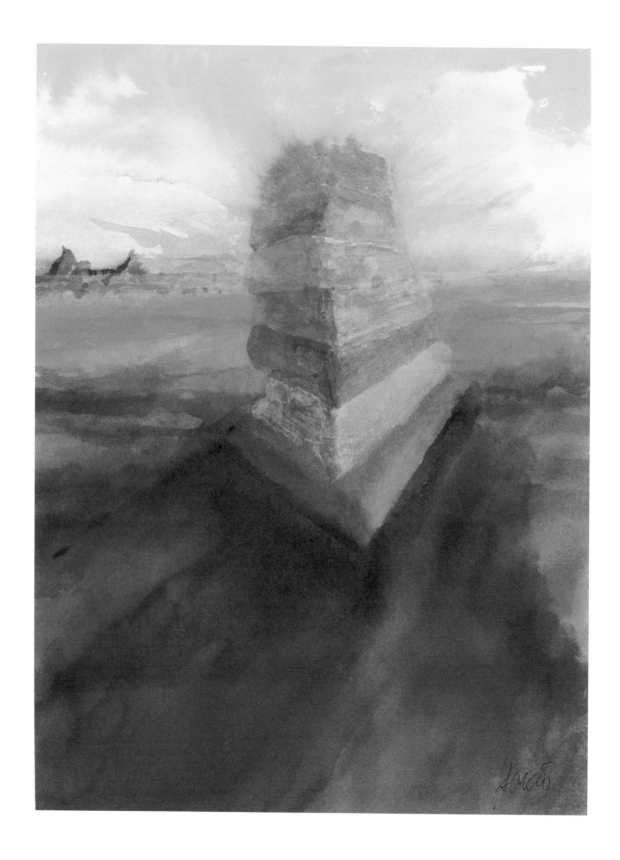

DESERT STORM
Gouache & watercolor on paper, 12″ x 9″, circa 1991

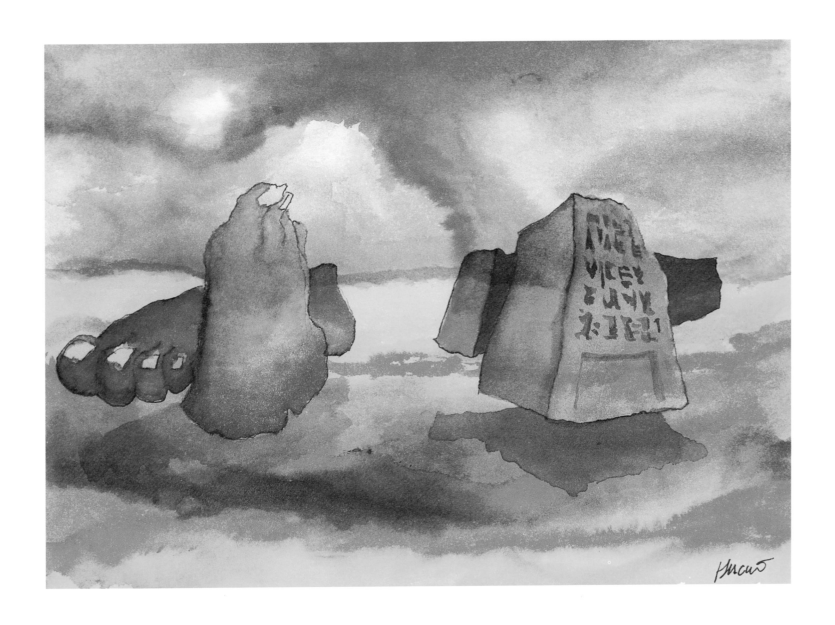

HIEROGLYPHICS (a.k.a. FOOTPRINTS IN THE SAND)
Watercolor & ink on paper, 7" x 10", 1992

LIZARD BOARD
Gouache on paper, 10½" x 9½", 1993

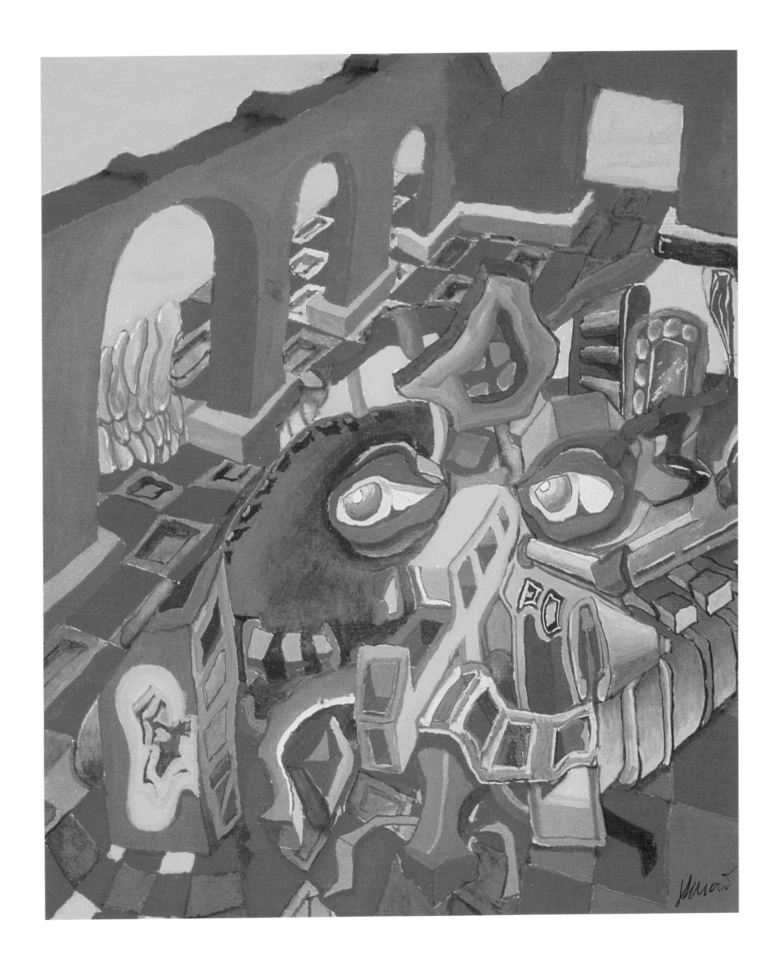

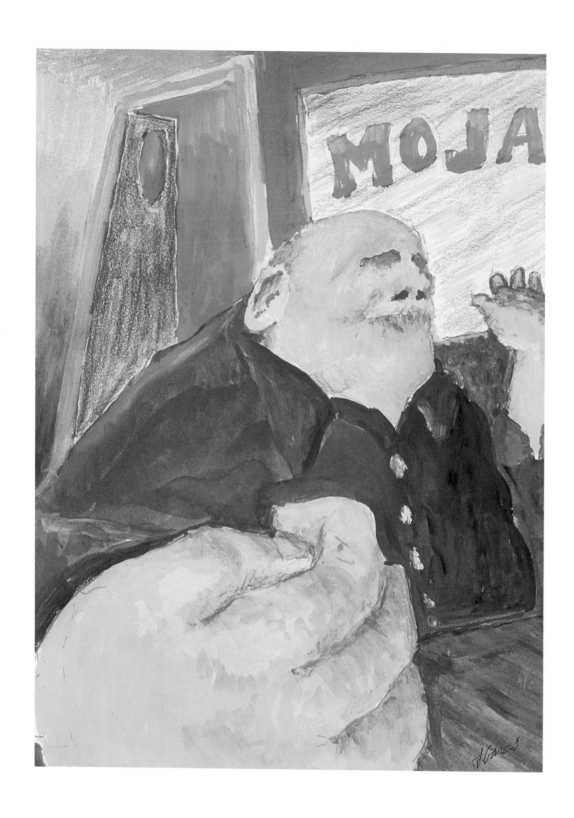

ABSALOM BAR
Gouache and colored pencil on paper, 12″ x 9″, 1992

THE CARDINALS
Watercolor, oil pastel & ink on paper, 5″ x 7″, 1991

CALIFORNIA MISSION
Gouache & watercolor on paper, 9" x 12", 1993

FEEDING IN THE LIGHT (a.k.a. NEIGHBORS)
Watercolor & ink on paper, 9″ x 12″, 1990

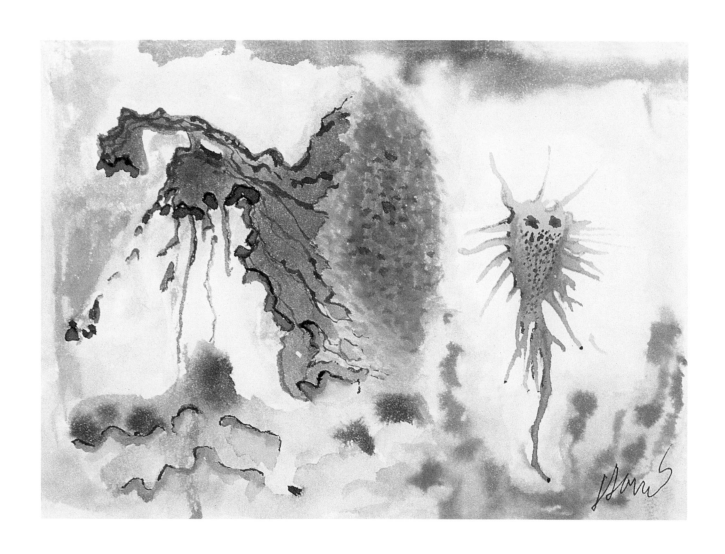

SEA ANEMONE
Watercolor & ink on paper, 4″ x 6″, 1991

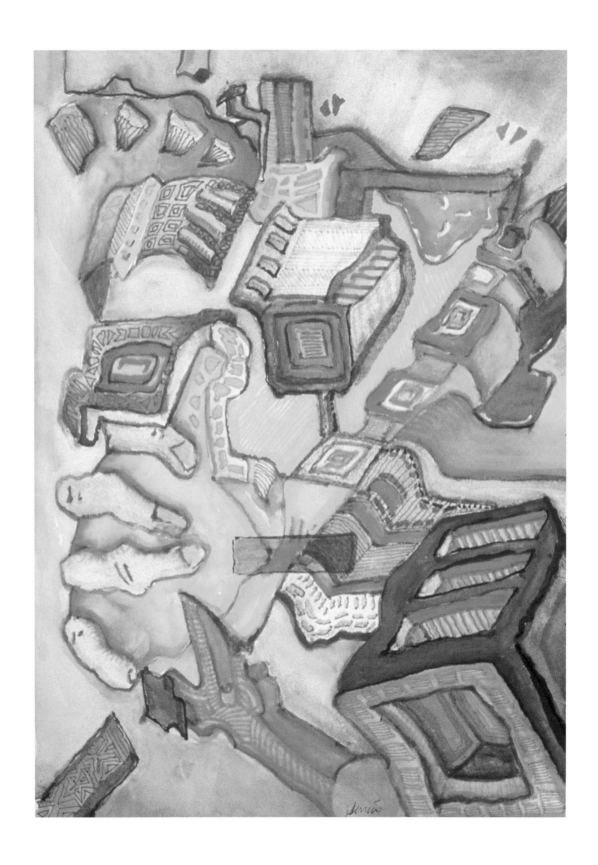

SURPRISE PACKAGE
Gouache on paper, 12⅜″ x 9″, 1993

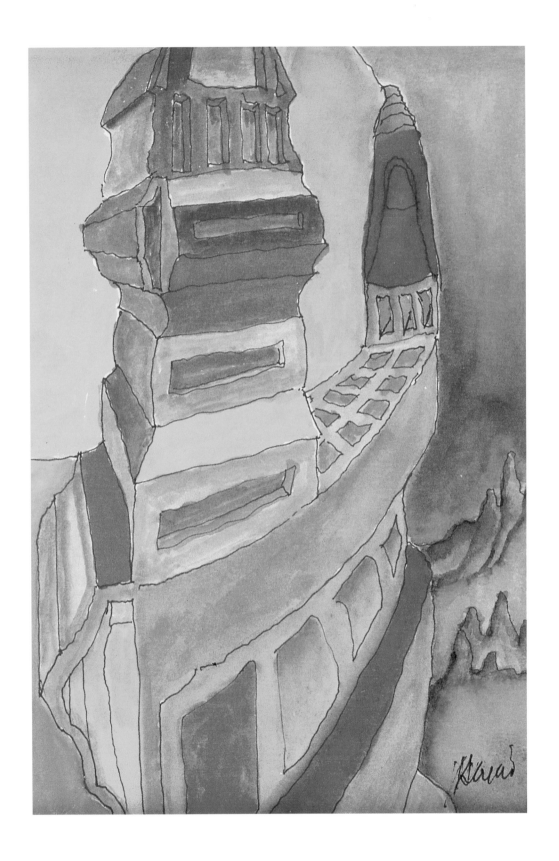

MOON MOUNTAINS
Watercolor & ink on paper, 6″ x 4″, 1990

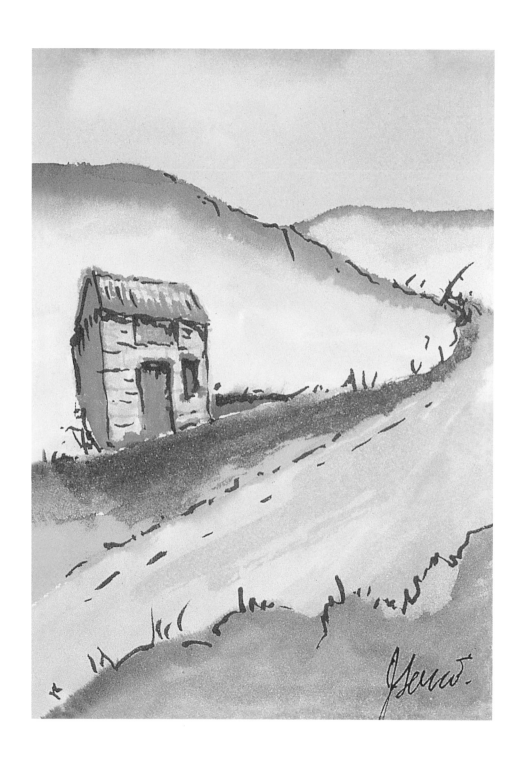

LAST CHANCE
Watercolor & ink on paper, 5″ x 3″, circa 1990–1991

RECOLLECTION
Marker & ink on paper, 5″ x 3″, circa 1990–1991

GREEK THEATER FEET
Watercolor on paper, 8 ½″ x 12″, 1993

SCALES
Watercolor on paper, 9″ x 12½″, 1993

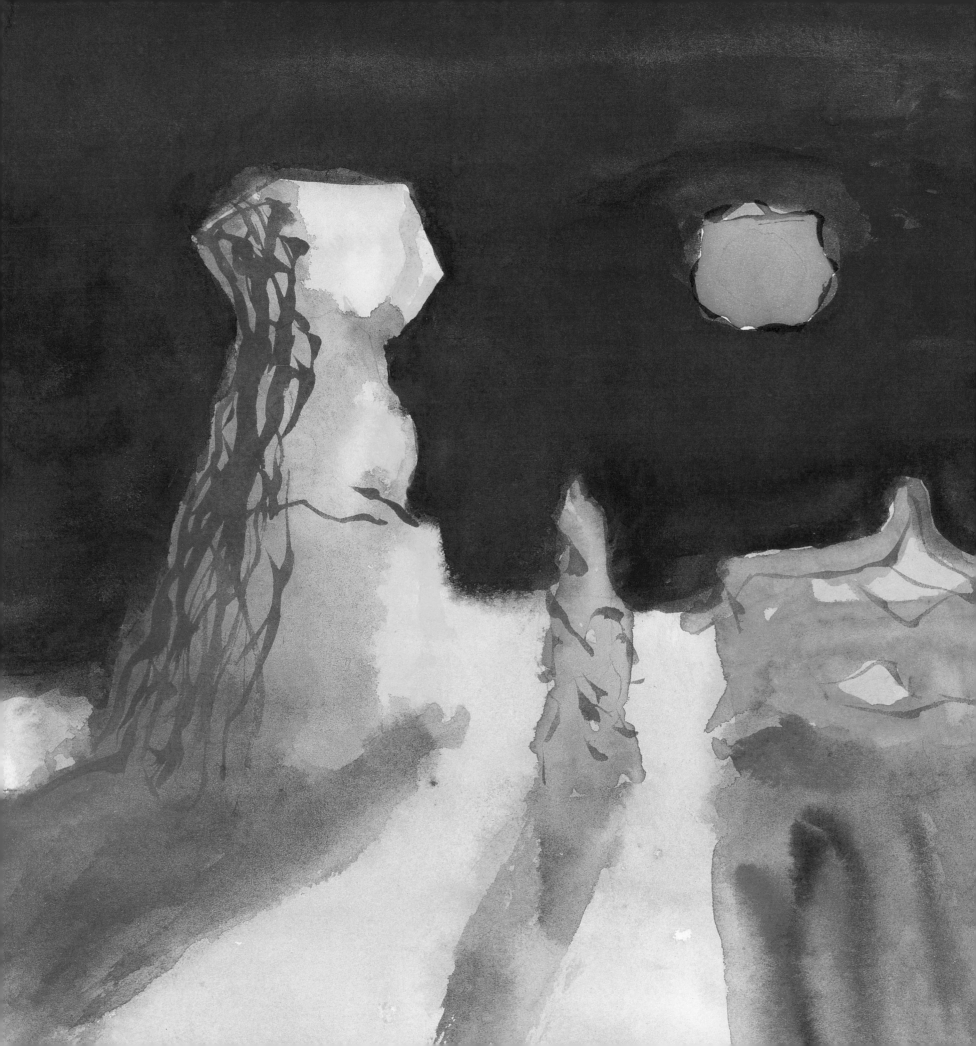

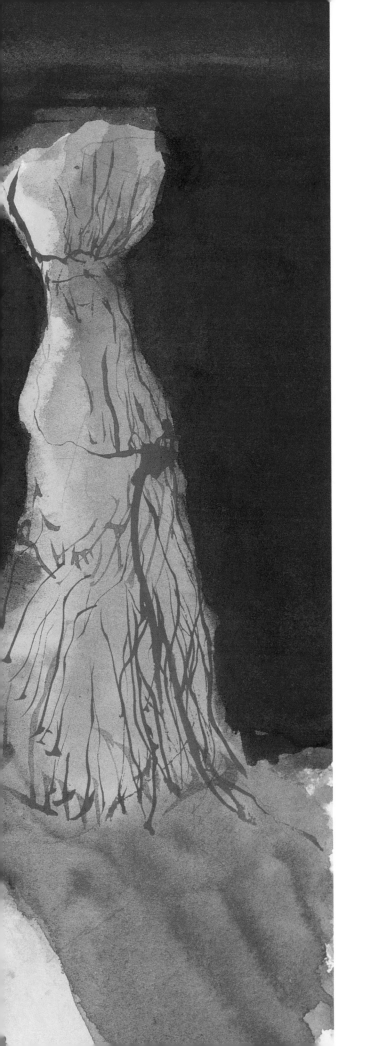

MEGALITHS
Watercolor on paper, 9˝ x 12˝, 1993

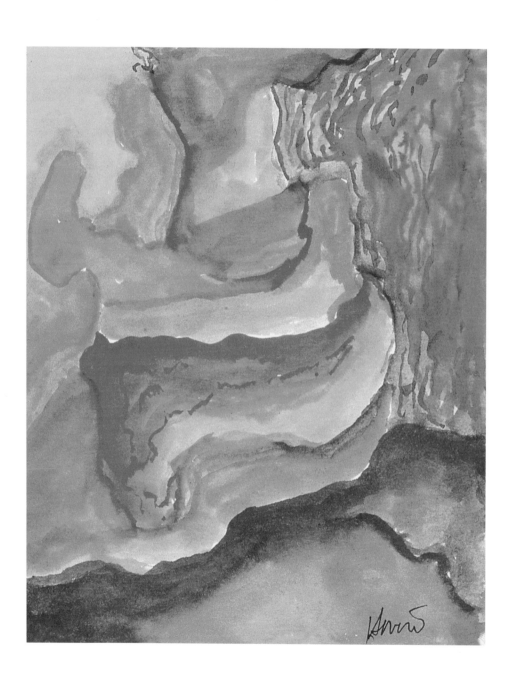

UNTITLED
Gouache & watercolor on paper, 10″ x 7⅞″, circa 1991

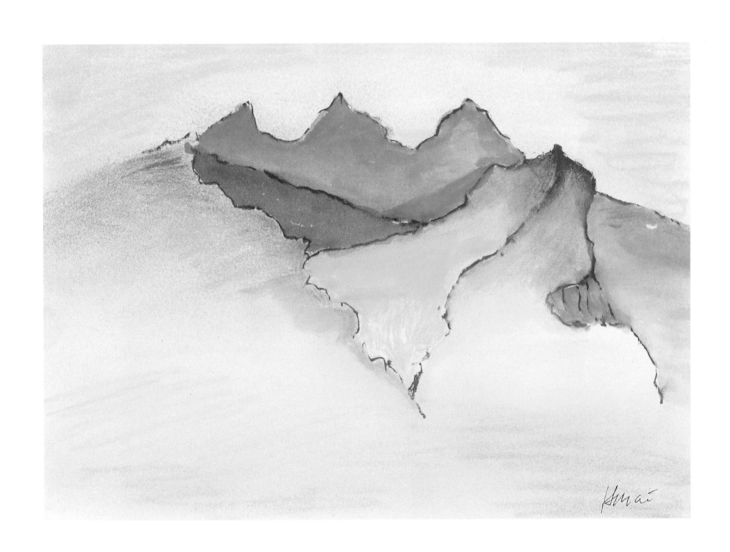

LANDSCAPE II
Watercolor & oil pastel on paper, 7″ x 10″, 1991

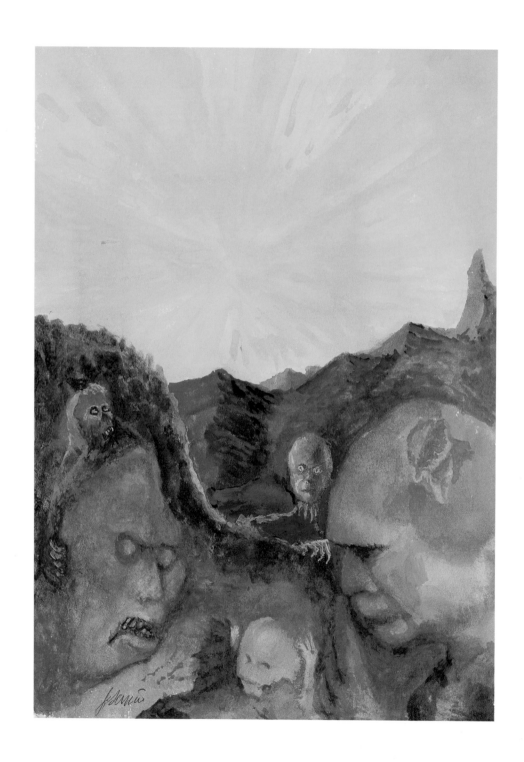

INFERNO
Gouache & watercolor on paper, 12 ¼″ x 9″, 1993

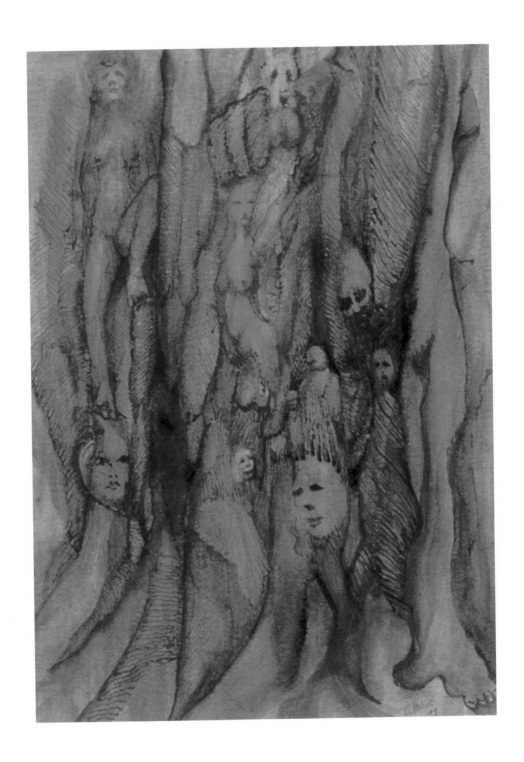

WHO GOES THERE?
Gouache & watercolor on paper, 12″ x 9″, circa 1993

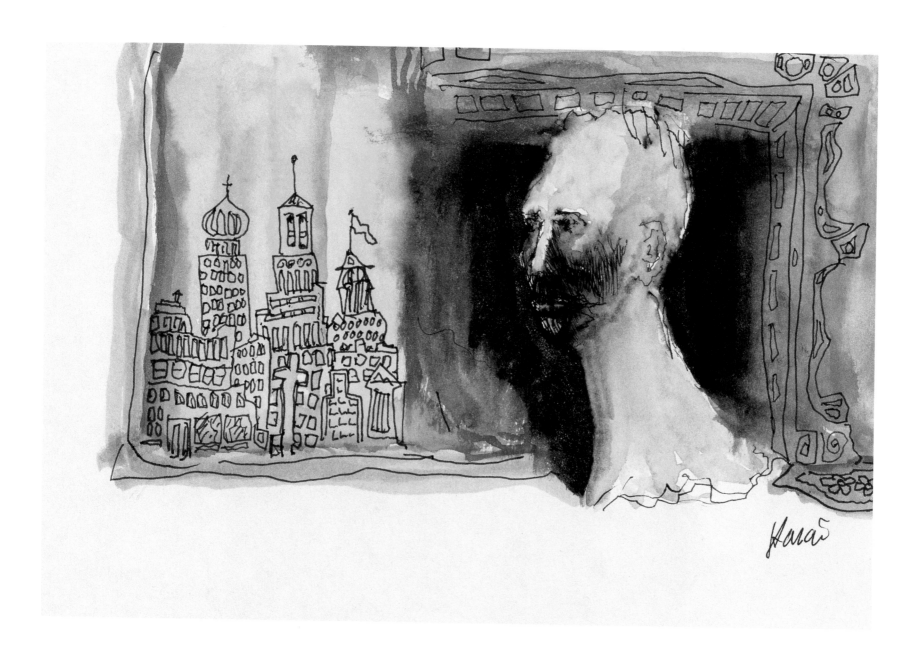

NEVSKY
Watercolor & ink on paper, 4″ x 6″, circa 1993

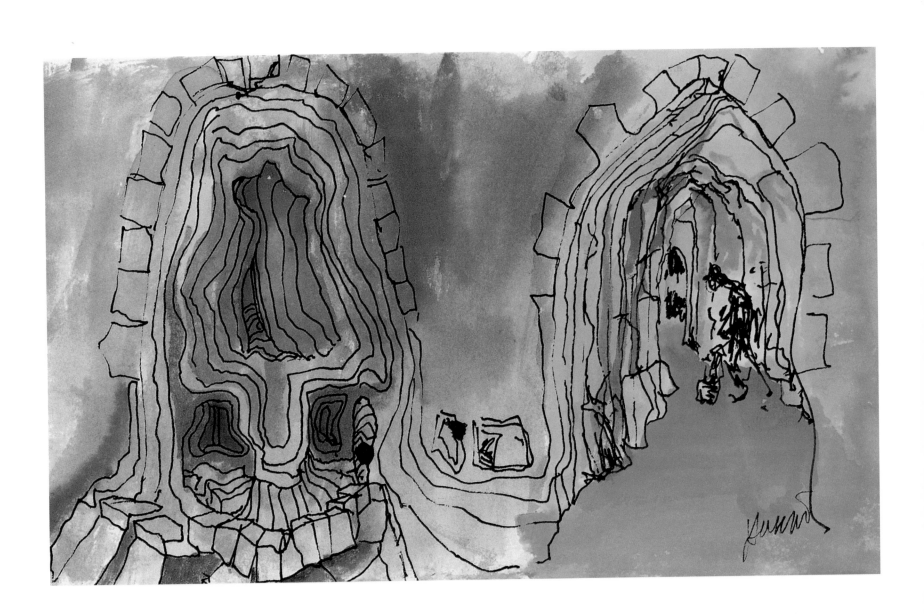

ARCHES
Watercolor & ink on paper, 3 ¾″ x 4 ½″ circa 1990

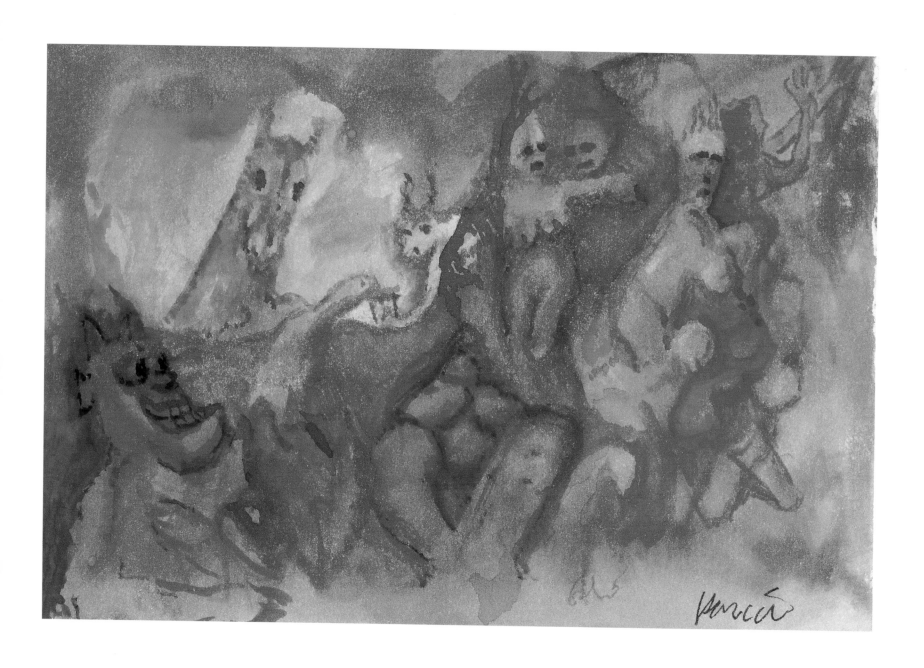

LUST
Gouache & watercolor on paper, 4" x 6", 1993

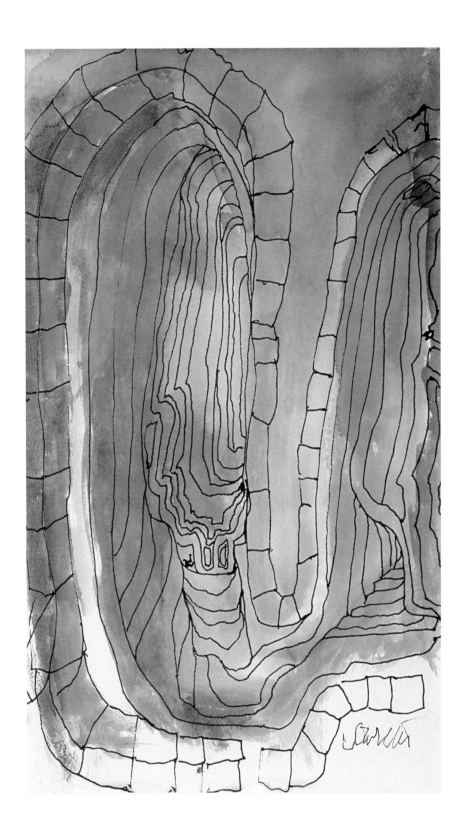

MORE ARCHES
Watercolor & ink on paper, 8″ x 5″, 1990

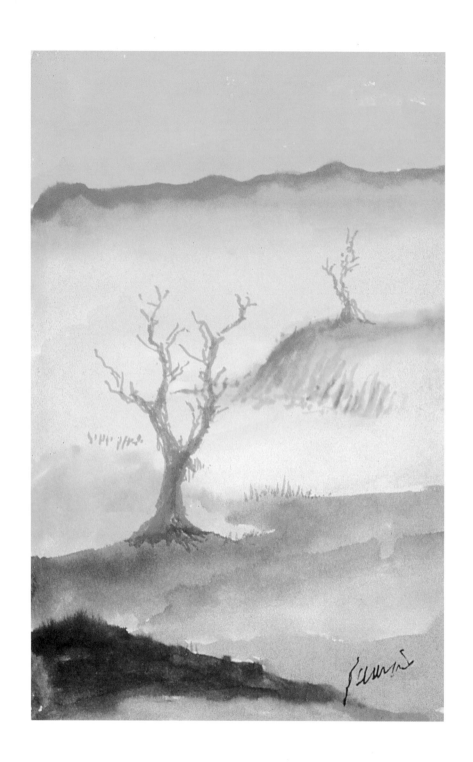

ORANGE HORIZON
Watercolor on paper, 8˝ x 5⅛˝, 1992

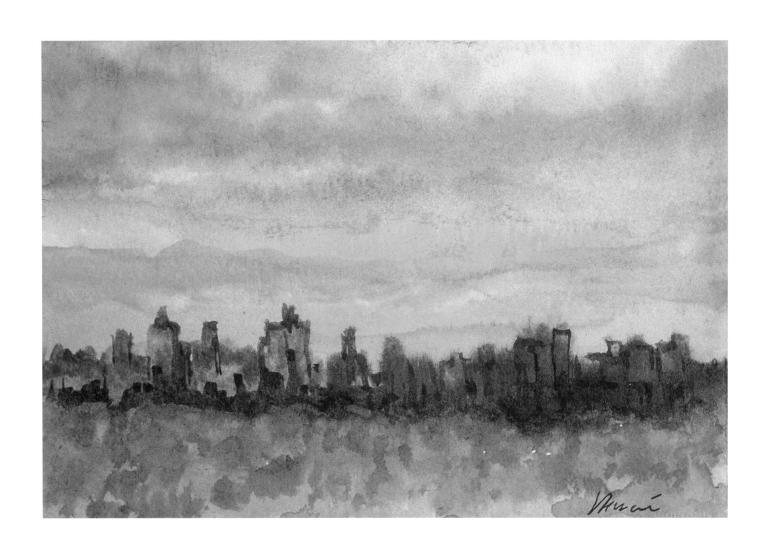

DAWN AT THE RITZ CARLTON
Watercolor on paper, 4˝ x 6˝, 1993

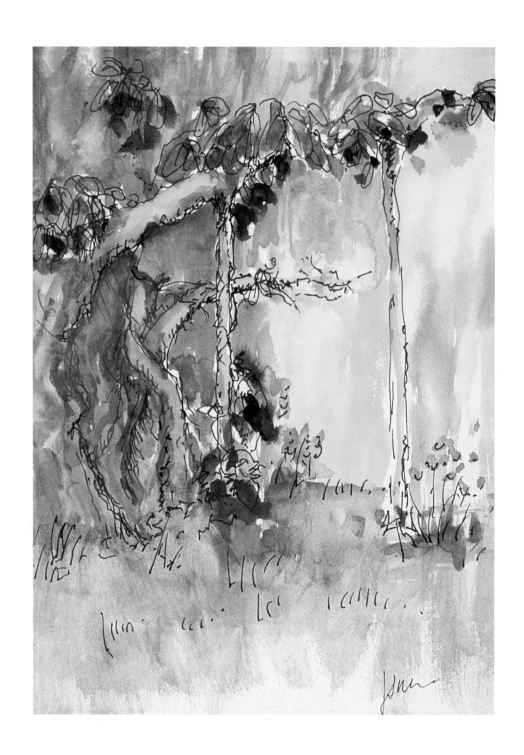

BANYAN TREES II
Watercolor & ink on paper, 8″ x 6″, 1989

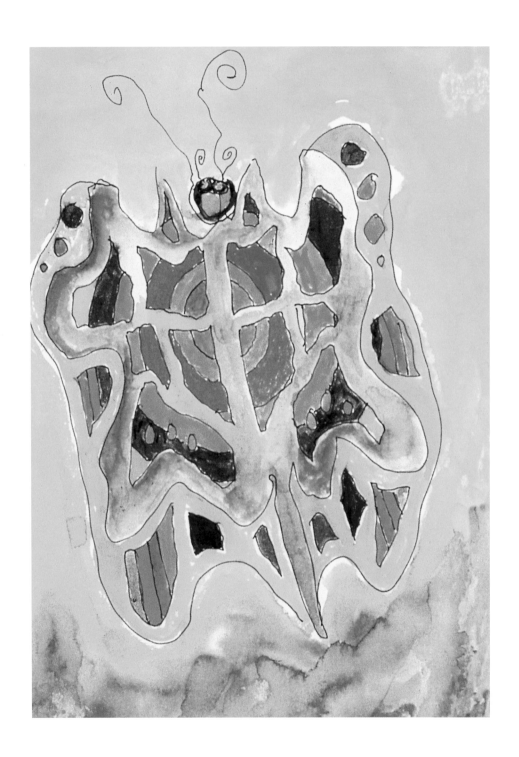

ANOTHER BUTTERFLY
Watercolor, gouache & ink on paper, 8″ x 4¾″, circa 1992

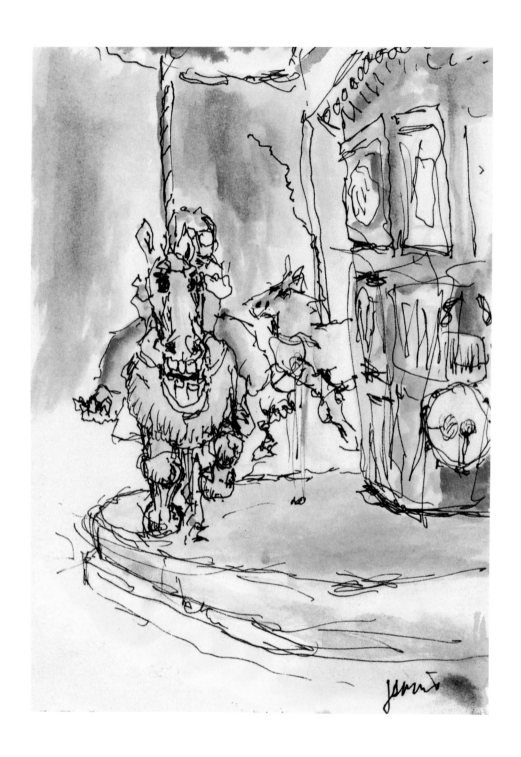

CAROUSEL
Watercolor & ink on paper, 6″ x 4″, 1990

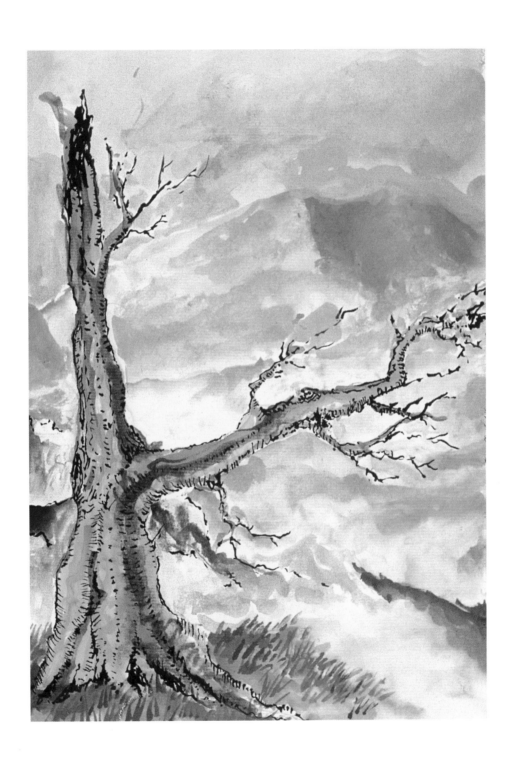

IRISH TREE
Watercolor and ink, 15″ x 11¼″, circa 1992

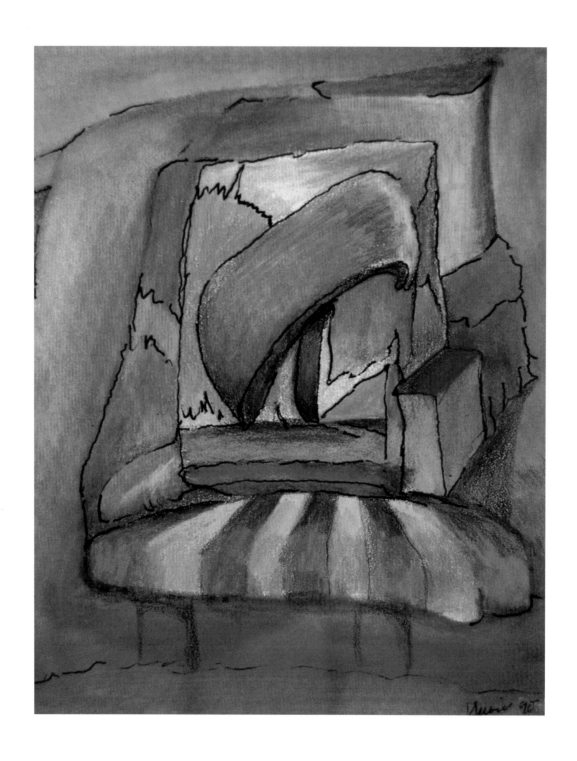

MODERN FURNITURE
Oil pastel and ink on paper, 7 ½″ x 5 ¾″, 1992

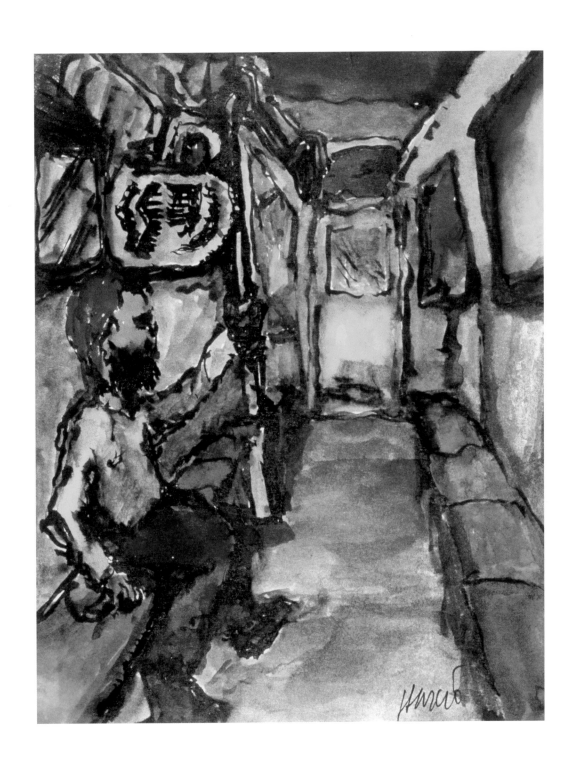

BUS TERRORIST
Watercolor & ink on paper, 6˝ x 4˝, circa 1992

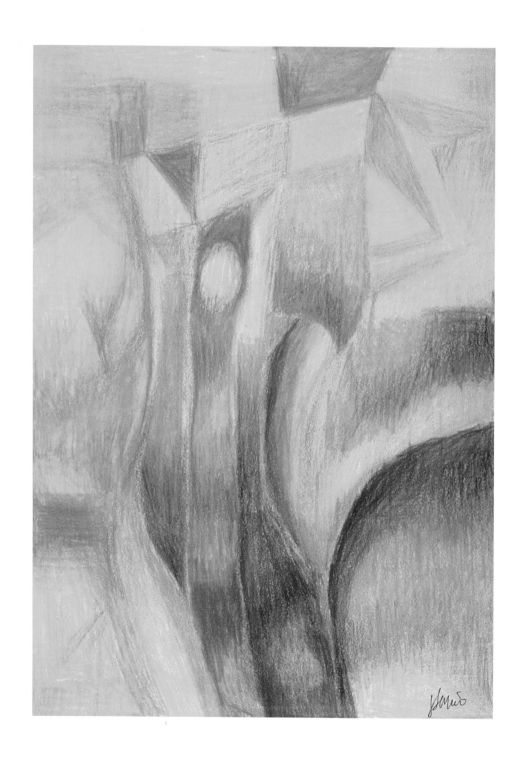

NUDE
Gouache and oil pastel on paper, 6″ x 4″, circa 1990

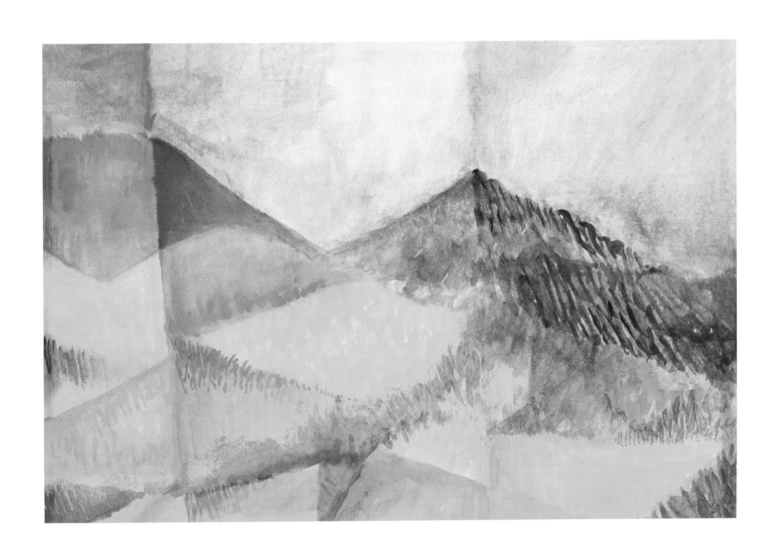

BLUE MOUNTAIN
Gouache on paper, 9″ x 12″, 1991

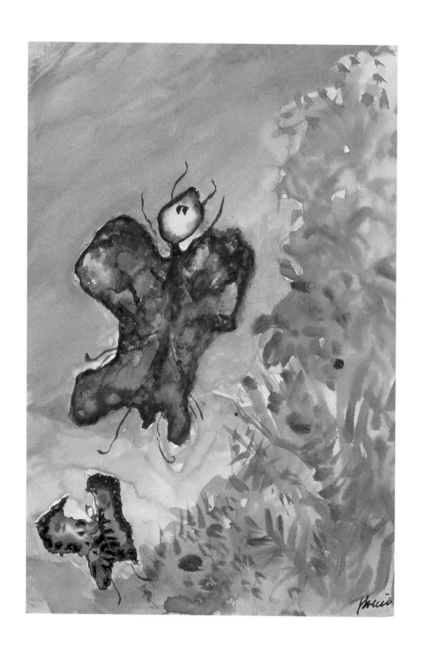

BUTTERFLIES III
Watercolor on paper, 12″ x 9″, 1993

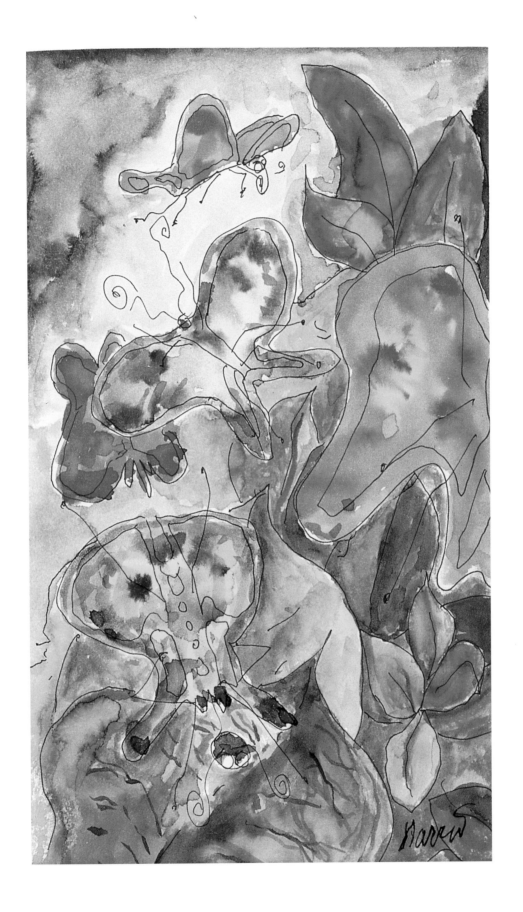

BUTTERFLY STUDY II
Watercolor & ink on paper, 14″ x 9″, circa 1992

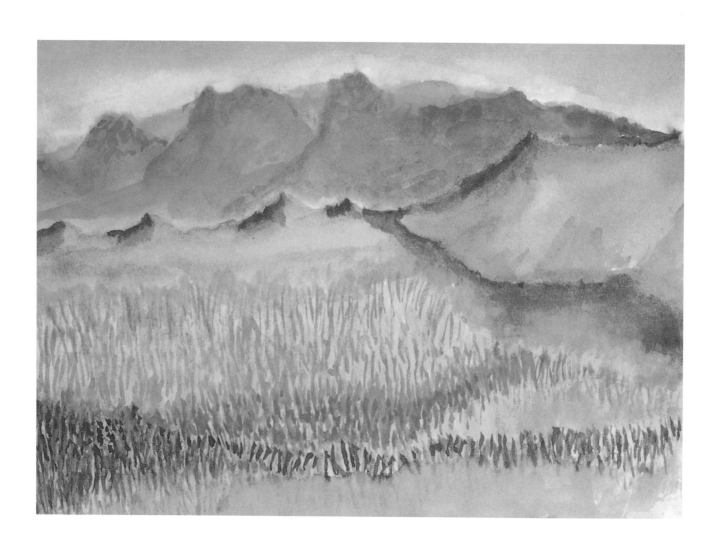

FLAMING MEADOW
Gouache & watercolor on paper, 4″ x 6″, 1991

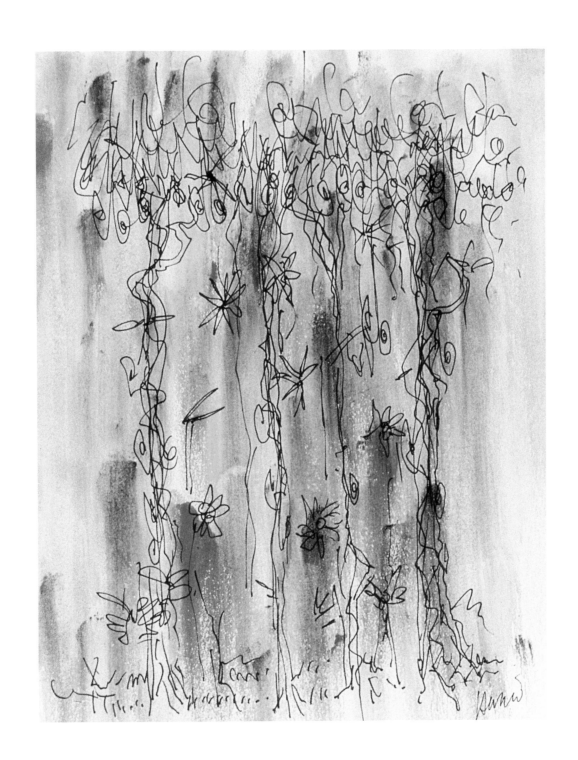

BANYAN TREES
Watercolor & ink on paper, 7 ½″ x 6″, 1993

RED ROOM
Gouache and oil pastel on paper, 6″ x 4″, circa 1993

SPARROW MONUMENT
Watercolor on paper, 9″ x 11¾″, 1992

CARTOON LIMBO
Watercolor & ink on paper, 7 ¾″ x 8 ½″, 1993

CHINESE DRAGON
Watercolor & ink on paper, 9½" x 10½", 1993

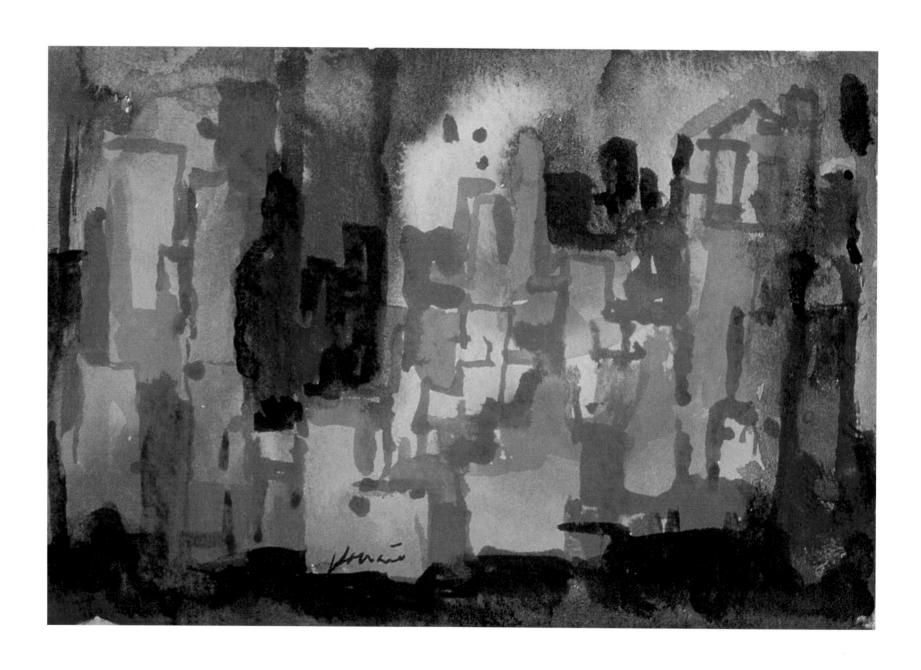

NEW YORK AT NIGHT
Watercolor on paper, 9″ x 12″, 1993

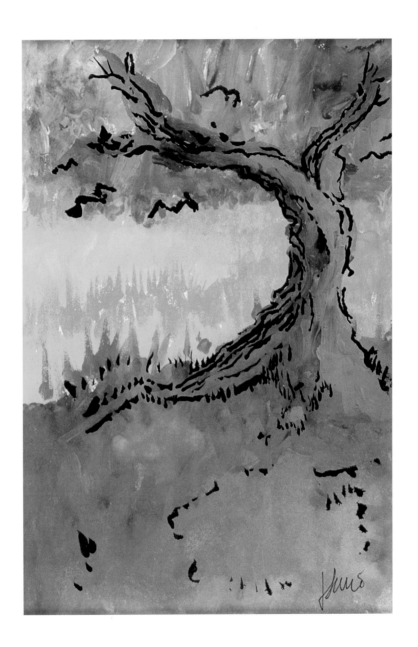

VAN GOGH'S TREE

Watercolor & ink on paper, 6″ x 4″, 1990

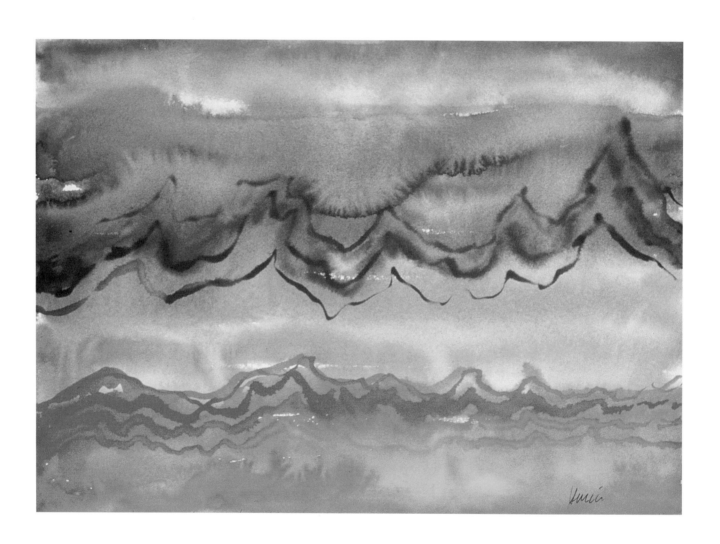

SEASCAPE
Watercolor on paper, 9″ x 13″, 1993

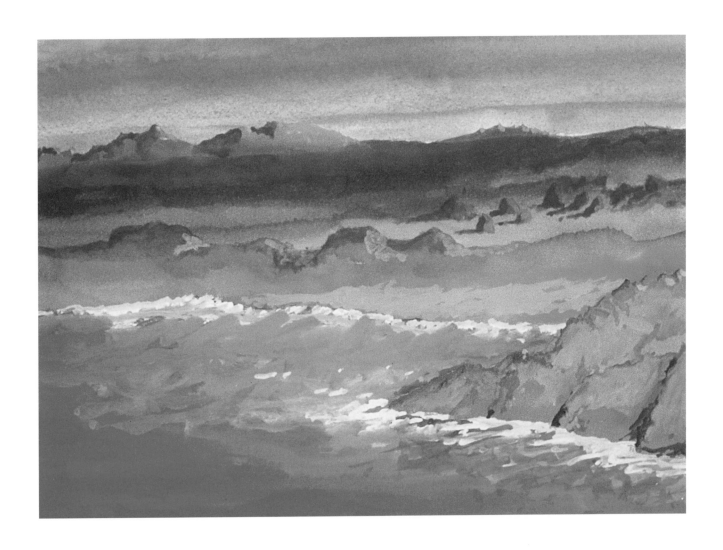

LANDSCAPE
Watercolor and gouache on paper, 8 ½″ x 11″, 1992

DRUMMERS
Watercolor on paper, 12″ x 9″, 1991

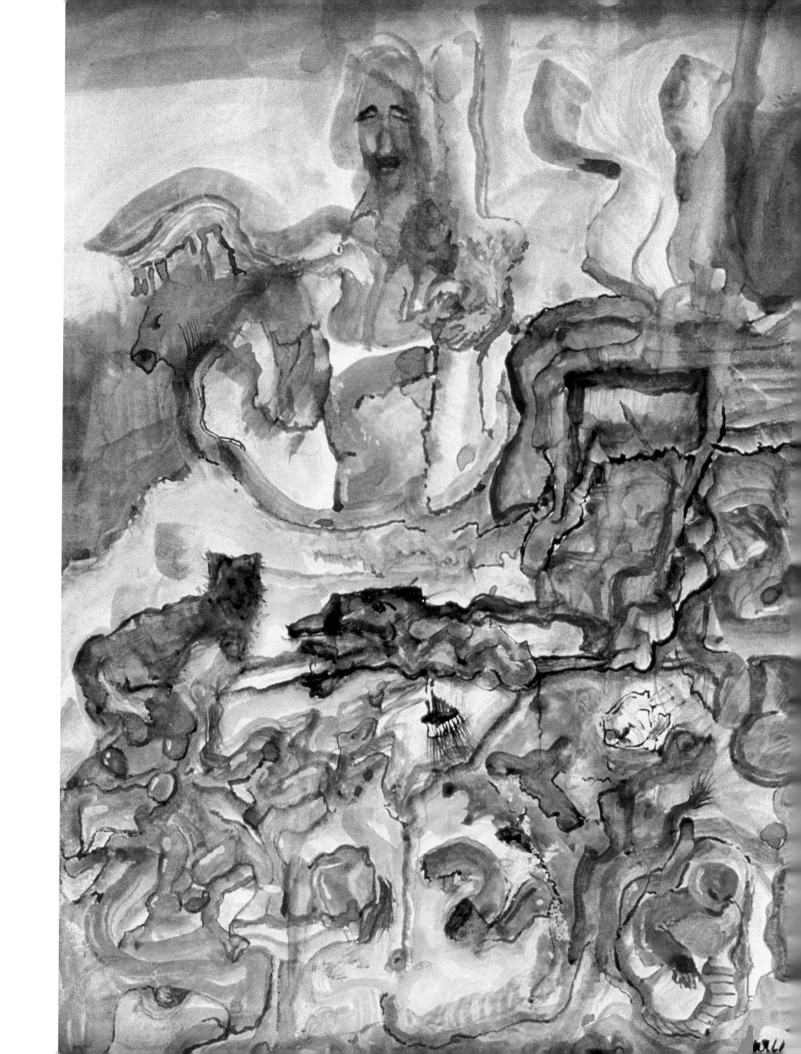

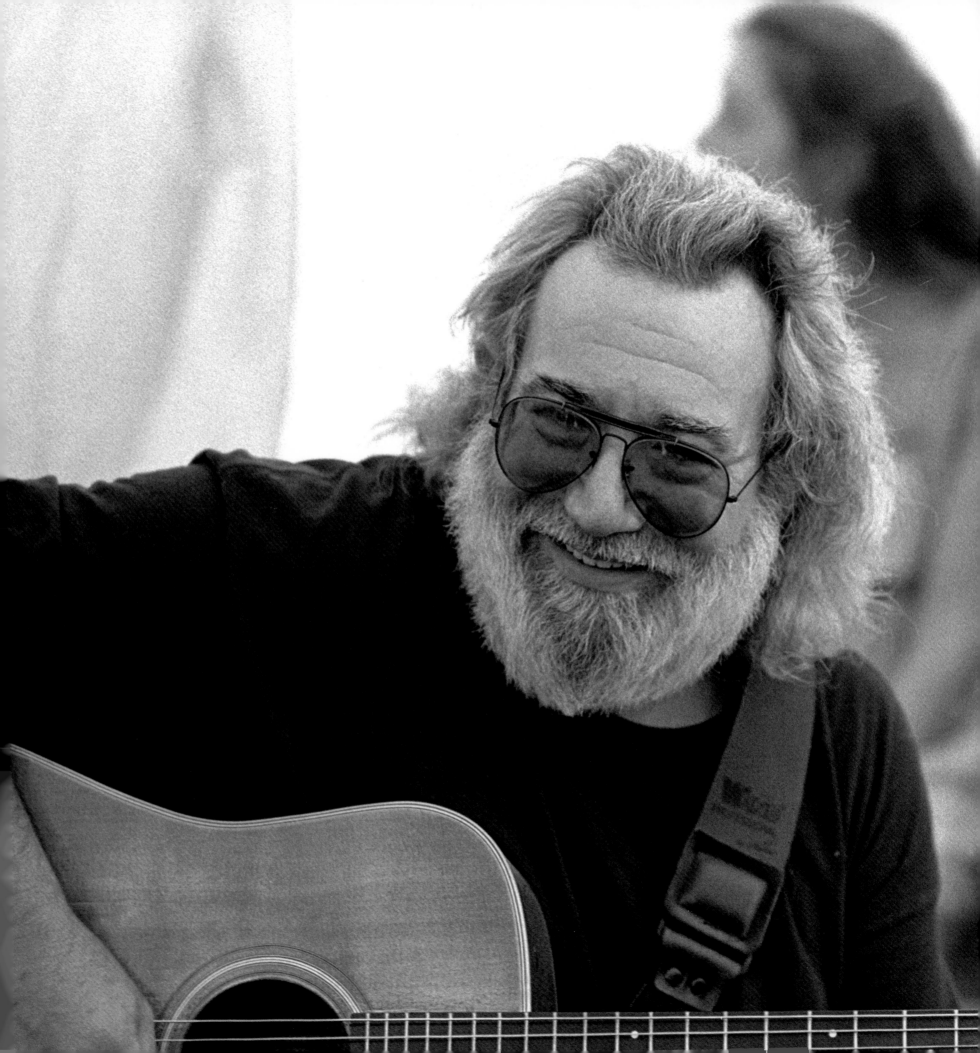

ACRYLICS

chapter three

Shamanic Vibrations

F. Lanier Graham

During the 1960s, when I was a young curator at New York's Museum of Modern Art, I collected rock posters in San Francisco for their collection. My fellow curators were quite surprised to see this remarkable new style of graphic expression. The vibrant energy of these posters was astonishing, a pulsating reflection of the music that was contributing so much to the development of the New Consciousness, which had its capital in San Francisco. Jerry Garcia and his friends were in the middle of all that. And Garcia never stopped being in the middle of all that until he passed away in 1995.

It was only later that I became aware of his visual art. I found it to be very moving, as moving as his music. The first of his paintings I saw were his quiet landscapes, such as "California Mission." I assumed they were based on things he learned as a young student at the California School of Fine Arts (now the San Francisco Art Institute), the most important art academy in Northern California. It was there that he studied with Elmer Bischoff and Wally Hedrick, who were among the leading San Francisco artists of the era.

These works grew out of the tradition of the French Fauves such as Henri Matisse, André Derain, and Georges Braque, for whom colors were units of passionate emotion, as well as German Expressionists such as Franz Marc who was so close to Nature that when he painted blue horses he was looking at Nature from the animal's perspective. That is close to how traditional shamans perceive the world.

Early on, Garcia believed he had to choose between visual art and musical art. He went for music because he liked the human interaction. But he never stopped painting and drawing. Some of his images, such as "Garcia/Grisman," visualize (with humor) the vibrations musicians are feeling when playing music for family, friends, clan or tribe.

Then I saw his more interior explorations, as he looked into and around the melting edges of his awareness. Painters of the Surrealist era, especially Max Ernst and Paul Klee, helped him feel free enough and confident enough to go on these deep voyages into the unconscious mind.

Paintings such as "Facets II" appear to be either memories

of what he found down in those depths, or perhaps a record of the actual process of discovery itself as he used the act of painting as a special form of meditation.

More recently I saw some of his Neoshamanic paintings such as the electrifying "Shaman" of 1990. I was so moved by "Shaman," that I purchased a limited edition print and hung it over my desk. Such paintings testify to what was happening as he became more conscious of what he was discovering in his formerly unconscious mind.

Garcia would not call himself a shaman, even though many of his devoted followers had the characteristics of a tribe. He was too modest for that. However, he knew that the Surrealists and the Abstract Expressionists had a profound respect for shamanic art, and that they had hoped to gain some awareness of the transcendental psychology behind tribal image-making and music-making.

The Neoshamanic spirit was a major factor in the development of late Surrealism and Abstract Expressionism during the 1940s and '50s. Tribal art had been an important influence on earlier modern artists such as Matisse and Picasso in previous decades. Indeed, many historians think of tribal art as the single strongest influence on the development of modern art. However, that influence was primarily formal for a long time. The earlier modernists did not really know what shamanism was, and they did not attempt to find out.

It was not until the middle decades of the twentieth century that contemporary artists began to reach for the shamanic psychology that lies underneath tribal art, and started to think of themselves as something akin to modern shamans. Garcia's hero, Max Ernst, led a number of European and American artists in this direction when he developed an alter ego that was a feathered power animal, and especially after he began collecting Native American art in Arizona during the early 1940s. By the mid '40s, artists such as Jackson Pollock, Barnett Newman, and Isamu Noguchi were thinking of their work as having a semi-shamanic character.

Garcia knew that every true shaman must undergo a special kind of death, a death of the ego, which is commonly visualized as becoming a skeleton of one's former self. Then one is very grateful to be "dead," dead to that little selfish self that was not large enough to love the world as a whole.

There are many levels of shamanic initiation into higher consciousness. Each stage in the clarification of aware-

ness brings one closer to the full potential of our humanity. Increasingly, it is said, one comes to feel at one with the spirituality of all beings, at one with the pulse of Nature, the sacred flowing of Natural Energy.

Garcia felt the wetlands ebb and flow, and urged us to protect them. The brushstrokes of his "Wetlands" paintings are as deeply felt as his concern and as fluid as his music. And he cried out for us to save the rain forests, the lungs of our planet.

Increasingly, as awareness grows, one is able to love all that is alive. Not every seeker reaches the end of the Quest. A shaman cannot become a full-fledged healer unless he or she has healed their own internal problems.

Garcia was not able to do that in time. Like many so the finest spirits of the era, he was trying to overcome his personal demons and generally bad health, both of which contributed strongly to his tragically early death.

But he left a radiant legacy, showing us what the striving should be toward, and melodious notes on which our souls can climb up and fly.

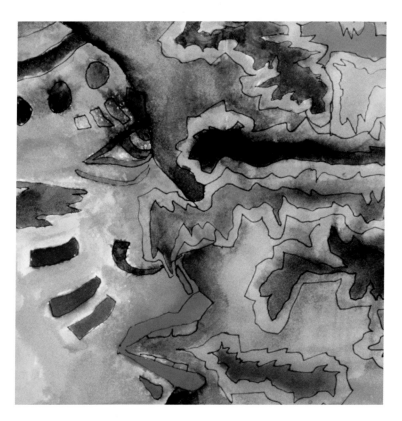

SHAMAN (detail)
Watercolor & ink on paper, 9" x 12", 1990

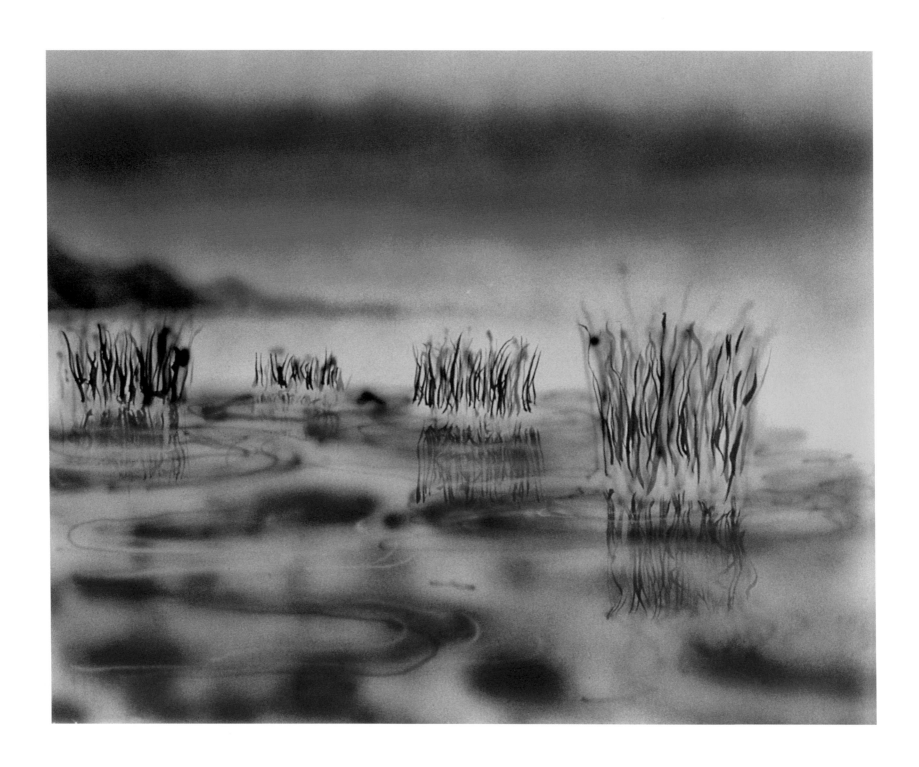

WETLANDS I
Acrylic airbrush on paper, 19″ x 24″, 1986

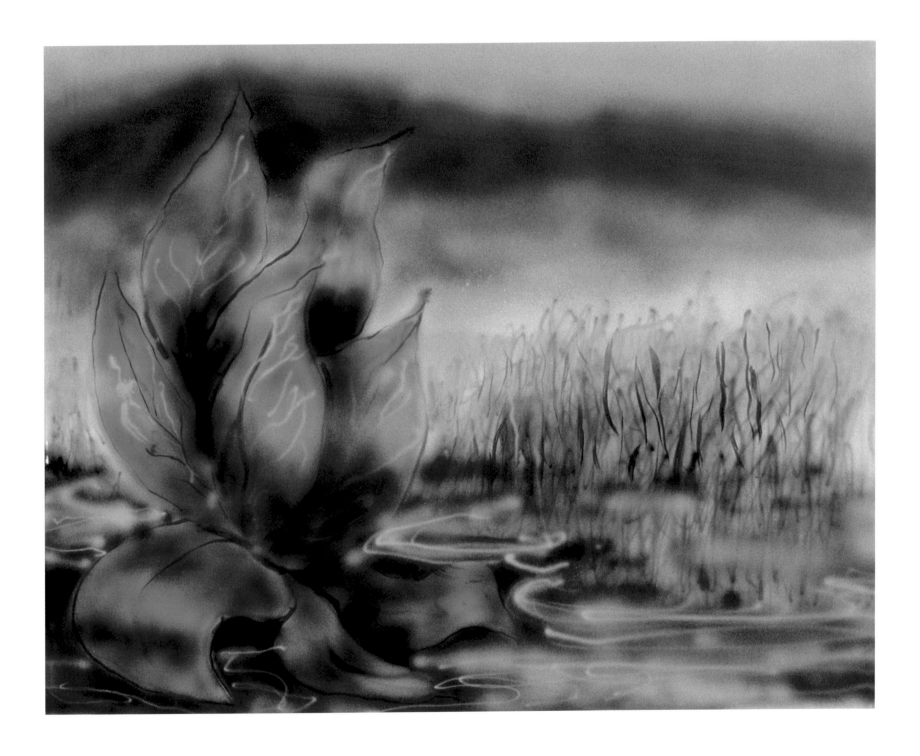

WETLANDS II
Acrylic airbrush on paper, 18″ x 24″, 1986

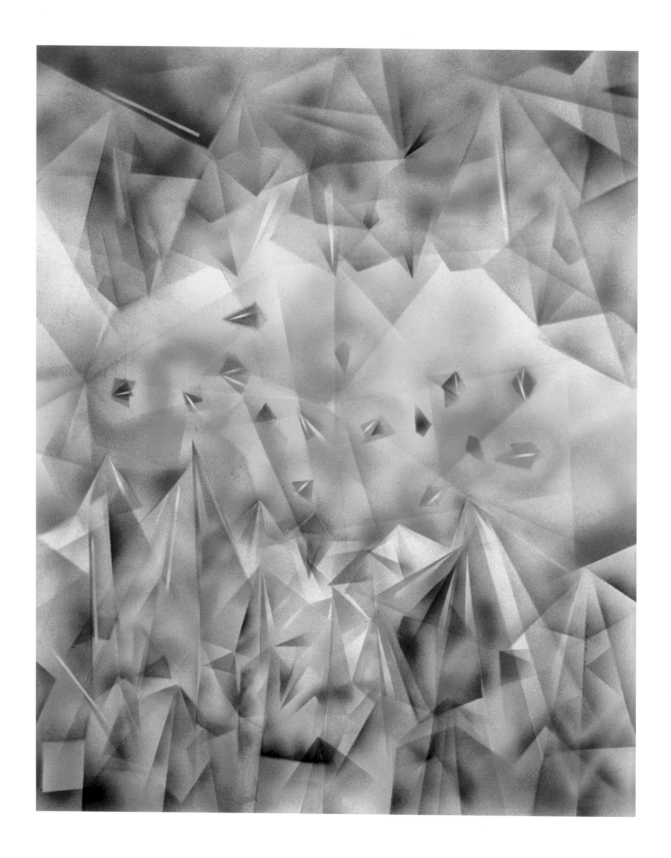

FACETS I
Acrylic airbrush on paper, 24″ x 19¼″, 1986

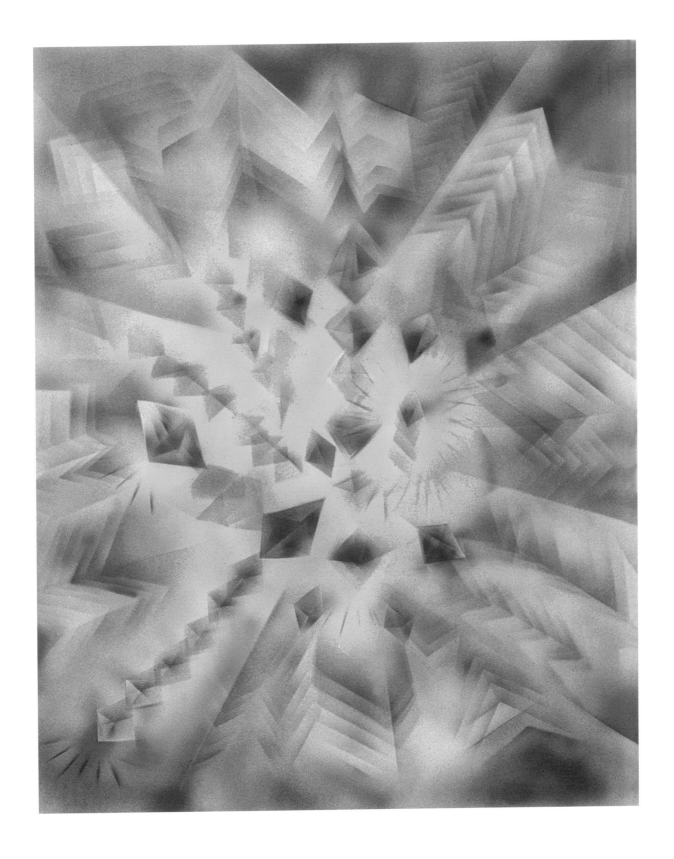

FACETS II
Acrylic airbrush on paper, 24″ x 19¼″, 1986

BLUE ICEBERG
Acrylic airbrush on paper, 24" x 19", 1986

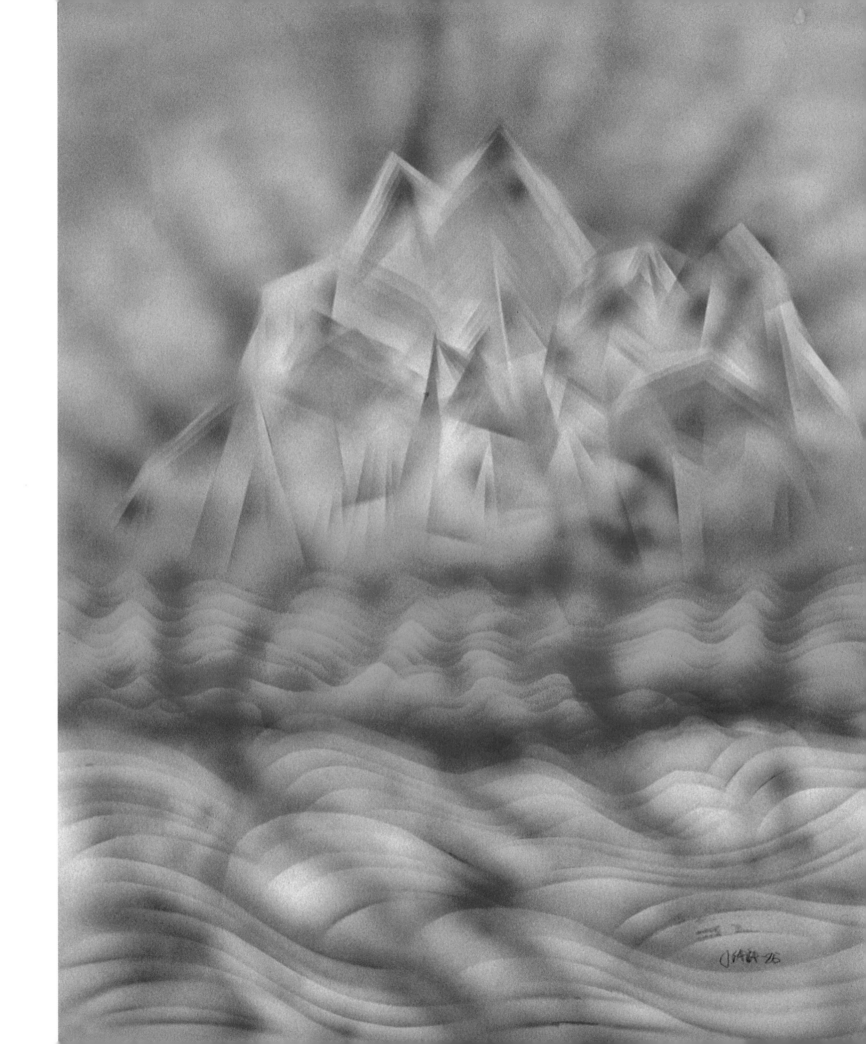

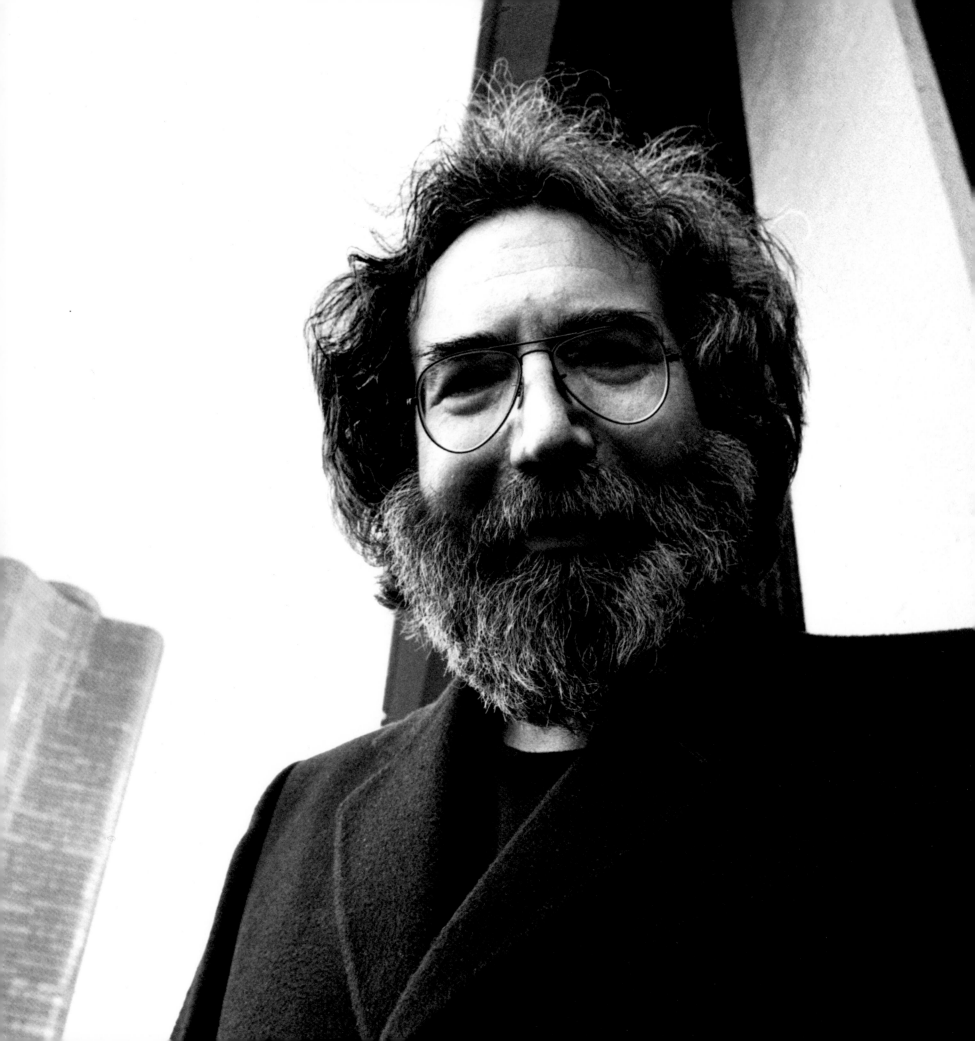

DIGITAL

chapter four

The Mark of a Man

Patti Smith

The mark of a man may be traced through his children, his personal conduct, and within the quality of his work. It can be found in the way he regards his fellow men and the influence he has upon them.

The distinctive handprint of Jerry Garcia can be found everywhere: embedded in our musical heritage, visual art, even in ties and ice cream. But perhaps his greatest legacy is love. The love he felt for his people, embodied in his music. The love the people feel for him, that is set in their being.

That is how I came to know Jerry, as much as through his music: the devotion of his people. It is a beautiful thing, this deep common love with a stranger. But I guess that was the sum of his beauty, that he never seemed a stranger.

Sometime around 1970, a friend took me to see the Grateful Dead at the Fillmore East. I stood in the wings. I had never experienced anything like that. I stood there entranced, and toward the end a very extraordinary thing happened. I was listening to Jerry play and suddenly, as if it was the most natural thing in the world, I strolled onstage toward the microphone. I wasn't singing then; I had never been in front of a microphone, and I have no idea what was on my mind. I was accosted by Hells Angels security types and soundly scolded. I was as bewildered as I was penitent. Why did I do that? That small mystery altered me. I had been drawn out of myself by Jerry's clarion call, a mystified rat caught in the gravitational pull of the benevolent Pied Piper.

That was my first encounter with Jerry Garcia, just another kid whose head had been turned by the Dead. He generated love; he was the sun personified. The people revolved around him and he, in turn, radiated light and sustenance.

Jerry would go off on long excursions into unfolding universes. Those that swam in the liquid currents of the Dead knew that they would not drown, but were safe with Jerry. Underwater with Jerry. In the cosmos with Jerry. On the unadorned road with Jerry.

We close our eyes and there he is: Jerry listening, motionless as he absorbs accents and harmonies, transposing all into his personal vocabulary. Calligraphic vines wrapping the spine of a song. His clusters of notes were the fruit of those vines.

Dipping into the well of traditional music, his voice a mellifluous creek, he gave the Dead an air of approaching rock from without. Songs like "Johnny B Goode," "Dancing in the Streets," and "Not Fade Away" seemed transmitted through the front porch and parlor, the oral tradition of an AM radio, a shared sense of hoedown—a truly American music that comforted and ignited.

His voice was reedy, as if cut with bullrushes. Touring Egypt, Jerry rode atop a camel. He saw the Sphinx and stood in the apex of the Pyramids. The music he played beamed into a sky strewn with star tissue, the nerve endings of the constellations, the Milky Way's swath cutting across the heavens like a brushstroke, the silk of his ties.

Jerry studied painting and he engaged in the processes of self-searching and pure articulation by shifting his creative power from music to the visual mediums. His expressionistic paintings are reminiscent of the watercolors of Hermann Hesse: they share the charm, the Fauvist palette and perspective of Hesse's landscapes painted in the 1920s in Ticino on the Swiss-Italian border.

Today, many proudly sport aspects of his paintings around their necks: funny, as he was never really a suit-and-tie sort of guy. One can barely imagine him without a dark-colored t-shirt cloaking him loosely, damp under the lights, letting his fingers hear the song of the Dead. Picking a musical pathway, his guitar pick his brush, the notes alive as paint while it lies in liquid suspension, waiting for its moment to spread over the canvas of the air.

I finally met him one day on a field in western Massachusetts during the last spring of the Seventies. We were opening the Dead. Jerry found me wandering the grounds looking for a PortaPotty. He brought me to a group of his security guys much resembling the ones who had dragged me off the stage less then a decade before. He provided me with my own trailer and plenty of food and water. This act of kindness impressed me. He met all of my people with genuine warmth and enthusiasm: that was the mark he left with us. It's the way I have seen him since: a true gentleman.

What does he leave us as he leaves us? Is there parable to his life beyond? Mourning his great friend and collaborator, Robert Hunter wrote in his elegy, "a lyric is an orphan thing." The great caravan may indeed feel orphaned without him, yet he is here, within the music offered from his expansive, tired heart.

It is said Jerry died smiling in his sleep. Where did he go? Far beyond the land of Dead encampments, of fellow-travelers joining a wandering carnival skirting the afterlife. Perhaps deep within his sleeping cells he reentered the atmosphere of his boyhood. Crouching in knee pants, scraping the sidewalks with colored chalks. Lifting his ear to the sound of birds chirping his future note by note. Far from the cravings of mind and body into the pure realm of the living smile.

"With the computer stuff, I tend to put in a certain amount of time because it's a learning process, and the more I work, the greater my understanding, and the more it makes things happen. I use [Fractal Design] Painter program a lot, but I also have two or three others I use: [Fractal Design] Sketcher and [Electronic Arts] Studio 32. Each has a few effects the others don't, so I import and can mix and match, turn documents into Painter documents and save files into other programs. It took me a while to figure out all this stuff. Part of it is just learning the computer and what it does. At the time it was very friendly; [Apple] MultiFinder really helped me save time. I also have a lot of extras, like adding architecture to my setup. I have a lot of extra memory, a million-color graphics card, and so forth and so on. It allows me to play around pretty freely."

–Jerry Garcia

FRANK I
Digital media, 1992

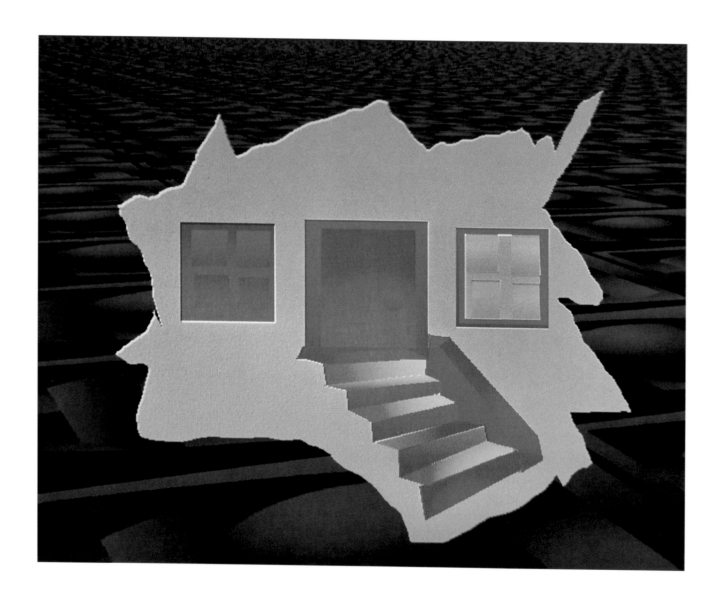

UNTITLED
Digital media, 1992

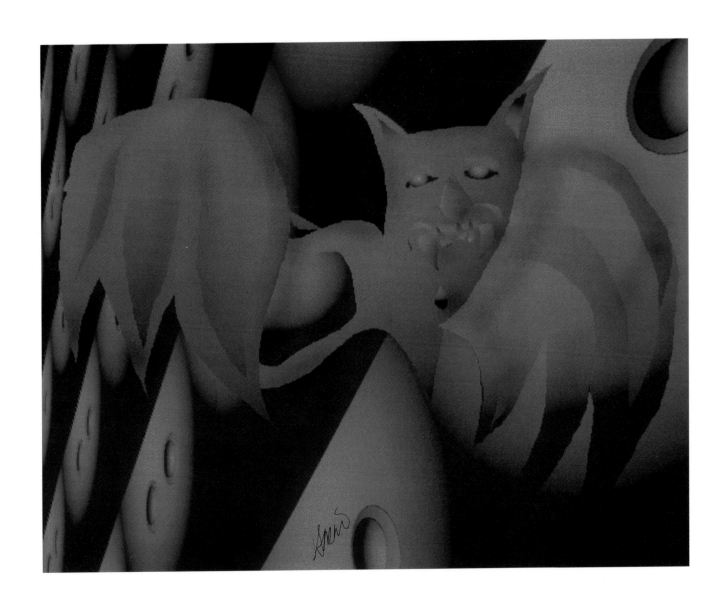

DEMON
Digital media, 1992

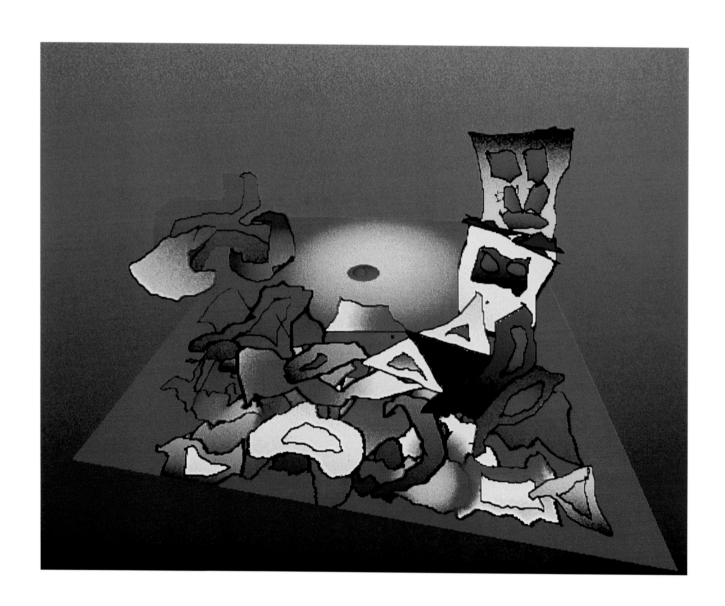

DWEEBISH
Digital media, 1992

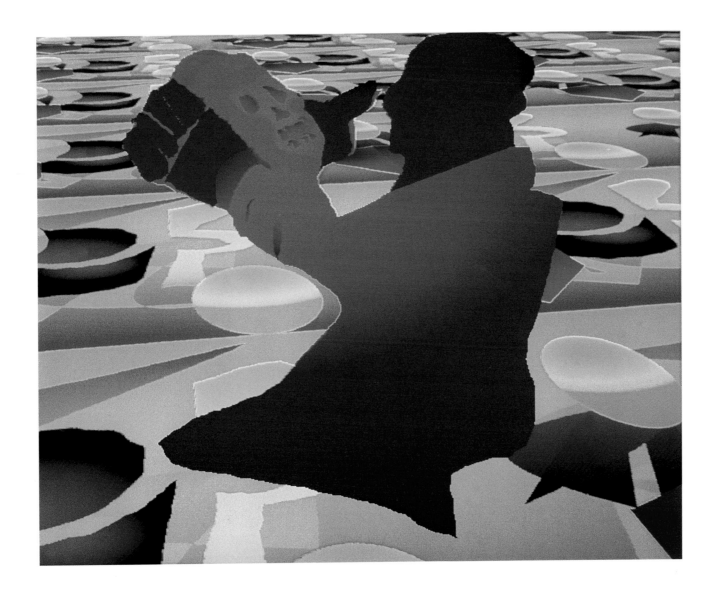

CLOWN HAMLET
Digital media, 1992

BAGLADY
Digital media, 1992

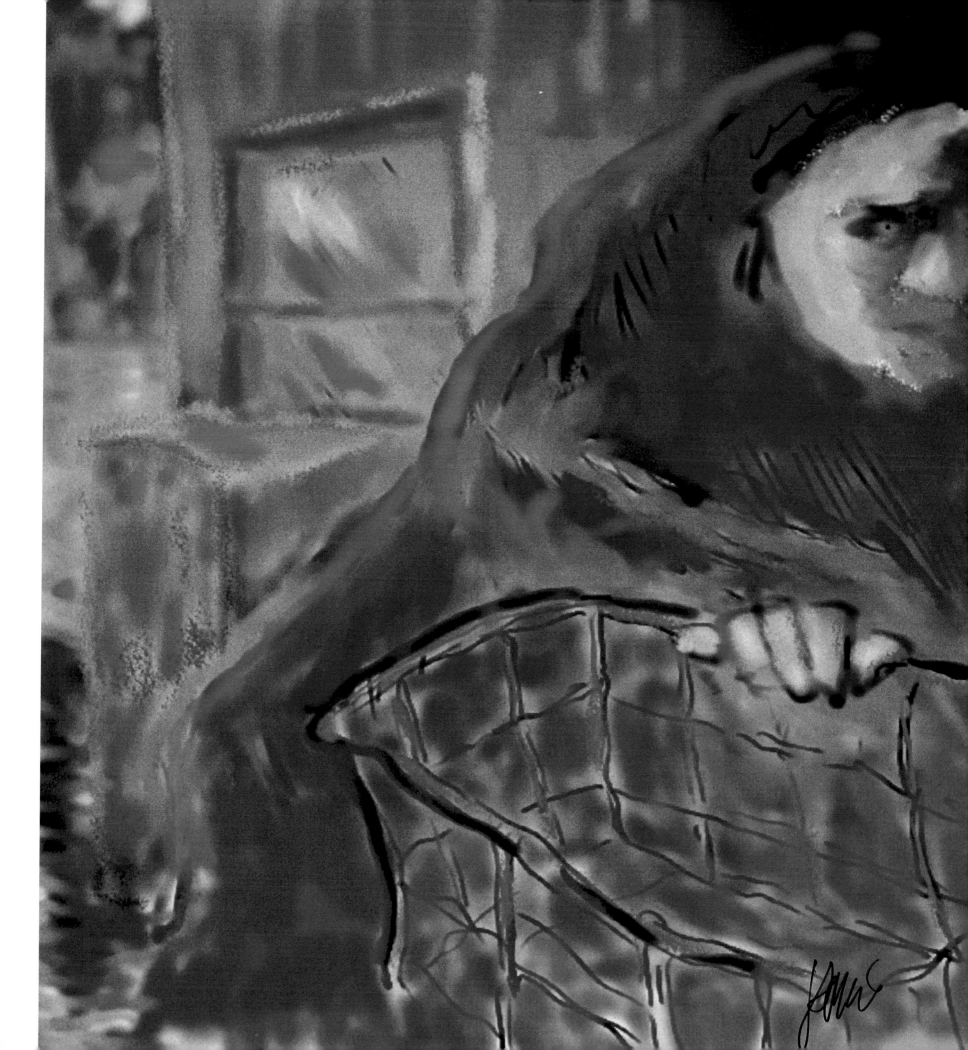

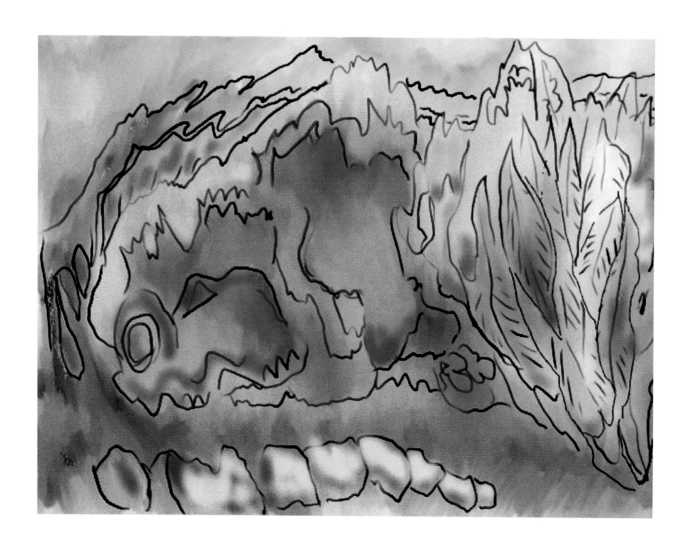

AIRSPACE
Digital media, 1992

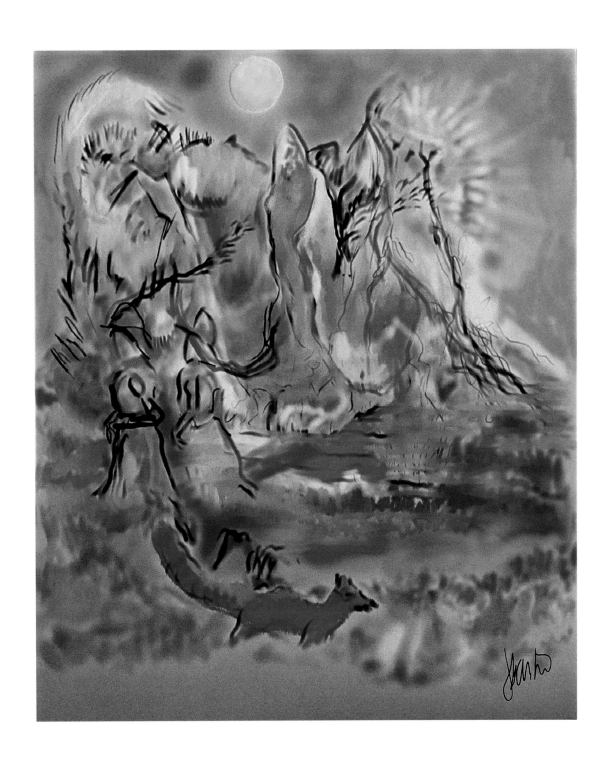

JUNGLESCAPE
Digital media, 1992

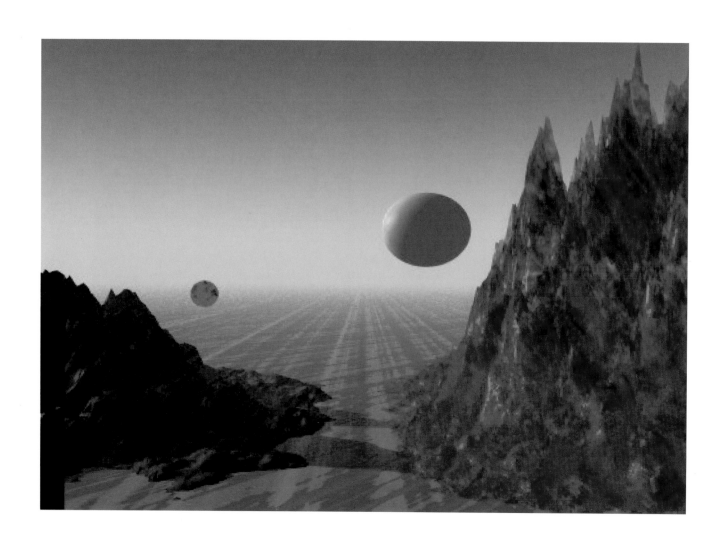

JIOM
Digital media, 1995

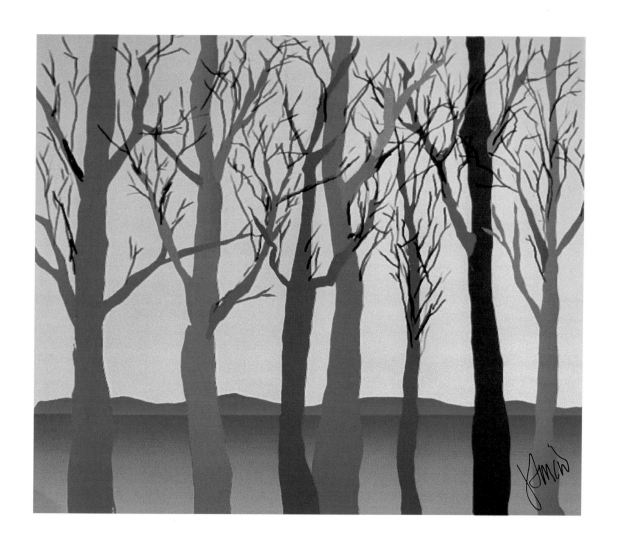

TREES
Digital media, 1992

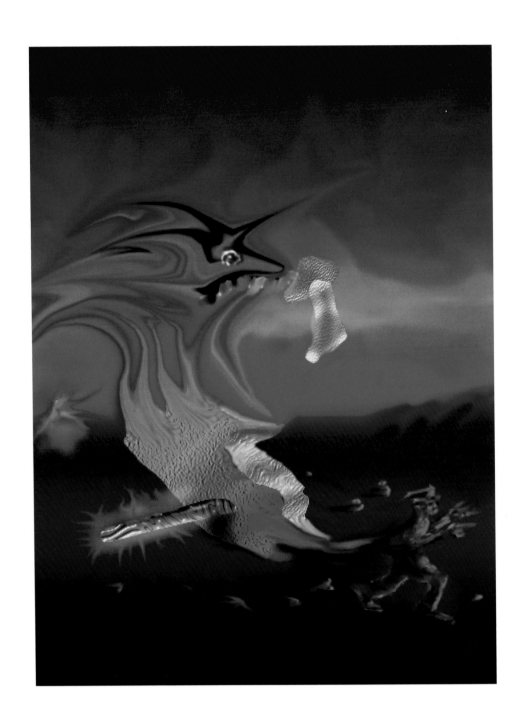

THE GENERAL GOES FOR A WALK
Digital media, 1995

OOP
Digital media, 1995

BOONKIE UNO
Digital media, 1994

BOONKIE TREE
Digital media, 1994

BOY I
Digital media, 1992

BOY II
Digital media, 1994

SOMA
Digital media, 1992

EXPLOSION
Digital media, 1992

UNTITLED
Digital media, 1992

SNAKE GARDEN
Digital media, 1992

Art and Commerce

What inspired you to design a line of ties? "I don't really have any control over them, they're just extracted from my artwork. I don't design ties, for God's sake!"

That Jerry didn't design "J. Garcia" neckties didn't at all keep them from selling.

The story goes that sometime in early 1992, a Seventh Avenue merchant attended an exhibit of Jerry's paintings in Miami and was inspired with the idea of producing ties derived from their vivid colors and designs. Somehow a deal was struck, and later that year, "J. Garcia Art-In-Neckwear" was launched at Bloomingdale's in New York City. All four thousand ties on hand sold out within two days, and the rest is history. Fifteen years later, the program continues to thrive and its sales record remains as one of the most remarkable achievements in the history of the men's apparel business.

Before the ties, was the ice cream. In 1987, Ben & Jerry's All Natural of Vermont received an anonymous request from Oregon for a flavor honoring Jerry, to be named "Cherry Garcia." Within weeks of its introduction, Cherry Garcia became Ben & Jerry's number one seller and has remained so ever since. It was clear from day one that

having Jerry in their lives was tremendously important to a great number of Americans.

While Jerry himself might have been bewildered with the phenomenal power of his association, there was at least one possible explanation. Years earlier, and most likely to the dismay of the Grateful Dead's record company, Jerry expressed his relaxed attitude regarding fans who taped the band's live concerts. "When we're finished with the music, they can have it." This open, generous license to his most avid followers was fundamental to creating one of the music business' most valuable recorded archives and perhaps the most dramatic example of customer loyalty in American pop culture.

Whether intentional or not, Jerry placed himself at the center of a dynamic entertainment and lifestyle brand that effectively extended far beyond the world of tie-dye and VW Microbuses. Today, the "J. Garcia" name and Jerry's art are found on a variety of products ranging from area rugs to fine wines, children's clothes, and, yes, Birkenstock sandals.

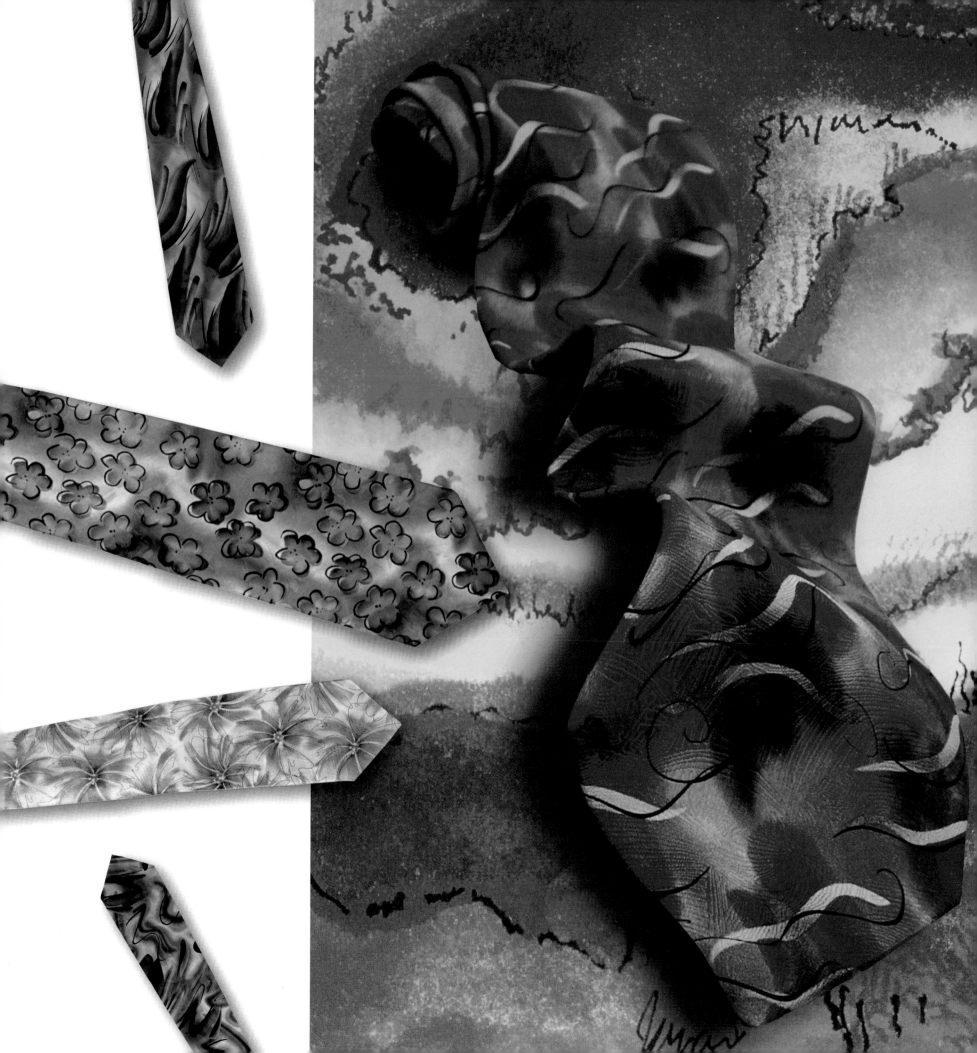

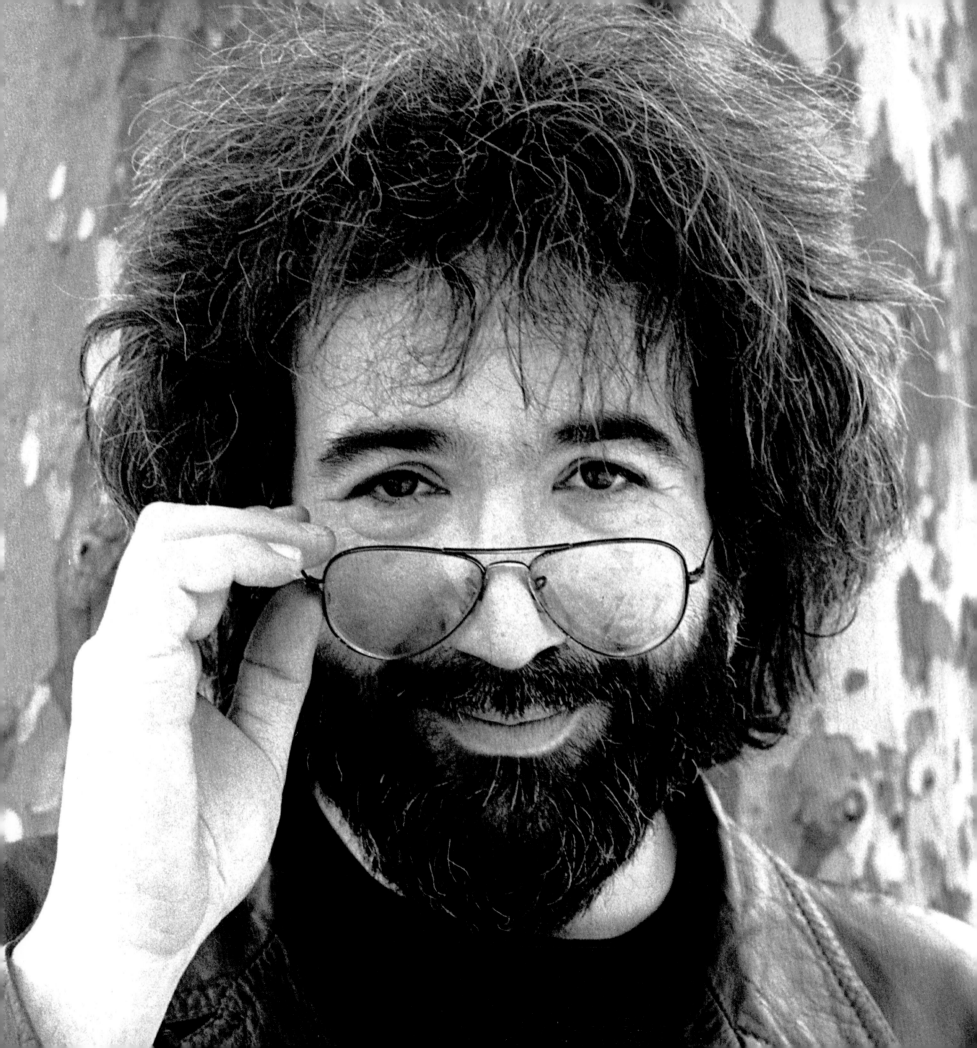

*"In the Land of Night, the Chariot of the
Sun is drawn by the grateful dead."*
– The Egyptian Book of the Dead

Dispatch from the
Land of Night

Herbert Gold

During the post-beat, pre–Summer of Love stirrings in the Haight-Ashbury district
of San Francisco, I interviewed a twinkly, still skinny acquaintance named Jerry
Garcia about the odd new custom of giving Dadaist names to musical groups.

"Moby Grape, Sopwith Camel, Jefferson Airplane, Quick-silver Messenger Service, the Cleveland Wrecking Company, what's that all about? Wouldn't the Jerry Garcia Quintet make more sense? So your band, the Grateful Dead...is that spelled G-r-e-a-t or G-r-a-t-e? And why?"

Out of the kindness of his bullshitting heart, Jerry explained that the name came from an Egyptian prayer or anthem or hymn—me vigorously putting stylus to clay tablet—as he recited the line: "We who are the grateful dead salute thee."

I duly passed along the misinformation to the readers of *The New York Times Book Review* in a "Letter from San Francisco." With all the praise heaped on Jerry over the years, folks have generally ignored his early career as a composer of ancient Egyptian tunes. An early incarnation of the band as the Warlocks came to be born again as the Grateful Dead because, unfortunately, the Egyptian prayer containing the lines, "We who are the Warlocks have gone electric for thee," turned out to be a hoax composed by an Egyptian pop composer with offices in the Sphinx. *The Book of the Dead*, previously not part of Jerry's daily reading, had been recommended by Ken Kesey. The Sixties wrestled hard with extreme authenticity.

Although I was present during the Summer of Love, I think

I can remember it. "Group marriage works!" a cute teeny-tiny Deadhead assured me, "and I've never been happier. We all love each other and raise our children together." How long has this been going on? I asked. "Since Thursday."

I joined the Psychedelic Rangers on hit-and-run middle-of-the-night expeditions to paint fire hydrants groovier DayGlo colors, thus bringing Truth and Beauty to the mean streets of Pacific Heights in San Francisco—also ending the Viet Nam war, demonstrating the creative power of LSD, and lifting a middle finger to the bureaucrats of the Department of Public Works. I shared a feast featuring a buffalo that had been rustled from the pen in Golden Gate Park because all power belonged to the people and so did all meat. (This was before the advent of rampaging vegetarianism, although tofu had been sighted just beyond the horizon by a few visionaries.) In January 1967, the first Human Be-In was declared in Golden Gate Park. Over a delirious scene where everyone in San Francisco was nineteen years old, except for those who were seventeen and those for whom age was another bureaucratic hassle, Tim Leary spread his fragrant demagoguery, Allan Ginsberg his kindly Buddhist summons to revolution, and Jerry Garcia sweetly sang, strummed, smiled his heart-breaking smile, and presided.

A Laguna Beach coffeehouse I frequented required applicants for jobs to read a work description and subscribe to the following Code of Behavior: "Must be willing to miss some Grateful Dead concerts." Management understood this might be a deal-breaker for many, but even if Jerry Garcia was within range, the espresso had to be brewed, the milk steamed, and the oatmeal-raisin cookies guarded. Like our buffalo chowdown, all cookies also belonged to the people.

On my wall hangs a black-and-white snapshot of Jerry lounging on the steps of a house in the Haight, the number 710 behind him, in full early Summer of Love drag: hat and boots, leather and patchwork like a Gold Rush miner or cattle rustler, his legs winsomely crossed. His expression is quizzical—What the hell is ahead for us all?—and he is caressing a black dog, which ignores the camera and looks off toward its own future. Maybe it knew something we didn't.

I was not an intimate of Jerry's, but we met fairly frequently over the years, at Grateful Dead parties, at showings of his art work, once at the vernissage of an exhibit of his psychedelic neckties. If there was a sample licking for the advent of "Cherry Garcia," the ice cream, I missed it, although like everyone, I knew he intended me to enjoy it. He was always cordial, gracious, and avuncular. He floated through his entourage like a dirigible, paying little attention to surrounding clouds, a secret smile on his face. I could never tell if it was the smile of a stoner or the smile of a visionary who saw himself more clearly than anyone. The ambient fellow musicians, potheads, P.R. guys, Deadhead fanatics, groupies, and hair-flipping would-be Plaster Casters seemed to read the smile as a permission to continue whatever it was they were doing.

This public ease was hard to match with tales of his struggling with the binges that seemed to accompany Grateful Dead tours. And not just the tours. Word was that he found it hard to resist offers from fans. Life on the road is difficult; life in general is difficult, despite the gifts of music, love, and fame. Heart, stomach, indulgences, diabetes, and obesity worried his friends, A diabetic coma in 1986 nearly ended the not long enough strange trip.

The cultish, nonstop-partying, we-are-special Deadhead confusion sometimes distracted from the essential contribution. The Grateful Dead, and especially Jerry Garcia, succeeded in making music that captured something magical in the American spirit—improvisational, boundary-less, at times nostalgic for a mythic past, and at times ecstatic about

a promised future. Beyond the madness and self-destructiveness of his personal trajectory, his gift to a generation will be what endures. And as that first generation enters middle age and late middle age, they are surprised that the gift keeps on giving. Jerry's art, a private refuge now made public with the publication of this book, is just the latest installment of that gift.

An editor of the *London Sunday Telegraph* telephoned excitedly with the news that Jerry Garcia had died and asked if I could write a farewell eulogy. While I paused to think, he added a warning note: "We want you to be really *gonzo*. Make it gonzo, please. We English aren't so good at that, but you folks in San Francisco… Gonzo it up, Herb, and cheerio."

His charisma, the fierceness of his aura, which brought tidal waves of denial flooding over some in his entourage, is signaled by the conviction that he could not possibly be dead. After his disappearance, an associate of the band wrote that she had contacted him in heaven, where he informed her that he was very happy and successful. Jerry Lives! (But Elsewhere, in real estate even nicer than Mill Valley.)

One of Jerry's friends went whole hog. Jerry was not in heaven, not even dead, but hiding out in Mendocino from the crowds while he worked on his fine art and prepared an album of acoustic guitar music. Our discussion took a drastic turn. I asserted that, like Elvis and Bruce Lee, he lives in memory and myth, but in fact has shuffled off this vale of tears and Muzak. Elvis, Bruce, and Jerry have escaped. They have, in fact, died.

"No!" cried the loyalist. As a person committed to the empirical method, accepting of the insights of Aristotle, Spinoza, Hume, and *The New York Times*, I made the mistake of suggesting: "Well, their wives think they're dead." I received a contemptuous glare in return: "What do women know?"

This New Age contemplator believed in avoiding bad vibes and hassle. He sought compromise. He regretted his sexism. He took a moment for inner ommmm-ing and then gazed compassionately into my eyes. He granted that Bruce Lee is dead; Elvis maybe; just not Jerry.

For days after Jerry's death, altars were set up outside the Ben and Jerry's shop on Haight. Vigils ensued, boomboxes mobilized. Jerry's sweet strong voice echoed down the cavern of the street. A young Deadhead assured the crowd,

"We're still a family, aren't we? We're a family, right? Phish can't take us away from Jerry, can it? We're still here, aren't we? They say Jerry's gone, but we know different. We're still here!"

The magic guitar and voice filled the air. Amid the flowers, bottles, album covers, photos, letters to Jerry, messages of eternal loyalty—accumulating on the sidewalk, taped to the stanchions, spilling into the street—the distraught boy asked me, "We're still all family, aren't we? Aren't we still a family?" Jerry was the papa who had deserted them, but could be kept alive in their hearts if the Deadheads stayed together, tending the faith.

Jerry Garcia orbited the earth in his own space helmet, like other charismatic figures, attracting asteroids and moons and space debris, which sought intimacy in his gravitational pull. They sought his warmth. They even treasured his distance. Sweetly smiling, he kept on whirling alone in his gifts and wounds, his trajectory uninterrupted until the long strange trip ended on August 8, 1995.

But in fact, the Summer of Love triumvirate, Allan Ginsberg, Timothy Leary, and Jerry Garcia, have not really disappeared. May the legend continue, as the ancient Egyptian prayer puts it: "We who are the grateful living salute thee."

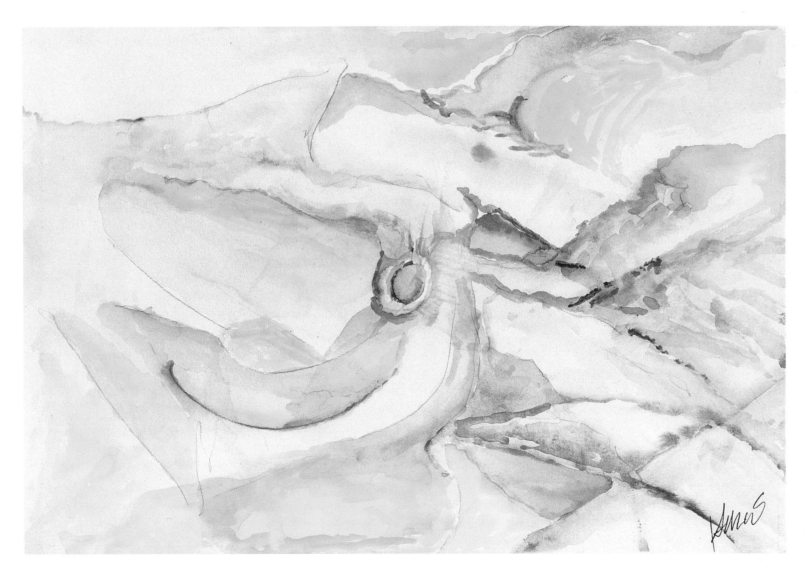

ABSTRACT
Watercolor on paper, 5˝ x 8˝, 1992

"It's still weird for me to walk into a room filled with my work. These little fragments of my subconscious. When I am finished with them, my part is done."

Selected Exhibitions

How an artist's career unfolds is always unknown. Unpredictability and chance are part and parcel of the creative process. Late in Jerry Garcia's musical career, in 1986, he came close to dying in a diabetic coma.

After he regained consciousness, art became a fundamental part of his therapy. At first, his neural pathways were so shattered he could not even play music. In the two months it took to normalize his brain shock, he was encouraged to draw and paint: for the sake of tranquility, to pass the time and to help his traumatized neurosystem recover. Jerry was given an airbrush and he spent a lot of his recovery time at home just drawing and painting. His friend and colleague Merl Saunders also helped him recuperate by re-teaching him to play the guitar.

Within a year Jerry had amassed a large body of work. His housekeeper at the time saw this as an opportunity. With no art background of her own, she started showing his work in small coffee shops around Marin County. She was later contacted by a gallery belonging to Roberta Weir (no relation to the Dead's Bob Weir), in Berkeley, California, and there, in 1991, Jerry had his first show as an exhibiting artist with John Kahan, selling more than fifty pieces. Garcia was very shy about showing his art and did not like to trade on his Grateful Dead image. However, he did enjoy meeting people and was happy that his artwork was being taken in earnest. The concerts were the forum for Jerry's public persona. His artwork allowed for a more private, solo expression.

Jerry continued to produce hundreds of pen-and-ink drawings, watercolors and gouaches, as well as works in mediums new to him. These included acrylic airbrush, etchings and works in the then burgeoning field of computer graphics. Shortly after his Berkeley show, an exhibition was scheduled with Chris Murray, director of the Govinda Gallery in Washington, D.C., an innovative, contemporary gallery know for producing many "first exhibits" for important painters and photographers. Established in 1975, Govinda had represented the talents of Andy Warhol and Annie Leibovitz in the early years. Jerry went on to exhibit in galleries in New York City, Chicago, Los Angeles, Atlanta, and Tokyo.

Jerry's shows were packed with fans and admirers curious to see yet another part of his life. The show at Ambassador's Gallery in New York City in 1993 caused a near riot. The streets in front of the gallery were choked with stopped traffic in the Soho district; the intensity was said to be unbelievable. Later that year, the Parco Gallery in Tokyo produced a huge show and even took an ad on a billboard in Shibuya, Tokyo. This show produced a catalogue and four special prints for the Japanese audience.

Jerry attended many of these openings but was still not entirely comfortable with revealing images that were, as he put it, "things just in my brain." Yet he unselfishly exhibited them and the world is richer for it.

February, 1991
J. Garcia / John Kahan, Paintings, Drawings & Prints;
Weir Gallery, Berkeley, CA

March, 1991
J. Garcia, Paintings, Drawings & Prints; Govinda Gallery,
Washington D.C.

February, 1992
*Jerry Garcia – Paintings, Drawing & Lithographs,
& Photographs by Herb Greene & Friends*;
Fay Gold Gallery, Atlanta, GA

December, 1992
New Pages from the Sketchbook of J. Garcia;
Weir Gallery, Berkeley, CA

December, 1993
Ambassador Gallery, New York City, NY

June, 1993
Deson Saunders Gallery, Chicago, IL

September, 1993
Renjeau Gallery, Boston, MA

October, 1993
Smile, Parco Gallery, Tokyo, Japan

December, 1993
Smile, Tsutaya Gallery, Kyoto, Japan

June, 1994
Kneeland Gallery, Las Vegas, NV

April, 1994
Ambassador Gallery, New York City, NY

June, 1994
Gene Sinser Gallery, Los Angeles, CA

December, 1994
Walnut Street Gallery, Fort Collins, CO

March, 1995
Fay Gold Gallery, Atlanta, GA

KEN NORDINE
Ink on paper, 6″ x 4″, circa 1993

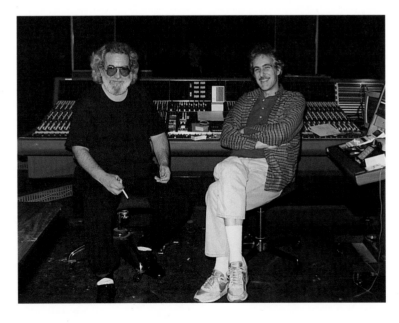

JERRY WITH JOHN KAHN, 1990

Chops and Provenance

Cylinder seals exist from as far back as Sumer, a Babylonian culture that flourished nearly five thousand years ago.

In the Far East today, stylized signature seals, or "chops," are still made of jade or ivory, with headpieces sculpted into the shape of animals, fish, or dragons. Aside from their traditional use on paintings and calligraphy, name seals continue to be used in business matters.

The history of Chinese seal carving can be dated back to the time of the Han Dynasty, coinciding with the invention of paper, circa A.D. 100. Over the next sixteen hundred years, as the medium traveled to Japan and the highly refined arts of printmaking were developed, chop marks came to be put directly on artwork, bearing a symbol denoting the print house that created it. Even the series of collectors who had owned the print had their own chops. Typically, the mark of the printmaker or artist would be on one of the bottom corners, and collectors would mark their seals along the edges of the print; thus the mark of the printmaker would be visible after the piece was framed, but the collectors' would be hidden. Chop marks continue to be a way in which to authenticate and show provenance for artwork.

The Jerry Garcia limited edition prints have a lineage of chop marks on the prints that show their history. Each of the chop marks listed is an embossed seal of the organization in charge of the prints at that period. All prints were originally intended to be sold with Jerry's signature, but there are many stories of how Jerry disliked signing his name in quantity. The prints that were hand signed (HS) were done before or at Jerry's art shows.

Art History and Chops of Jerry Garcia Fine Art Prints

1987–1991 The Art Peddler

Prints were sold hand-signed by Jerry.

1992–1993 DB Artworks

Management changes hands; Jerry puts Vince DiBiase in charge. No chop marks at this time, but DB Artworks added an embossed *DB* in 1995.

1993–1995 The Art Peddler

Reinstated as dealer due to contractual reasons. Under Art Peddler, the *Embossed Fish* is added, in 1995 following Jerry's death, in conjunction with silk-screened "signatures."

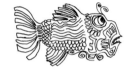

1995–2003 The Estate of Jerry Garcia

After Jerry's death, his art program continues. Deborah Koons Garcia and David Hellman are the co-executors in charge of his estate. She hires April Higashi to archive the artwork. The *EJG Hand Chop* is established in 2001 and added to "Lifetime" and "Estate" prints sold or shown under the control of the Jerry Garcia Estate. Originally, it is placed on the right. In June of 2002, where there was no hand, the *Embossed J. Garcia Signature* is added. The *EJG Hand Chop* is then moved to the left, and *Signature* is on the right. Where there is an *EJG Hand Chop* on the right, the *Embossed J. Garcia Signature* is added to the left side.

March 2003–2005 The Jerry Garcia Estate LLC

The Estate is closed and forms a LLC, including his widow Deborah; Jerry's daughters Heather, Annabelle, Sunshine, Trixie, and Keelin; and Jerry's brother, Tiff. Together they hire Christopher Sabec to oversee his intellectual property. April Higashi is named Art Director and Curator and sets further standards. All remaining "Lifetime" and "Estate" prints in the Jerry Garcia Estate's inventory are editioned with the *JGE Hand Chop* on the left and *Embossed Signature* on the right.

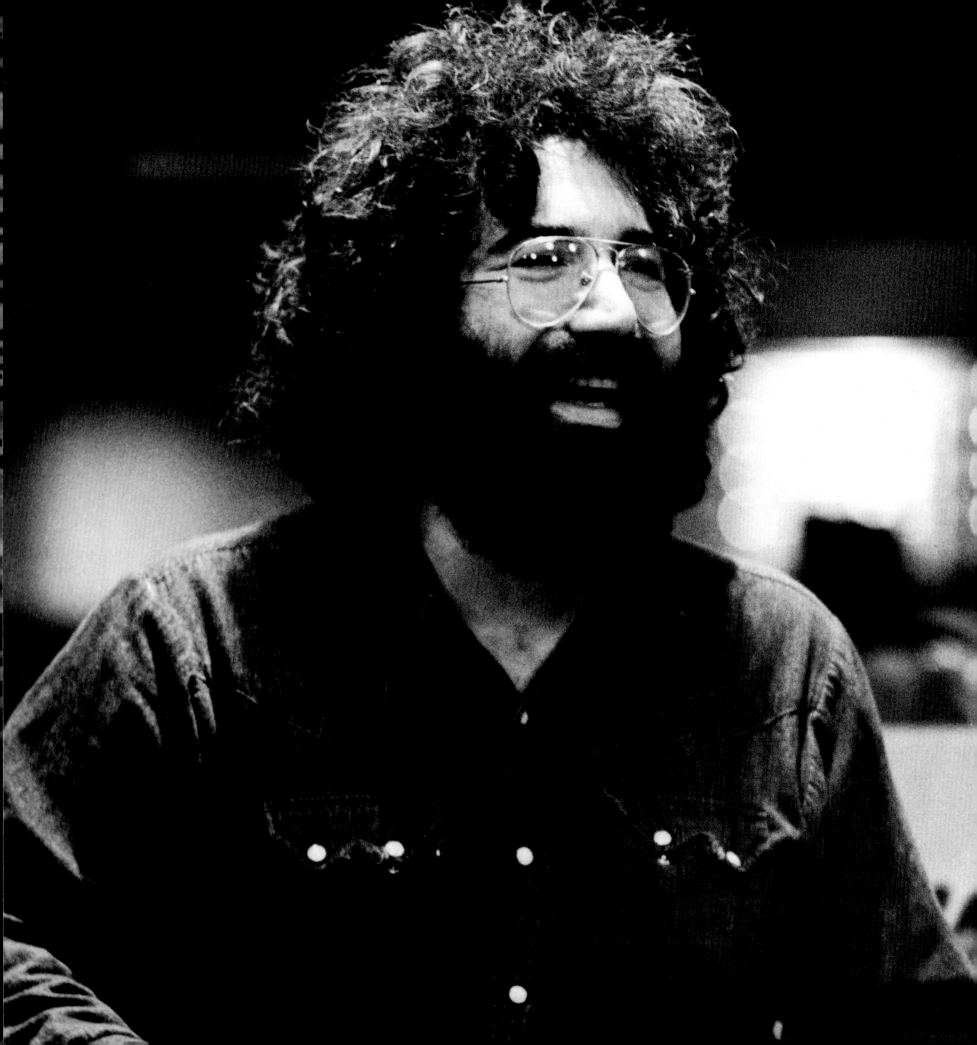

Contributors

 Bob Dylan is without question one of the most original and poetic voices in American popular music. He has won numerous Grammy Awards, a Golden Globe, an Academy Award, Kennedy Center Honors, and was inducted into the Rock & Roll Hall of Fame in 1988. In fall 2004, Mr. Dylan released *Chronicles: Volume One*, the first in a three-book memoir series, to wide acclaim.

 Mickey Hart is best known for his nearly four decades as half of the percussion tandem of the extraordinary band the Grateful Dead. He is also the spearhead of the WORLD series on Rykodisc, which offers music from virtually every corner of the globe, and the founder of the Endangered Music Fund and Rhythm For Life. The self-titled album of his group Planet Drum remained #1 on the *Billboard* World Music Chart for 26 weeks and received a Grammy. Hart composed the production for the opening ceremony of the 1996 Centennial Olympic Games, as well as scores, soundtracks, and themes for movies and television. He has written four books documenting his lifelong fascination with the history and mythology of music: *Drumming at the Edge of Magic*, *Planet Drum*, *Spirit into Sound*, and *Songcatchers: In Search of the World's Music*.

 Deborah Koons Garcia is a filmmaker who has lived in Marin county for over thirty years. Her most recent film is the award-winning documentary *Future of Food*.

 Like his younger brother Jerry, **Clifford "Tiff" Garcia** is primarily an artist and musician. Now retired, his colorful career included stints in the Merchant Marines and the Marine Corps, being a mailman, a baker, and, for fifteen years, the merchandizing fulfillment director for the Grateful Dead.

 Annabelle Garcia-McLean was born in 1970, the daughter of Jerry and Carolyn (Mountain Girl) Adams. She currently lives in the countryside near Eugene, Oregon, where she pursues a career in painting and co-owns an Indie record label with her husband, Scott.

 Carlos Santana is at the pinnacle of a remarkable recording and performing career spanning five decades, having sold more than fifty million recordings, played live to upwards of thirty million fans, and garnered countless awards and honors, including a 1998 induction into the Rock and Roll Hall of Fame and a star on the Hollywood Walk of Fame. Ever since an electrifying performance at the original 1969 Woodstock Festival, the world has been enraptured. Each new release—including, to date, ten platinum and nine gold albums—emerges as a reflection of Carlos' personal growth and spiritual and artistic evolution. His album *Supernatural*, the 36th of his career, won nine Grammys in February 2000, including Album of the Year.

 Donna Jean Godchaux-MacKay was born in Sheffield, Alabama, and worked as a back-up singer in Muscle Shoals, appearing on songs with such artists as Elvis Presley, Boz Scaggs, and Cher. She married Keith Godchaux in 1970. They joined the Grateful Dead as keyboardist and vocalist in 1971, remaining members until March 1979, recording on some of the Dead's classic albums, and performing with various aggregations of the band members. Keith died in a car accident in Marin County, California, in 1980. Donna married David MacKay, a bass player, in 1981, and continues to perform today, with the Heart of Gold Band.

 Tom Turner is the Senior Editor at Earthjustice, a nonprofit, public-interest, environmental law firm that represents hundreds of organizations, without charge, from eight offices around the United States.

 In October, 1966, **Grace Slick**, a former model, became the new female singer for Jefferson Airplane, and soon after recorded lead vocals on *Surrealistic Pillow*, their second album, including her composition "White Rabbit," one of the touchstones of the rock era. In 1974, she and Paul Kantner morphed the Airplane into the Jefferson Starship and continued singing and writing hit songs. Since her retirement from the stage, she has become a prolific painter; her works include portraits of old friends such as Jimi Hendrix, Janis Joplin, and Jerry Garcia. As one of the first female rock stars, Grace helped redefine the role of women in modern music.

 Victor Moscoso's posters for dance-concerts at the Avalon Ballroom and the Matrix first brought his work international attention in the "Summer of Love" (1967), and his legend mushroomed as one of the original (and continuing) *Zap Comix* artists. He continues to produce comix, posters, album covers (for Jerry Garcia, Bob Weir, Herbie Hancock, etc.) and Clio-winning animated commercials. Moscoso is currently working on a book of his artwork, *Sex, Rock and Optical Illusions*, for Fantagraphics Books.

 James R. Donaldson—world traveler, sailor, journalist, and poet—is also an acclaimed writer, producer, and director of documentary films that have won numerous prestigious national and international awards and accolades, including Best Documentary at the Houston International Film Festival and a Cine Golden Eagle for Best Film. His works include *Ghosts of Cape Horn* (1980); *Whales Weep Not* (1982); *America's Cup 1987* (1988); *Timeless Voices: The Gyuto Monks* (1989), again with music by Mickey Hart; and many others.

 Andy Leonard, trained as a fine arts photographer, was vice president (and default art director) of Grateful Dead Records and Round Records from 1972 to 1976. A stint as Bob Weir's manager and tour manager was followed by combat duty in New York City in the 1980s as general manager of the famous rock nightclub The Ritz. He currently owns and operates the internationally acclaimed beach-shack seafood joint The Reel Inn in Malibu.

 Paul Pena traces his ancestry to Cape Verde, a string of desert islands off the west coast of Africa. He learned the traditions of American blues straight from the masters: T-Bone Walker, John Lee Hooker, B.B. King, and Mississippi Fred McDowell, among others. Today, we know him as the songwriter and blues artist who became the first Westerner to win a world title in the International Throat-Singing Contest held bi-annually in the Central Asian Republic of Tuva. The story of his epic journey to Kyzyl, the Republic's capital, was captured in the Academy Award–nominated documentary *Genghis Blues*.

Ohio-born **Baron Wolman** sold his first photo essay, a story about life behind the then-new Berlin Wall, during his military tour of duty. From Germany he moved to California to continue his career as a photojournalist. In 1967, a fortuitous meeting with Jann Wenner, the founder of *Rolling Stone*, resulted in his becoming their first chief photographer. For three years his photographs became the magazine's graphic centerpiece, and they are still widely exhibited and published. In the mid-seventies Wolman learned to fly and began a successful career in aerial photography. During the same period, he founded Squarebooks, a book publishing company. Wolman currently lives in Santa Fe.

Formerly the West Coast Editor for the *Village Voice*, **Jon Carroll** also served as an editor for *Rolling Stone* during its formative years. A National Magazine Award winner, Carroll writes a popular daily column for the *San Francisco Chronicle*.

Beginning with the directing and videotaping of a live Halloween show at Radio City Music Hall in 1980, **Len Dell'Amico** became the Dead's "video and film guy," which lasted through 1991. His projects also included a Showtime special called *Live Dead!* and the video *So Far*, which was the best-selling music video of 1988 and won the American Film Institute's award for best long-form video. He has directed and/or produced innumerable concert films and music videos with such artists as Sarah Vaughan, Herbie Hancock, the Allman Brothers Band, Linda Ronstadt, Blues Traveler, Carlos Santana, Ray Charles, Reuben Blades, and Bonnie Raitt.

F. Lanier Graham is presently the Director of the University Art Gallery, California State University, Hayward. He was formerly chief curator of the Fine Arts Museums of San Francisco, and is the author of *The Rainbow Book*; *Goddesses in Art*; *Duchamp & Androgyny: Art, Gender, and Metaphysics*, and many others.

Punk rock's poet laureate, **Patti Smith** ranks among the most influential, idiosyncratic and iconic rock'n'rollers of all time. Her music, an electrifying fusion of rock and poetry, has taken her from structured rock songs to avant-garde experimentalism. Although unashamedly intellectual, she is known as a powerful concert presence. Her non-reliance on her gender obliterated the expectations of what was possible for women in rock. Impossible to categorize, moving easily between the literary and musical worlds, always unpredictable and impassioned, she is an unique performer who has always remained true to her singular muse. Smith is an acclaimed and widely published poet and playwright as well. She has been in and out of the performing and recording business for three decades, producing nine albums—starting with *Horses*, the first art-punk album (1975)—and earning two Grammy nominations along the way. Her latest album, *Trampin'*, appeared in spring 2004

As CEO for Grateful Dead Productions, **Peter McQuaid** oversaw Grateful Dead Records and all non-music merchandise development, licensing and distribution programs. GDP achieved notable success throughout the 1990s and its unusually independent business approach became a model that is followed by a number of today's popular music artists. Peter currently consults with a variety of artists, managers and business advisors regarding emerging opportunities in music and merchandise distribution.

Author of thirty books, including *Bohemia*, *Fathers*, and *Salt*, and numerous short stories, distinguished author **Herbert Gold** was one of the first mainstream cultural observers to write about Jerry Garcia and the Grateful Dead phenomena. His work has appeared in *The Atlantic*, *Harper's*, *Playboy* (which he prefers to call *The Playboy Review of Culture and Philosophy*) and other noted periodicals. His latest work is the revised edition of *Haiti: Best Nightmare on Earth* (Transaction, 2002).

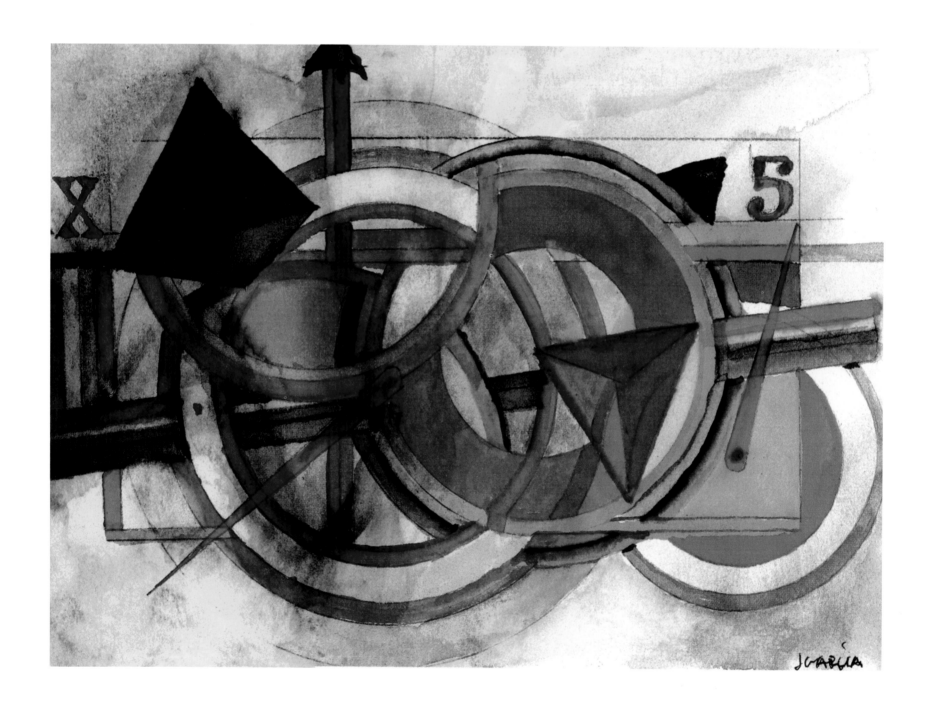

CLOCKWORKS
Watercolor & ink on paper, 6″ x 9″, 1993

184

Special Thanks to:

Deborah Koons Garcia whose extensive collection of paintings, drawings, and digital works were made available to us for use in this book.

Tiff Garcia for the contribution of "Early Works" paintings and cartoons.

Other collectors for their contribution in re-documenting work for this publication:

STILL LIFE	Tiff Garcia
FACE TO FACE	V. L. Patterson
CAR ON FIRE	Gold Lion Fine Arts
JUKEBOX	Len Dell'Amico
SLOT MACHINES	Len Dell'Amico
THE KABBALIST	Sheri & John Scher
Imaginary Drawings	Len Dell'Amico
AMERICAN ABROAD	V. L. Patterson
TRUMPET PLAYER	V. L. Patterson
DAVID	Christine Hanrahan & Keith Porter
PIANO PLAYER	David Kay
MICKEY	Len Dell'Amico
VID-GAME	Len Dell'Amico
FRANKENSTEIN	I. Brewster Gallery & Nicky Isen
COTTON CLUB	V. L. Patterson
RELUCTANT DRAGON	Cassidy Rose
TRIGGER FINGER	I. Brewster Gallery & Nicky Isen
WAR MACHINE	Len Dell'Amico
AUGUST WEST	Peter Daniels
VINCE	David Kay
DREAMING WITH FISHES	V. L. Patterson
BACKGROUND NOISE	V. L. Patterson
LOVER'S LANE	V. L. Patterson
CHERRY '57 NASH	John Paul Cowan
BIRD GUY	Bob Bushnell

BLUES BROTHERS	Christine Hanrahan & Keith Porter
PROFILE	Emil Areton
Etchings	John Paul Cowan
DUCK SERIES	Len Dell'Amico
SHAMAN	Joram Salig
FEEDING IN THE LIGHT	David Kay
MOON MOUNTAINS	Mark & Martha Mortensun
RECOLLECTION	Trixie Garcia
MEGALITHS	Samuel Srochi
ANOTHER BUTTERFLY	Orlando & Margaret Toro
MODERN FURNITURE	Doug Carideo
BUS TERRORIST	David Plants
BLUE MOUNTAIN	Mark & Martha Mortensun
WETLANDS I	Mark & Martha Mortensun
WETLANDS II	Matthew & Heather Osborne
FACETS II	Peter Daniels
BLUE ICEBERG	John Paul Cowan
SWIT!! WAKING ME IF NEEDED	John Paul Cowan

and for the Limited Edition:

MR. TWIDGE	Orlando & Margaret Toro
CORPORATE	V. L. Patterson
SELF PORTRAIT	V. L. Patterson
SMILE	V. L. Patterson
Imaginary Drawings	Len Dell'Amico
STREET GUYS	Lynne Torrey
GUITAR MAN	Len Dell'Amico
OLD MAN BY THE WATER	Kipp Armstrong
RIPTIDE	Michael F. Levy

Photographers who assisted in documenting the artwork:

Trillium Press, Rick Edwards Photography, Skip Barton Photography, Scott Wyberg Photography, Reis Birdwhistell, and Selective Photography

A Last Word

April Higashi

When I was first asked to set up an exhibition of Jerry Garcia's original artwork in 2000, I did not know what this was going to involve. I had some familiarity with his music–his solo work, the Grateful Dead, and his other bands–but it was mostly through osmosis, the pervasiveness of his music in our culture.

I was in art school in San Francisco in 1986, near Golden Gate Park and the Haight-Ashbury. Dressed in the requisite black, I would often go out after my night class to a club; returning to my dorm room, I would come back to a cloud of smoke within which my colorful roommate and her latest company were grooving to a Grateful Dead tape.

My roommate loved Jerry, more than art school itself. In her second year, she moved in with a fifty-year-old man in a van and became part of that counterculture. I never saw her again, although she did contact me years later through the Jerry Garcia website after cruising the credits and wondering how someone like me could have landed such a "lucky" job.

I do not fall into the category of a "Deadhead"; I started with a clean slate in managing Jerry's artwork. Up until that time, the only connection I had had to Jerry as a visual artist was observing the phenomenally popular "J. Garcia" line of neckties. I became involved obliquely, being invited by Deborah Garcia to bring order and clarity to the legacy of Jerry's artwork. My role has expanded to include working with other members of his family. Since being hired I have overseen the archiving, preservation, authentication, exhibition, and quality standards of all of Jerry's artwork that is available to us.

Over my time as Art Director and Curator, I have gained respect for Jerry both as an artist and as a person. He had his flaws and he made his mistakes, to be sure. But he gave an enormous gift to, and greatly influenced, the American popular culture. My impression of Jerry, after having contact with many of his friends, loves, family, and associates, is that he was an genuine, good and generous person.

Jerry did not set out to be a Great Artist. Often when one has that intention, the artwork reflects pretense and contrivance. Jerry's art is authentic. His work poses no consistent theme or style, no particular statement of intent. He is an artist who had nothing to prove; he drew because he loved to draw, and it shows. Just as he was at home with improvisation as a musician, he was naturally inclined to be an improviser in his art. His pen-and-ink drawings, gouaches and watercolors reflect a directness and honesty.

I have made a sincere attempt to represent Jerry Garcia as a visual artist who has his own integrity and legitimacy apart from his talent and fame as a musician. I take this responsibility to heart, knowing that the manner in which an artist is seen and presented to the world, especially after his death, is a crucial part in determining his legacy.

The body of work in this book has been carefully sourced, salvaged, researched, organized, archived, and curated from the collections of his family and friends, art dealers, and helpful collectors. I must say, this occasionally took me down some pretty weird paths.

The artworks in this book were selected for artistic merit, historical provenance, and range of style and media.

Jerry's digital works were taken from his Mac Powerbook's SyQuest drive in 1995. Some of these pieces may not have been meant to be shown as final pieces. They have been titled with Jerry's file name and date on file, when available.

Because there were few records documenting all the artwork, the titles, years, sizes and media have been carefully compiled from many sources. In some cases the artwork had two names, one named by him and one by his art dealer. The titles Jerry gave the works, when known, are the ones used in this book and may conflict with some other published print titles. In any case, I believe this is as comprehensive a look at Jerry, through his artwork, as can be accomplished.

Jerry was an original. His sun shown brightly, as a true Leo. Everyone around him felt some of that warmth. Being the collector and caretaker of his artwork has been, and continues to be, a great honor. Getting to know Jerry Garcia in this way, and seeing the effect he had on people's lives, inspired me to want to put this book together—a remarkable collection from a remarkable man. Jerry kept the qualities of creativity, curiosity, and generosity at the forefront of his priorities. I hope that in some way this book helps us all remember to stay connected to our own.

Warm thanks and acknowledgement to all who have helped in putting this book together, including:

Deborah Garcia, who hired me and had the vision to share Jerry's artwork in a professional manner, and to keep his memory alive.

Christopher Sabec, CEO; and Peter McQuaid, licensing director of the Jerry Garcia Estate, who helped shape the book; Seth Augustus Quitner for archiving and art department assistance, and all the other members of the Estate who have been supportive of this project: Annabelle Garcia-McLean, Tiff Garcia, Trixie Garcia, Heather Katz Garcia, Sunshine Kesey, and Keelin Garcia.

Chris Murray of Govinda Gallery, whose introduction to Palace Press made this book possible.

Palace Press's amazing book team—Raoul Goff, Mark Burstein, and Peter Beren—has been a pleasure to work with in creating this historically important book. Thanks as well to Lisa Fitzpatrick, Lauren Salazar, and to the designers Noah Potkin, Usana Shadday, Gabe Ely and Alan Hebel.

Roberta Weir; Dennis McNally, Greatful Dead publicist; Eileen Law, Greatful Dead archivist; Vince and Gloria DiBiase; Megamu Yamamura and Toshiya Oki, liaisons to Japan, for their video interview at the Parco Gallery.

Charlie Winton, CEO of the Avalon Publishing Group, who acquired this book; Thunder's Mouth Press: John Oakes, publisher; Sandee Roston, associate publisher; and Gayle Hart of Avalon, who was always there when we needed her.

The many collectors, dealers, galleries, and photographers who have generously assisted in documenting their originals and sharing their stories.

Last but not least, my companion Eric Powell, who is always supportive in my creative endeavors and also, coincidentally, shares Jerry's birthday.

Colophon

Jerry Garcia: the collected artwork was printed with a 200-line-screen four-color process with dry-trapped spot-gloss varnish. The text stock is 157-gram Japanese matte art paper. The case is covered with Japanese Asahi cloth and foil stamped. The Numbered Limited Edition includes six additional gatefolds, a limited and numbered art print from the Jerry Garcia Estate LLC, a unique CD of Jerry Garcia performances spanning his entire career, including previously unreleased material, and a certificate of authenticity. The edition is encased in a cloth-wrapped clamshell box with foil stamping and a hand-tipped image on the front.

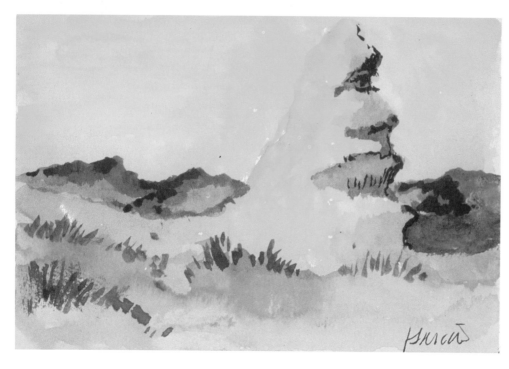

CYCLOPS ROCK
Watercolor on paper, 4˝ x 6˝, 1993

Insight Editions

Publisher and Creative Director: Raoul Goff
Co-Publisher: Christopher Sabec, CEO & Manager, Jerry Garcia Estate LLC
Series Editor: Chris Murray
Project Director: Peter Beren
Executive Director: Michael Madden
Project Editor: Mark Burstein
Designers: Noah Potkin, Ian Szymkowiak, Alan Hebel, Usana Shadday
Project Coordinator: Lauren Salazar

Jerry Garcia: The Collected Artwork
Limited Edition CD

1. *On the Road Again* (Live), 1964, Mother McCree's Uptown Jug Champions (2:55)

2. *Cream Puff War*, 1967, Grateful Dead (3:18)

3. *Dark Star* (Live), 1969, Grateful Dead (12:29)

4. *Uncle John's Band* (Live), 1972, Grateful Dead (6:46)

5. *Candyman*, 1970, Grateful Dead (6:10)

6. *Mission in the Rain*, 1975, Jerry Garcia (5:00)

7. *Jackaroe* (Live), 1977, Grateful Dead (5:52)

8. *The Wheel* (Live), 1982, Grateful Dead (6:23)

9. *Waiting For A Miracle* (Live), 1989, Jerry Garcia Band (5:37)

10. *Scarlet Begonias > Fire On the Mountain* (Live), 1990, Grateful Dead (19:34)

11. *Whisky in the Jar*, 1994, Jerry Garcia and David Grisman (4:15)

Tracks 1, 7 & 11: Traditional; Track 2: J. Garcia, (Ice Nine Publishing) ASCAP; Track 3: R. Hunter/Grateful Dead, (Ice Nine Publishing) ASCAP; Tracks 4, 5, 6 & 10 (a): J. Garcia/R. Hunter, (Ice Nine Publishing) ASCAP; Track 8: J. Garcia/R. Hunter/B. Kreutzmann, (Ice Nine Publishing) ASCAP; Track 9: B. Cockburn, (Songs of Universal) BMI; Track 10 (b): R. Hunter/M. Hart, (Ice Nine Publishing) ASCAP. Compilation © Copyright 2005 Jerry Garcia Estate LLC, All rights reserved. Used under license. Special thanks to: Grateful Dead Productions, Warner Strategic Marketing, Ice Nine Publishing, Acoustic Disc and Michael Wanger.